Pixar and the Aesthetic Imagination

The publisher gratefully acknowledges the generous support of the Robert and Meryl Selig Endowment Fund in Film Studies of the University of California Press Foundation, established in memory of Robert W. Selig.

Pixar and the Aesthetic Imagination

Animation, Storytelling, and Digital Culture

Eric Herhuth

UNIVERSITY OF CALIFORNIA PRESS

University of California Press, one of the most
distinguished university presses in the United States,
enriches lives around the world by advancing scholarship
in the humanities, social sciences, and natural sciences. Its
activities are supported by the UC Press Foundation and
by philanthropic contributions from individuals and
institutions. For more information, visit www.ucpress.edu.

University of California Press
Oakland, California

An earlier version of chapter 5, "Disruptive Sensation and
the Politics of the New: *Ratatouille*," appeared as "Cooking
like a Rat: Sensation and Politics in Disney-Pixar's
Ratatouille," in the *Quarterly Review of Film and Video* 31, no. 5
(2014): 469–85.

Cataloging-in-Publication Data is on file with the
Library of Congress.

ISBNs 978-0-520-29255-0 (cloth); 978-0-520-29256-7
 (paper); 978-0-520-96605-5 (ebook)

Manufactured in the United States of America

26 25 24 23 22 21 20 19 18 17
10 9 8 7 6 5 4 3 2 1

For Carissa

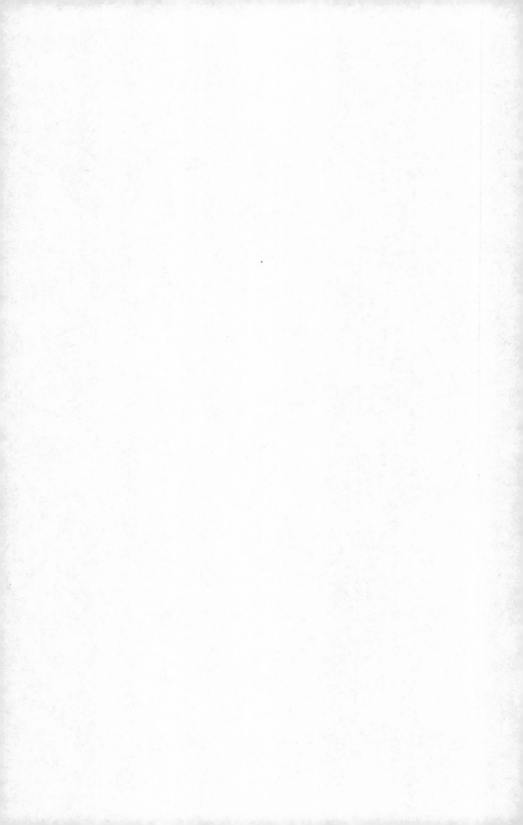

CONTENTS

ILLUSTRATIONS

ACKNOWLEDGMENTS

This book would not have been possible without the support of the University of Wisconsin–Milwaukee. I am indebted to my UWM colleagues at the Center for International Education and in the Media, Cinema, and Digital Studies program for their encouragement and conversation. I am particularly grateful to EJ Basa, Mike Beebe, Tim Brown, Dalia M.A. Gomaa, Bridget Kies, Molly McCourt, Adam Ochonicky, Kristi Prins, Ali Sperling, Heather Warren-Crow, and Hyejin Yoon for their insightful commentary at various stages of this project. I also want to acknowledge Tulane University, the Society for Animation Studies, and the Society for Cinema and Media Studies and its Animated Media Scholarly Interest Group for providing opportunities for me to present my research at conferences and invited talks. The generous spirit of the scholars attending these events has been vital to this project. For their assistance researching Pixar Animation Studios, I want to thank Maggie Werner, Aileen Morrissey, Brett Warne, and Aurica Hayes. Jon Brown's (jontbrown.com) artwork on the cover provided a wonderful final touch, and I cannot thank him enough for his time and talent.

It was a privilege to think through this project with a vibrant community of scholars. My work benefited from the readings of Richard Grusin, Elena Gorfinkel, Esther Leslie, and Suzanne Buchan. I extend

my sincere thanks to them for their thoughtfulness and guidance. Kalling Heck and Mark Heimermann were brilliant resources throughout the writing process, and I am deeply grateful for their friendship. During my time in Milwaukee the advice and ideas offered by Peter Paik and Kennan Ferguson proved incredibly valuable and will continue to influence my thinking and writing in the future. Patrice Petro deserves more acknowledgment and thanks than any single statement could muster. Her intelligence, consistent presence, political sensibility, and courage make her an exemplary adviser and colleague, and I am very grateful for having had the chance to work with her.

Finally, I want to thank my family for their kind encouragement and support. Writing a book takes time, and I sincerely appreciate the gracious treatment I have received while taking the time to write.

Introduction

This book explores Pixar Animation Studios' feature films through a series of aesthetic concepts. These include the uncanny integrity of digital commodities in the *Toy Story* films (Lasseter 1995; Lasseter, Unkrich, and Brannon 1999; Unkrich 2010); the technological sublime in *Monsters, Inc.* (Docter, Silverman, and Unkrich 2001); exceptional and fantastic bodies and spaces in *The Incredibles* (Bird 2004); and taste, sensation, and becoming in *Ratatouille* (Bird and Pinkava 2007). All of these analyses are grounded in the idea that there is a tradition of animated films addressing aesthetic experience and that this tradition continues in Pixar's storytelling. The narratives, characters, and carefully designed worlds raise these aesthetic concepts to varying degrees, but primarily, this address of aesthetic experience can be observed through two, interactive levels: characters discovering their worlds and audiences watching and thinking about that discovery.

Emerging from this idea is the notion that mapping such a tradition through film and animation theory and through philosophy and political theory delineates a critical methodology for analyzing animated films and producing cultural criticism. This focus on aesthetics is historically and theoretically appropriate for analyzing animated films that develop imaginary characters and worlds. And it is equally appropriate

for investigating cultural, economic, environmental, and technological transformation in the digital age. The breadth of this dual claim speaks to the pervasiveness of animation across media environments but also to the expansion of animation as a category of inquiry within cinema and media studies. The term *animation* is certainly capable of referring to all moving images and even other media featuring fabricated movement. Moreover, while the term *animation* evolves and moving images and screens proliferate, an affinity has seemingly developed between animation and the abstract, technological, moving parts of life and culture in late capitalist society. The study of animation and animated films has the potential to illuminate not only our digital context and the prevalence of moving images but also our aesthetic context given that capitalism, technology, and natural phenomena stimulate and transform our senses, feelings, and judgments.

Before diving into this investigation, I want to discuss how exactly this abstract and academic line of thought follows from the entertaining products of a major commercial animation studio. Does this theoretical discourse blatantly disregard Pixar Studios' own philosophy, organization, and commercial and cultural goals? Or does the terrain of aesthetics subtend both the studio's entertainment art and its generative capacity for theory and criticism? This introduction begins to think through these questions by discussing the critical commentary surrounding Pixar Studios, its films, its brand, and its creative culture. From here the conversation turns toward the aesthetic and artistic ideas that are fundamental to Pixar and its films. This discussion sets up the subsequent chapters, which explore how animated films have addressed aesthetic experience, how Pixar films build on that legacy, and how analyzing these films generates cultural criticism.

PIXAR ANIMATION STUDIOS

As the first studio to produce a computer-animated feature film, Pixar usually presents its history as an entrepreneurial success story, which

includes technological and business innovations that established the company as a cultural force within the digital era and one of the most successful brands in the entertainment industry.[1] This American success story follows a group of brilliant computer scientists and engineers who managed to create breakthrough technologies in computer graphics, acquire the patronage of investors (Alexander Schure, George Lucas, and Steve Jobs, among others) over decades of development, and hire talented animators even before becoming a filmmaking studio. The dream uniting these creative technicians over the years was to make a feature film with computer animation, an impossible feat when their journey began. The films finally produced by Pixar during the late 1990s and early 2000s correlate with the studio's cultural and economic success in that they explicitly address dynamics of new and old media and express themes associated with the entrepreneurial culture of Silicon Valley. The studio's cultural impact can be measured by the number of historians and teachers using Pixar's shorts and films to mark the advances of computer animation and CGI in the film industry. And the ease with which Pixar's animated characters traverse transmedia environments marks the increasing ubiquity of software and screen culture. The cultural relevance and consistent reflexivity of Pixar's products in conjunction with the stylistic continuity of the studio's computer animation has contributed to building an iconic, profitable brand. And while these early films are part of a broad history of innovation and globalization, the studio remains known for managing its production processes in-house, for developing proprietary software, and for maintaining a consistent creative culture and labor force.

Ed Catmull's book *Creativity, Inc.* epitomizes this legacy as it presents Pixar as a model of post-Fordist labor. Catmull is president of Pixar Animation Studios and Walt Disney Animation Studios, but he is also well known for his earlier academic work in computer graphics. *Creativity, Inc.* celebrates commitments to storytelling and technical prowess; it champions honest dialogue, protecting new ideas, taking risks, and makes the case for worker autonomy and artistic vision. Around the

time of his book's release, however, Catmull emerged as a leading figure in the wage-fixing scandal implicating several animation studios.[2] Harking back to Walt Disney's battles with labor, this turn of events suggests that Catmull's creative industry model continues the exploitation of animation labor and has a problematic relation to the free-market principles associated with California-style capitalism. It seems that Catmull's commitment to protecting the new may have led him to suppress wage competition.

In the growing scholarship on Pixar the studio's post-Fordist model and its representative status within digital culture have received considerable attention, and this informs many of the critical readings of the studio's films. Leon Gurevitch's work is exemplary in this regard. In a pair of articles Gurevitch situates Pixar's animation within a broader context of CGI that extends and reproduces a variety of industrial and commercial logics. This includes the fact that the totality of computer generated space-time is designed, and such design is heavily influenced by the commercial and algorithmic logics of modern design industries.[3] Gurevitch's point is that the continuity of designed space-time shares a practical and cultural continuity with product design, which informs the visual and storytelling aesthetics of many computer-animated films. Furthermore, Pixar's films in particular tend to include depictions of commercial advertisements and other screen media during crucial narrative moments. These meaningful encounters with screens are a fundamental trope in Pixar character development and thereby present "the attention economy's primal scene dramatized over and over again."[4] The upshot of these analyses is that the rehearsal of the logics and practices of product design and the commodification of attention provide a form of training for audiences, orienting them to new customs within consumer culture and creative, media-driven capitalism.

Pixar's success in the film industry correlates with its own successful construction of a post-Fordist mode of production, and its films help cultivate the expansion and reproduction of that mode. For anyone who

has seen a Pixar film, however, and noted the strong presence of nostalgia and analog media, it is also obvious that this cultural and economic work is not straightforward. In the case of *WALL-E* (Stanton 2008), for instance, the robot protagonist is at once industrial and digital; the character references the slapstick humor of the Fordist era but also the future of precarious, individuated, digital work. The film effectively conceals much of its own work, as Paul Flaig explains: "The film suggests that a refusal to show work calls attention to such absence all the more symptomatically, whether this be the industrial boredom *WALL-E* nomadically transforms, the missing century of modernism in its final credit sequence or the ideology and aesthetic of Pixar as corporate friend. Images 'visibly labored' might be most present precisely when they are avoiding industry. In such moments, this might be when their fun factories are working hardest."[5] Pixar as fun factory is a designation from a *New Yorker* article by Anthony Lane, and it connects the studio to the legacy of industrialized entertainment and the creative culture of California technology companies.[6] But in the case of computer animation, and digital audiovisual effects more broadly, there remains the problem of polished products distorting specific traces of work and world.

Scholarship on Pixar has begun to characterize the company's oeuvre as a dialectical bridge that connects not only different modes of animation production but a host of cultural and economic transitions. As a bridge, the studio's films do not present a revolutionary break but a route for old and new practices and ideas to travel. This means that despite the more radical themes found in what Judith Halberstam has called "Pixarvolt" films, the broader impact of Pixar and its products may be that they mitigate extremes and render transition more palatable.[7] This includes the transition to precarious, individualized, and creative forms of labor that are, nevertheless, concealed by digital mediation, corporate organization, and aesthetic styling that minimizes recognizable traces of individual authorship.

Related to these labor issues is the popularity of the Pixar brand itself, which attracts and retains top talent in computer science and animation

fields and continues to receive celebratory treatment through fan litera-
ture and popular criticism. Perhaps the strongest indication of Pixar's suc-
cessful branding appears through the efforts of fans to connect all of the
films in a single fictional cosmos or overarching "Theory."[8] Even criticism
of the studio's products tends to emphasize the consistent themes and val-
ues that repeat across films, and these are easily interpreted as messages
aimed at reproducing the studio's conditions of production. In the words
of one critic Pixar, through its narratives about self-actualization and
developing one's unique skill set, has produced a "filmography that con-
sistently conflates individual flourishing with the embrace of unremitting
work," and "at its bottom, this is the logic of pure capitalism."[9] I imagine
that producers at the studio are pleased with both forms of commentary.
While one is fan fiction and the other critical nonfiction, both emphasize
the significance of Pixar's consistency and gesture toward a promising
future for the studio. Barring the end of capitalism, fans and workers will
continue to invest in the Pixar cosmos given that it consistently depicts
stories and themes relevant to contemporary life.

As many commentators have noted, this successful branding is in one
sense attributable to the studio's "braintrust": a team of senior Pixar cre-
atives who workshop each film under production.[10] The braintrust
serves as a mechanism for establishing aesthetic and creative standards
at the studio.[11] The central figures of Pixar's braintrust were trained at
Disney-founded CalArts, and these industry leaders (which include
John Lasseter, Andrew Stanton, Pete Docter, and Brad Bird) have been
significantly influenced by the Disney tradition—at times rebelling
against it and at times perpetuating its tenets. Comparable to Walt Dis-
ney himself, Pixar's leadership, especially that of John Lasseter, describes
the studio's principles as oriented around art and technology working in
concert.[12] This self-description correlates with what J. P. Telotte calls
Pixar's "technical self-consciousness," which refers to the narratives,
characters, and themes that reflect or refer to the studio's technical inno-
vation, new medium, and its corresponding privileged market position.[13]
And, like other California tech companies, the studio's creative and

technical leaders and founders largely consist of white men of compara-
ble age. This has led many critics to read Pixar films as reflective of
these demographics.[14] Pixar's early films tend to revolve around male
relationships—buddy and father-son stories mostly. While commenta-
tors have noted that Pixar characters challenge essentialist identities,
unlike classical Disney narratives about inherent nobility, many of the
studio's films remain committed to traditional characterizations of mas-
culinity.[15] Overall, the reflexivity of the films channels both critical and
celebratory commentary toward the studio, its braintrust, and its brand.

In sum, the investment by fans and critics in the Pixar brand and the
standardization facilitated by Pixar's braintrust support the growing
scholarship on Pixar as an entertaining escort into a problematic post-
Fordist, digital era. In this formulation the films themselves become
advertisements for Catmull's book, and they serve reflection-based cri-
tiques of the studio and its culture. The critical readings offered by the
films are actually more variable than this and quite capable of illumi-
nating broader cultural shifts and debates, which is evident in the
scholarship already mentioned. What is lacking in the foregoing com-
mentary, however, is a thorough consideration of the implications and
critical possibilities facilitated by Pixar's commitment to creativity. In
other words, how does Pixar's commitment to the artistic and creative
practices of animation shape its products, and how does this inform the
studio's navigation of contemporary culture and markets? Finally, what
critical readings do such products offer considering the growing schol-
arship on aesthetics as a critical methodology?

We can begin to answer these questions by turning to the work of
Jerome Christensen, who devotes a chapter of his book *America's Corpo-
rate Art* to analyzing Pixar's relation to Disney in an effort to investigate
how a corporate culture can function as a corporate conscience.[16] The
argument refers to Disney's 2006 acquisition of Pixar, which thrust
John Lasseter and Ed Catmull into leadership positions at Disney and
made Steve Jobs Disney's largest shareholder.[17] The reigning interpre-
tation of this event is that Pixar's creative culture became the guiding

force within Disney Animation. I mention Christensen's argument because its use of figuration (he posits that Pixar is Disney's Jiminy Cricket or conscience) points to what lies at the core of Pixar's own culture or conscience—which is, in short, animation. Catmull's book is called *Creativity, Inc.*, after all, and it is fitting to find an imaginary figment, an animated character, as the corollary for Pixar's culture. Furthermore, Christensen's commitment to delineating corporate strategy and studio authorship through film analysis is effectively expanded through his metaphorical reading of the personified conscience that is Jiminy Cricket. This directs his examination of Pixar and its films toward a larger comment on the nexus of industry, culture, and law— namely, if a company's culture can be its conscience, then it, too, is subject to the notions of liability and responsibility attributed to persons.[18] This argument is facilitated by the imaginary figure of Jiminy Cricket, and it demonstrates how corporate art makes opportunities for cultural criticism. And finally, to say that Pixar is the Jiminy Cricket of the Disney Company highlights the abstraction, artifice, and art that are central to Pixar's organization.

SEEING AS AN ARTIST

But what kind of creativity is this exactly? How does it guide Pixar's philosophy, and what else might it do? Catmull describes how Pixar's organization and practices are oriented around "protecting the new" and "learning to see" the world as artists do, which involves applying the skills of animators to the philosophy behind the organizational structure of the company. For example, all new hires must attend Pixar University and learn basic lessons in drawing. This includes teaching employees to see and draw an object without thinking about the concept they use to give it meaning. According to Catmull, this results in a more realistic drawing because it avoids concepts that distort reality, and employees learn "to suppress that part of [their] brain[s] that jumps to conclusions." When describing the task of drawing a chair without

seeing a chair, Catmull adds, "The real point is that you can learn to set aside preconceptions. It isn't that you don't have biases, more that there are ways of learning to ignore them while considering a problem. Drawing the 'un-chair' can be a sort of metaphor for increasing perceptivity."[19] The idea behind these liberal arts lessons is that they help Pixar workers resist routine and habitualized modes of understanding and perceiving the world, which serves as a tremendous resource for the creative labor of storytelling and animating.[20]

Catmull explains that animators must understand how the human perception system works in conjunction with conceptual knowledge to negotiate the many details that make up our experiencing of the world. When explaining how this knowledge about perception and aesthetics functions in the context of management and animation, Catmull refers to the work of the philosopher Alva Noë, a notable figure in studies of perception and consciousness. Noë offers a skill-based or actionist approach to perceptual consciousness, which maintains that a person's awareness of what is present is an active process that relies on sensorimotor *and* conceptual understandings that develop in concert with one's experience. What things are present and available depends on a person's experience, contextual knowledge, and a variety of sensorimotor skills, as well as the brute existence of those things. For Noë, "perceiving is *exploring the world*."[21] Sensorimotor and conceptual modes of understanding are skill sets that develop through use, and art is a resource for cultivating them. Noë's philosophy provides Catmull with an explanation for the intimate bond between making *a* world and knowing *the* world. Artifice and construction are fundamental to Catmull's preoccupation with perception and reality, and this speaks not only to his computer graphics background but also to his management style, which includes the suppression of competitive wages.[22] The suggestion here is that there is a link between Catmull's brand of constructivism and his manipulation of labor.

But the presence of Noë's philosophy in *Creativity, Inc.* hints at the critical possibilities facilitated by a commitment to aesthetic judgment.

While Catmull finds the philosophy relevant to the management of animation, storytelling, and creative labor in general, Noë's work also offers a valuable articulation of the relationship between aesthetics and criticism. Noë appreciates art for creating a space for judgments that do not use prescriptive, conceptual rules or criteria but involve the "non-judgmental use of concepts" and lead to criticism, or those efforts to convince others of the validity of one's experience through "justification, explanation and persuasion." Noë writes that "the critical inquiry that the art work occasions and requires is the very means by which we exercise the understanding that brings the work of art into focus and so allows us to feel it, to be sensitive to it."[23] Art provides a kind of fine-tuning of the sensorimotor and conceptual modes of understanding involved in knowing the world. It explicitly positions knowing the world as experimental and exploratory, and it prompts reflection on the processes of knowing and reckoning with newness. This formulation leads Noë to compare art to philosophy in his book *Strange Tools: Art and Human Nature*. Philosophy, like aesthetic experience, is not a strict application of rules or criteria. It involves probing the meaning of what humans do and think and the processes involved.

Figuring perception as a "skillful exploration" of the world reasserts art and philosophy as activities that directly influence everyday life through their capacity to refine and examine the exploratory skills used to know the world and judge experience. Pixar's animated worlds can be understood as thought experiments in this fashion. They vary in their specific themes and environments, but, in accord with the ideas of Catmull and Noë, they depict changes to modes of knowing the world, and they depict the reconfiguration of communities. Many of the characters, often nonhumans, suffer from epistemological crises as their perception and understanding change. This is the case when the robot WALL-E disrupts the programmed routines of robots and humans living aboard a futuristic spaceship, and it is the case in *Toy Story* when the toys face their potential obsolescence and the vulnerabilities of being toys. These crises map onto contemporary situations, including anxieties about new

technology, media, and globalization. In the chapters that follow, I will show how aesthetic concepts disclose the epistemological vulnerabilities addressed by different Pixar films. But these chapters also take aesthetic experience to be explicitly related to politics and judgment. Aesthetic experience, grounded in feeling-based judgments, indicates a plural world full of new encounters and phenomena that are open to unique, individual judgments. This quality can disrupt social order and convention, but it can be mobilized to reproduce concepts and tropes within popular culture—commodity and technology fetishism, fantastic bodies and spaces, and the championing of individual talent and identity.

Pixar's productions warrant a robust critical discourse appropriate for the studio's historical and cultural context. To recast my argument about aesthetics and sociocultural change in different but familiar terms, my contention is that the Pixar narratives, characters, and worlds are engaged in what Jack Zipes calls a "civilizing process" or the human need to adjust society and adjust to society in the midst of a changing world.[24] Zipes observes this process in his studies of fairy tales, but it relates to Pixar films as well. Before *Brave* (Andrews, Chapman, and Purcell 2012), the majority of Pixar's films presented nonhuman characters and allegorical narratives in contemporary or futuristic settings that are more technological than magical. These films imagine alternative social and communal formations, or "the reconstitution of home on a new plane," but with greater proximity to a contemporary, everyday reality.[25] The reflexivity of Pixar films is particularly pronounced through their contemporary and futuristic worlds, which resonate with the real-world contexts of the 1990s and 2000s. This reflexivity is attributable to the creative teams at Pixar learning and exploring their medium, and it is attributable to the aesthetically oriented culture led by Ed Catmull and John Lasseter. Thus, it is appropriate to think of the films as contemporized fairy tales that retain an exploratory, experimental orientation toward knowledge and politics. This orientation, while possibly conducive to progressive or even subversive political thinking, has also proven effective for circulating conservative and

neoliberal values. This dialectic demands considering Pixar's artificial worlds and transformational stories as opportunities for thinking through aesthetics as a contested domain, at once inclined toward market-oriented newness and innovation as well as criticism and pluralistic thought.

CHAPTERS

I have already noted Christensen's conceptualization of Pixar Studio's aesthetic orientation as comparable to the character of Jiminy Cricket, but it is also figurally represented on the jacket of *Creativity, Inc.* by the silhouette of the character Buzz Lightyear directing an orchestra (Figure 1). The figure recalls Mickey Mouse in "The Sorcerer's Apprentice" and other cartoons in which creative authority is ceded to an animated character. The figures that character animation offers for representing Pixar's creative culture and guiding inner voice are fitting because these characters derive from animated worlds and stories. In addition to the trope of authorship and creation, these characters are frequently portrayed as exploring, discovering, and responding to their worlds. This enables audiences to discover the rules of the animated world along with the characters. And this emphasis on making sense of perception and experience is foundational to what we call aesthetic experience—or modes of making sense of sense experience. As I describe in the first chapter, there is a long-standing tradition of animated films addressing aesthetic experience that Pixar's films effectively build upon. Following recent studies of aesthetics in philosophy and political theory, I describe this address of aesthetic experience as an interrogation of nature and a relief of conceptual burdens. These qualities are evident in production and reception customs that developed throughout modernity and the history of cinema and are evident in the theorizations of notable animation scholars such as Scott Bukatman, Esther Leslie, and Paul Wells, and in the commentary of film theorists such as Andre Bazin, Stanley Cavell, and Vivian Sobchack. The upshot of this investigation of aesthetics, animation, and

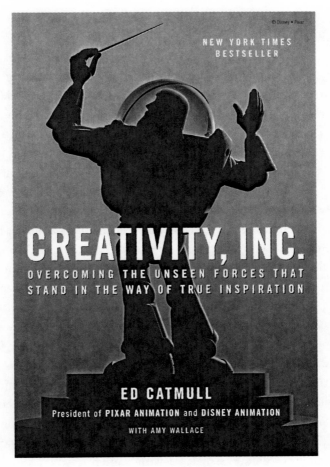

Figure 1. The book jacket of *Creativity, Inc.* alludes to the trope of animated characters becoming the source of animation and creation.

film theory is that there is a historical pattern of animated films serving the contemplation of radically different worlds, viewpoints, and therein epistemological vulnerability. Such depictions allude to the aesthetic qualities of judgment and knowledge, and they contribute to dialectical theories of animation. This animation tradition is central to Pixar's

own storytelling and how its films engage cultural and environmental transitions.

To begin enacting the critical perspective developed in the first chapter, the second chapter explores the uncanny life of digital commodities through the *Toy Story* films. The term *uncanny*, by denoting a disturbing uncertainty, refers in this case not only to the premise of living toys but to the series of contradictions expressed by the toy characters. As nostalgic, transitional objects, the toys provide an opportunity to compare the fetishistic consumer logic of the predigital era to more recent instantiations of commodity fetishism and brand logic. This enables the films to demonstrate how commodity logics can thrive in highly automated contexts that render technology intensely personal and relational while being mass produced. The computer animation of the *Toy Story* films enhances these contradictions through a stylized realism that presents a recognizable but uncertain and disorienting world in which the toy characters and their audiences must discover the commercial customs and rules that maintain order and meaning.

Comparable to the uncanny in the *Toy Story* films, *Monsters, Inc.* facilitates thinking through changes in the concept of the sublime, which, like the uncanny, denotes discord within a subject's perception and knowledge of the world. The third chapter, then, examines how *Monsters, Inc.*'s treatment of fear, interpersonal intimacy, and technological structures offers an opportunity to contemplate how the ego-affirming, technological sublime associated with Kantian aesthetics differs from postmodern formulations of the sublime. These latter formulations are mobilized in the film to rationalize fear toward others and to reconfigure divisions between communities. The polymorphic bodies of the monsters, the cartoonish child characters, and depictions of complex industrial structures demonstrate the enhancement of sublime aesthetics through computer animation. The detailed digital sequences and spaces amplify tensions between agents and environments, but the animated characters also express how the uncontainable and unknowable qualities of aesthetic, interpersonal experience can both undermine the

stability of structured environments and serve the liquid infrastructure of late global capitalism.

A film primarily about family, *The Incredibles* offers up a portrayal of 1960s-era superhero characters, providing a very different opportunity to analyze the dynamics between individual agency and systemic conditions. Through its themes of the fantastic and the mundane, the film facilitates contemplating the maintenance of a competitive, liberal society via a dialectic of exceptional and routine experience. This inquiry, taken up in the fourth chapter, focuses on depictions of exceptional bodies and spaces and how a logic of exceptionality operates through the film to disrupt and affirm norms and laws. The stylized animation of the film amplifies these themes and supports the overall narrative, but the animation complicates the film's dialectic by evoking processes of biopolitical governance through its own capacity to build and administrate depictions of everyday life. In this context the mythic order of superheroes appears to provide a clearer social hierarchy that delivers consumers and citizens from the deceptive machinations of a technology- and market-driven, competitive, liberal society.

The final chapter takes up sensation in relation to aesthetic experience, exploring how *Ratatouille* can be read as an allegory about the relationships between taste and democracy and between sensation and mediated creativity. In the world of the film, sensation disrupts rules and conventions but also leads to reconfigurations of bodies, relationships, and the perceptual and epistemological habits that determine political possibilities. While the film makes available cynical readings about post-Fordist labor and the precarious conditions of innovative workers, this chapter attempts to take seriously the film's overtures toward new political configurations. This entails focusing on the film's depictions of disruptive sensations and processes of becoming, as well as how the animation of these sequences enables audiences to learn the rules of the world as the characters' stories unfold. This combination of style and narrative continues the tradition of addressing aesthetic experience, but the film's political and economic overtures suggest that the

aesthetic domain of experience remains a contested space capable of supporting political change and vulnerable to the absorbing forces of market activity.

In myriad ways Pixar's commitment to aesthetics begins with *Toy Story* and persists throughout the studio's films. *A Bug's Life* (Lasseter and Stanton 1998), *Finding Nemo* (Stanton 2003), *Cars* (Lasseter and Ranft 2006), and the films that come after *Ratatouille* and Pixar's acquisition by Disney are not discussed in this project, but they do share many commonalities with those I analyze. Themes about modernity, technology, and entertainment remain prevalent in these films, along with valuations of individual creativity. But I do not feel compelled to organize all of these films under a single theoretical armature; the brand itself does enough. Instead, I have selected the films that strike me as obviously addressing serious cultural issues and transitions and that were equally important to developing Pixar's brand and creative culture early on. But perhaps even more than this, my choice of films responds to an effort to think through the aesthetic concepts and categories that dominate the recent history of media culture and economic and political activity. By letting the films take the lead in this effort, each chapter illuminates how traditional aesthetic concepts—the uncanny, the sublime, the fantastic, and taste—have been re-envisioned within digital culture. The chapters also highlight the distinct visions of each film, often cleverly articulated for promotional purposes by the directors, in juxtaposition to these aesthetic concepts.

Research about Pixar tends to fall into a few basic categories: biographical, commercial, fan-based, and academic. This project exists within the last category, and unlike technical publications and industry studies, it affirms the value of aesthetic and humanistic inquiry by showcasing its purchase on political and critical discourse and thought. While philosophical aesthetics has a problematic history that suffers from elitism, anthropocentrism, racism, and sexism, among other shortcomings, a turn to aesthetics now is appropriate given the plight of the humanities in higher education. The defunding of public institu-

tions and the expanse of neoliberal culture generates amnesia around the centrality of the arts and humanistic inquiry. Or, more insidiously, neoliberal culture treats the domains of nonquantifiable, affective, subjective, metaphysical, and speculative experience as opportunities for market expansion. Aesthetics, in this context, remains a contested domain, but it is not a philosophical mode that can be jettisoned for being problematic or even inconsequential to modern life. If anything, its purchase on the useless, the particular, the arbitrary, and the new may be more consequential than ever.

Aesthetic Storytelling

A Tradition and Theory of Animated Film

Over the last four decades the study of animation has expanded with the popularity of computer animation and CGI. Prior to this expansion, animation's marginalized past within the age of cinema included the modern legacy of cel animation and cartoons, which at times overshadowed other animation techniques and designations and distinguished itself from live-action film. This legacy cannot be explained exclusively through technological or industrial histories because it is also an aesthetic history. Scott Bukatman, for instance, finds that cartoons and comics serve as an archetype for other "genres in which physics and conditions of everyday life are transposed into a new register (and sometimes simply revoked)." These media "set about overturning established orders and hierarchies, frequently pausing to meditate on their own possibilities."[1] The prevalence of interpretations and theories of animation that focus on the transposition of the physical "conditions of everyday life" and focus on subversion and reflexivity mark an obvious fact that is often overlooked or taken for granted in studies of animation: that many of the films and cartoons that shape animation traditions address aesthetic experience explicitly. They are able to address aesthetic experience through characterization and worldbuilding but also through the expectation that these films will break

with order and challenge hierarchies. For this reason the treatment of animation as different from other moving image media, even when it could refer to all such media, draws attention to the dynamic relationship between aesthetics and judgment.

This is not to say that animated films tend to be about encounters with art but rather that they frequently depict or explore aesthesis, the making sense of sense experience, a process that integrates thought and feeling. Perhaps all art addresses aesthetic experience by definition, but the metamorphoses, the visual metaphors, the caricatured characters, and the fantastic worlds of animated films have distinct purchase on the dynamics between sensorial perception and conceptual understanding. This address is partly established through the absence of the sensing human body or, more precisely, through the presence of human performance that has been substantially mediated by drawings, software, and puppets. This extra mediation draws attention to the process through which perception and sense experience lead to a meaningful sense of world. Furthermore, it is not just the films doing the work. Audiences, artists, producers, critics, and theorists frequently discuss animation and create animated films with descriptions like Bukatman's in mind. This is evident in distinctions like that made by Tom Gunning between "animation[1]," which refers to "all cinematic moving images," and "animation[2]," which refers to "the genre of animation" distinct from live-action film.[2] While animation can include any genre, Gunning's distinction presupposes an interpretive community in which the two definitions make sense. Such accounts delineate an animation tradition that has been quite dominant in the United States and in commercial animation more generally. To clarify my own terminology: I will use the term *animation* to refer to the generation of movement, broadly speaking, and *animated film* to refer to the moving-image productions that are commonly designated animation.

The intersection of audience interpretation and animation performance, which is central to addressing aesthetic experience, has come into greater relief thanks to Donald Crafton's recent study of American

animated film in the 1930s and 1940s. Crafton develops the idea of "animation performativity," or "the aesthetic functioning of bodies in ways that cause events to happen onscreen, as well as the functioning of movie audience members as coanimators, as fellow performers of the films."[3] This organizing principle intimates the close relationship between animated film's formal aesthetics and the human body's own "aesthetic functioning," which includes perception and sense experience. Indeed, Crafton's history illuminates the significant role of embodied, sensorial knowledge in developing animated characters and worlds, and he consistently discusses these characters and worlds as interacting with audiences.[4] My own use of the term *address* is meant to describe multiple relations between audiences, contexts, and animated films and to denote multiple directions of response and influence. Addressivity suggests understanding films as reacting to and pointing toward their contexts. Films generate original audience experiences, but films respond to and point to other experiences for audiences to consider in relation to their own. An address is an action, a direction, and a location.

But what does it really mean to say that animated films have addressed aesthetic experience both through characters and worlds and through interpretive communities and traditions? First, I do not think that animated films address aesthetic experience exclusively or systematically or that live-action films do not address aesthetic experience as well. What I do think is that animated films have functioned as an opportunity to see media differently, to watch moving images in a less scripted mode, which, of course, can become a script in itself. The imprecise, tautological term *animated film* functions similarly to Gunning's "animation²" in that it emphasizes cultural and aesthetic connotations over technical connotations. After all, in the digital age, *film* rarely refers to a material, and *animated* broadly denotes the generation of movement. But the term also approaches Suzanne Buchan's theorization of "animated worlds" to the extent that *animated film* refers to the prominent display and experience of fabricated worlds.[5] The open-ended term does not describe a category but instead serves as a means for designating a

cinematic mode or tradition of storytelling focused on interactions between fabricated characters and worlds.

Visual style is fundamental in this mode, but so, too, are narratives and characters that we watch move. We watch and listen to artificial characters interacting, often in surprising ways, with and within artificial worlds. The affordance of animated film, which is related to motion photography in general, includes the capacity to present and dramatize an alternative sensorial integration between subject and world. This challenge to normal sense experience accords with the general idea that animated film has been a minor form in film and media studies, at least to the extent that aesthetic experience is conceived as an exception to routine, instrumental, and procedural experience. But the standardization and massification of audiovisual aesthetics in commercial cel animation, for instance, suggests that these media are not rare exceptions but familiar alternatives. Whatever shifts in audience expectation and spectator modes of judgment can be associated with animated films, these remain largely commonplace and commercialized— even if the expectation is for overturning hierarchy and order.

To better delineate and articulate the tradition of animated films to which I refer, this chapter examines multiple theories of animation and several key animation experiences, all of which suggest that animated films address aesthetics and judgment through an interrogation of nature and a relief of conceptual burdens. Many of the films produced by Pixar Animation Studios build on this legacy of animation. Despite an ongoing interest in realistic animation, Pixar's early features indicate that the digital era does not amount to a fixation on simulation or the suppression of playful, cartoon presentations. Whether depicting a boy frightened by his toys coming to life or a rat becoming a great chef, these films express the challenges of living in a plural world in which knowledge is limited and nature is subject to change. Furthermore, these explorations of epistemological confusion and conversion remain highly profitable and culturally relevant. This thesis complicates assumptions that family films are inherently conservative or subversive. Instead, the address of

aesthetic experience afforded by and depicted in animated films serves as an opportunity for a dialectical form of criticism engaged with the complexity and uncertainty of recent historical, cultural contexts.

AESTHETIC STORYTELLING

John Lasseter, chief creative officer at Pixar and Walt Disney Animation Studios, explains that his primary goal and artistic passion is to provide entertainment for children and families. Lasseter has described Pixar's mode of production as one in which storytelling drives technological innovation, believability is preferable to realism, and emotionally compelling character growth serves as the foundation to every film. According to Lasseter, the creative process at Pixar is about building an animated world around this emotional core and finding ways of telling the story visually.[6] This approach to making animated films is indebted to the Disney animation tradition, Hollywood cinematic conventions, and character animation more broadly.

Pixar's emphasis on storytelling is historically quite significant given that it leads the industry in what Alla Gadassik refers to as the "story defense" of animation. This defense is a response to the propensity for computer animation, and its commentators, to eclipse the embodied artistic practices of animators by focusing on technical labor, automation, and simulation.[7] The story defense contends that the humanity and human trace of the medium persists through the story and characters. It also dovetails with claims that digital cinema retains the legacy of film through audiovisual narrative conventions.[8] In the case of Pixar the response to the highly automated, digital, disembodied context of computer-based production leans heavily on the character animation tradition. Lasseter's emphasis on believability over realism echoes the "illusion of life" approach articulated by Disney animators Ollie Johnston and Frank Thomas. As Lasseter describes it, this approach makes obvious to an audience a level of artifice that prevents mistaking the moving images for reality or live-action film, yet this approach aims at creating

movements, characters, and stories that are captivating enough for audiences to forget about that explicit artificiality to varying degrees. This approach to animated film constitutes an aesthetic storytelling that features a stylized realism suitable for bildungsroman narratives and the presentation of worlds with rules to be discovered by both characters and audiences. Such a mode of presentation expresses both the disruption and exploration associated with aesthetics and new experiences.

In general, aesthetics opposes utilitarian, procedural, or routine modes of relating to the world and the things within it. But the opposition between aesthetic and determinative judgments is hardly fixed and pure. Film, whether digital or analog, is one of the best examples of how fluidly these modes operate in modern contexts in that moving images have the capacity to be experienced as a precise historical trace but are not confined to this experience. Consider, for example, how many instructors explain film theory's adoption of the concept of the index by referring to bullet holes and footprints, which bear an imprint of a past impression comparable to chemical photography. Bullet holes and footprints can serve as compelling evidence of past events, but they do not need to be read this way. To refer to the event of encountering a footprint as an aesthetic experience means considering that the print's appearance could just as well resemble a face or conjure up any sort of image, whether intentionally or unintentionally. Aesthetics is about the particularity of such subjective experiences, but, as historians and theorists have described, experience is shot through with numerous historical, cultural, and bodily factors. The particulars of unique individual experience intersect with generalizable accounts.

For example, Wolfgang Schivelbusch's *The Railway Journey* is a frequent referent in cinema and media studies because he describes historically how people learned to see through the window of a moving train through a kind of "panoramic perception," and this mode of looking lent itself to a variety of commercial and technological modes of seeing and relating to the world.[9] The specific feelings and affects prompted by looking out a train window are generalized to mark the age of modernity. This kind of

historical argument accords with the history of cinema presented in Mary Ann Doane's *Emergence of Cinematic Time,* which attributes cinema's fascination with indexicality and contingency to the context of modernity. The rationalization of time under capitalism and industrialization created conditions that made film's indexical capacity particularly meaningful in the sense that film enables people to think about the contingency of time by witnessing and presenting the seemingly arbitrary details of temporal life and reality. Of course, Doane details how this function of cinema is also a modern form of rationalization.[10] The point here is that experience is itself contingent on historical and cultural variables, and more specifically, cinema, even after narrative forms became dominant, addresses modernity by facilitating the contemplation of modernity—that is, the rationalization of time and space among other aspects.

In relation to the arguments of Schivelbusch and Doane, cel animation (and other profilmic techniques with frame-by-frame manipulation) seems equally invested in modernity and the rationalization of time given its construction of moving characters and things in space and time. Live action, then, is not cinema's (or animation's) only mode of contemplating modernity. As with the basic footprint and bullet hole examples of indexicality, the moving image entails multiple modes of contemplation. It can crystallize the chaos of reality in a recorded order, and it can generate dreamlike free movement through highly regimented fabrications. How moving images are judged, assessed, valued, and used depends on numerous contextual relationships. One person's view of contingency could be another person's view of cosmic order or vice versa or both at the same time, depending on the context and the belief systems involved. I raise this point because, as Bukatman's comment intimates, animated films have on many occasions been judged differently from live-action film even when they share a basic photographic ontology. In other words, in the context of modernity animated films have become central to aesthetic and technical styles that challenge the hierarchy and fixedness of concepts and rules. This tendency can in turn suspend a viewer's judgment of that world. This

formulation implies that a subject relying on a given mode of knowing a world could very well be wrong, which further implies a case of pluralism (multiple viewpoints and worlds) or epistemological vulnerability. And as animation and cinema technologies conflate in the digital age, storytelling conventions become more significant as guiding elements for audience expectations and evaluations.

The issue of judgment is often raised in modern contexts that suffer from relativism or the complexities of multicultural democracy in which the goal of inclusivity brings with it the challenge of incommensurability. Judgment commonly refers to the process of reconciling particulars—experiences, cases, events, actions, and so forth—with generalizable concepts or rules. As networks of media and migration alter national demographics and opinions, it can be incredibly difficult to locate stable traditions and values that are widely accepted. How are particular cases, events, and actions to be judged reasonably in such a postfoundational political climate when it is very difficult to find shared lines of reasoning? This diagnosis often leads political theorists to concerns over heightened conflicts between subcultures, cultures, and nation-states.[11] But the issue of judgment within modernity is even broader when we consider the challenges brought about by rapid technological innovation. Not only do these include social and psychological challenges but legal challenges, too, as legislation struggles to keep pace with technical practices.[12]

Animated films have become a mode for explicitly addressing the instabilities involved in processes of judging, for knowing and evaluating the particulars of the world. This mode resembles descriptions of aesthetic judgment as an activity lacking determinative concepts. Furthermore, the activity of judging artificial worlds, or not knowing precisely how to judge them, is an exercise for dealing with constant newness and a lack of tradition. This correlates with philosophical and political discussions surrounding modernity and epistemological difficulties, and it approaches claims found in film theory more generally.[13] The aesthetic storytelling of animated films becomes a conventional mode for contemplating the unconventional. As the following discussion

will elaborate in more detail, this formulation gains distinct character in the history of animation theory. And in subsequent chapters this formulation crystallizes through specific aesthetic concepts read through Pixar's films. But first, I want to clarify my conception of aesthetics and how it will serve as a critical methodology throughout this project. This will set up the question of how exactly animation's address of aesthetic judgment has been articulated in animation and film theory.

PHILOSOPHICAL AESTHETICS AND CRITICISM

Without committing to a single definition or theory of aesthetics, this project is influenced by recent strands of scholarship in philosophical aesthetics, all of which owe considerable debt to the formulation of aesthetic judgment in Kant's *Critique of Judgment*. When making the case for thinking of aesthetic experience as a critical resource, the basic claim is that aesthetic experience challenges habits of thought and action, and it illuminates how experience itself is constructed. In this vein *Critique of Judgment* has been read as a work that attempts to reconcile Kant's moral philosophy with an aesthetic relation to the world and as a work that initiates a critique of Kant's own transcendental logic and subject-oriented position. Steven Shaviro argues that this "critical aestheticism" can be observed in the philosophy of Alfred North Whitehead and Gilles Deleuze and that it offers valuable insight into contemporary developments in media, art, technology, science, and economics.[14]

In these philosophical accounts, instead of a subject who thinks and legislates, the subject of aesthetic experience feels and responds.[15] According to Kant's well-known formulation, aesthetic judgments are disinterested and reflective. A person judging a beautiful object, for example, has no interest in it and finds no purpose for it but likes it all the same. Furthermore, that person finds no concept, no practical theory learned from society or science to explain the liking of the object. It is not that the qualities of beauty reside in the object, but the judgment is ultimately based on subjective feelings informed by a particular

experience with the world, and, in Kant's formulation, this leads to suppositions about shared feelings or a *sensus communis*.[16] Philosophers such as Whitehead and Deleuze are not Kantians, but they build on Kantian aesthetics to critique philosophy itself. The aesthetic idea (especially beauty) is that the world and the things in it give shape to our subjectivity and experience regardless of whether we know these things rationally. This radical empiricism revises philosophical distinctions between epistemology and ontology by claiming that experience and existence are not so different at the level of objects affecting each other.

What I take from this discourse is the notion that aesthetic experience provides opportunities to critique dominant forms of overrationalized experience and existence but also that new phenomena and environmental changes are registered aesthetically every day. This everyday perceptual and emotional knowledge informs a variety of performances and art practices, including character animation. In turn, aesthetics as criticism refers to the process of examining these performances and the knowledge informing them. Unlike the radical empiricism of Deleuze and Whitehead, however, my approach retains the concept of judgment as an aesthetic activity that is proper to spectators and theorists and is often raised by animated films, especially Pixar's.

Sianne Ngai's work on the aesthetic categories and "ugly feelings" that pervade late capitalism is the most developed deployment of aesthetics as a critical methodology to date. Ngai's work recasts the philosophy of aesthetics around the feelings and emotions typical of modern consumer life. Instead of analyzing these through the well-trod concepts of beauty and the sublime, Ngai considers diminutive concepts. Many of these—for example, animatedness, cuteness, and zaniness—resonate with the growth of animated media, and they affirm the relevance of animation for diagnosing recent cultural developments. While I do not believe that the Pixar films I analyze square with Ngai's accounts precisely, my articulation of the relationship between aesthetic experience and judgment does follow Ngai's description of aesthetic objectification or the bond between form and judgment.[17]

In short, experience and judgment function together, but we tend to describe (and obscure) them in a two-part process that occurs when we contemplate and discuss our feelings and sensations.[18] First, there are the feelings and the affects of experience, and then there is the objectification of those feelings and affects involved in communication and judgment. A person experiences beauty or cuteness or interest, and then the person tells others (or herself) about the experience or the thing that triggered it. The experience has become an object, and this objectification binds the experience (beauty or cuteness or interest) to the initial object—the beautiful flower, the cute child, or the interesting painting. Art, then, can serve as a way to think about experience itself by displaying its objectification. At a basic level we make objects when we talk about feelings. The activity of judging inheres in the naming of our feelings and the events that trigger them and then in the communication of that with others. This typically includes the presumption that what is true for me should or could be true for others. Furthermore, the activity of objectification and judgment can generate new feelings and redirect ongoing sensations. Breaking this process into parts actually misrepresents the continuous and cumulative nature of experience and judgment. There is no clear line where experience ends and judgment begins.

Animated films display objectified feelings and affects through characters but also through fabricated worlds with undisclosed norms and rules, and this presentation asks audiences to recalibrate their expectations and interpretative skills for the fictional world. The narratives that take place in these worlds likewise portray characters reconfiguring how they understand their world after having encounters with new and surprising phenomena that challenge their established worldview. These stories of discovery and transformation are certainly designed to appeal to children learning about their environments, but they also suspend mature judgment to the extent that judgment relies on criteria (or expectations) and understanding (interpretation). The activity of judging artificial worlds, or not knowing precisely how to judge them, and then watching characters engaged in comparable dilemmas serves

as an exercise for audiences dealing with newness and a lack of tradition. It presents the imagination, that which reflects on what is not present, as a creative resource not just for making and imagining new worlds but for adjusting to a constantly changing world. As the critical readings of Pixar films mentioned in this book's introduction bear out, this exercise of the imagination dovetails with the ethos of the creative class working within entertainment and technology industries. But while this aesthetic culture generates new market opportunities and encourages worker innovation and flexibility, it also embeds foundational ideas about political possibility that are not invested in reproducing neoliberal culture or post-Fordist economic practices.

For one thing, this address of aesthetics is not implied or latent in the films. It is explicit and beckons criticism. It is not surprising that Ed Catmull discusses training employees at Pixar to see the world as artists or, in other words, to develop the aesthetic side of judgment. Such training is a form of discipline appropriate to the neoliberal era given its emphasis on individual creativity. Perhaps more than ever, creativity and ingenuity are understood as the responsibility of labor, and the technology industries amplify this through the production of new tools for producing tools and by leaving the potential uses of said tools for consumers (laborers) to discover. The address of aesthetic experience and creativity that occurs in popular media like that of Pixar certainly acculturates audiences to the labor of creativity, but it also presents this culture to audiences in distorted and dramatized forms for their own contemplation. The idea here is that the films are a form of entertainment art that serves as a metadiscourse and facilitates an exploration or interrogation of customs and habits.[19] Popular entertainment often presents metacommentary on the function of entertainment in culture, and Pixar's productions demonstrate this through their narratives and characters, as well as digital aesthetics.[20] In short, to better see and sense how pervasive the role of aesthetics is in our highly mediated, digital, global, and neoliberal context, what better way than to analyze highly aestheticized, obviously artificial, synthetic worlds that tend to feature narratives about aesthetic experience?

Of course, animated film, or any art form for that matter, does not have a monopoly on aesthetic experience. Objects in general cannot be judged exclusively in utilitarian terms.[21] There is always the possibility to remove an object from the realm of utility or consumption and to judge it aesthetically. This does not mean placing your hammer in an art gallery, but it may mean noticing that your hammer has a pleasant, even beautiful, look that has nothing to do with an appreciation of its function. Such a transformation of the relation between subject and object prompts questions about the appearance of the world: how do these relations and the concepts that organize them change?[22] Creative media often reflect on such experiences, but animated films have offered overt references to this experience through depictions of metamorphosis and visual gags, as well as through their created worlds. Animated film has a tradition of making obvious the aesthetic worlding of an aesthetic world. The creation of diegetic time and space through cinematic and animation techniques is a kind of worlding, but so, too, is the revision and creation of perceptual and conceptual rules and routines. This is an abstract way of describing animated worlds like that of the television show *The Flintstones,* in which elephant trunks serve as gasoline pumps and so on.[23] This kind of animation offers an aesthetic experience about the role of aesthetic experience in everyday life. It investigates or plays with the process of developing concepts and rules about how the world works, and it makes explicit that such rules can be revised when our experience demands it or when we are inclined to use our imaginations to do so. In short, there are multiple experiences of interest here: the experience of watching animated film and the experience of characters depicted within the animated diegesis, as well as how the latter resonates with the former.

MUSICAL WHALES AND HUNGRY DINOSAURS

There are plenty of examples of this kind of storytelling, but a rather straightforward case is the Disney cartoon *The Whale Who Wanted to Sing at*

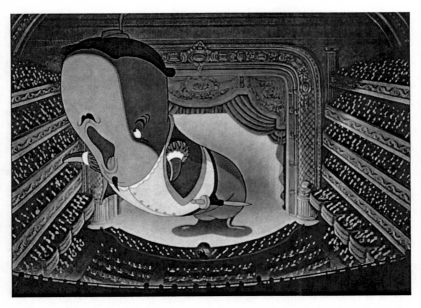

Figure 2. *The Whale Who Wanted to Sing at the Met* (Geronimi and Luske 1946). Willie, the singing whale, challenges the sensory and spatial norms of opera. *Make Mine Music.* Walt Disney Home Video, 2000. DVD.

the Met (1946). In this animated short a whale possesses the remarkable ability to sing and is eventually harpooned and killed by a ship captain who believes the whale swallowed multiple opera singers. Other human characters who hear the whale are enthralled with pleasure from the music. The cartoon humorously exaggerates the notion that whale communication is a kind of singing, and it explores the power of music, song, and voice. The short imagines what it would mean socially and audiovisually if a whale could really sing. This includes a depiction of Willie the whale on stage that challenges performance customs and the laws of physics (Figure 2). And this fantastic sequence includes depictions of the whale's impact on the senses of the audience (Figure 3). Sense experience is central to understanding the humorous cartoon physics and social commentary. This story adumbrates Pixar's *Ratatouille,* which depicts a rat

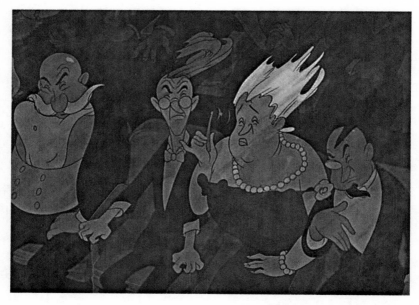

Figure 3. *The Whale Who Wanted to Sing at the Met* (Geronimi and Luske 1946). The opera audience feels the impact of Willie the whale's performance. *Make Mine Music.* Walt Disney Home Video, 2000. DVD.

who is a great chef and explores how the reality of a rat-chef would challenge assumptions about taste—in both the sensorial and social senses.

An earlier example of interest is Winsor McCay's *Gertie the Dinosaur* (1914), which develops several important tropes, including the animation of legendary creatures and the interjection of the animator into the animated world.[24] The hyperbolic, fictional encounter between McCay and Gertie raises the question of what new experiences are possible in the modern, cinematic era. It does this by portraying a dinosaur character interacting with its drawn environment and with its creator, and it is worth noting that Gertie's first actions upon emerging from her cave include eating a large rock and then a tree (Figure 4). This illuminates how McCay imagines his dinosaur feeling (and feeling about) its world: the world is food that the dinosaur likes to eat.

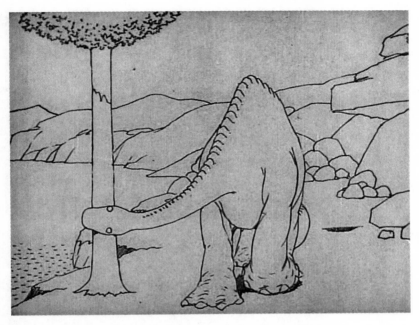

Figure 4. *Gertie the Dinosaur* (McCay 1914). Gertie eats the drawn environment. *Winsor McCay: The Master Edition.* Milestone, 2004. DVD.

This rather obvious formulation gains new meaning in the digital era in the film *Jurassic Park* (1993), which includes an homage to McCay's *Gertie. Jurassic Park* introduces the cloning and modification of dinosaur DNA to its main characters and its audience through a short explanatory film that features cartoon animation. Alluding to showmanship reminiscent of McCay, the character John Hammond sets up and interacts with the short film (Figure 5). Figure 6 shows the extent to which the cartoon dinosaur presented in Hammond's short film resembles a Gertie-like dinosaur possibly making her way back to a cave. Even though there is not much CGI in *Jurassic Park,* the use of CGI effectively parallels the creation of dinosaurs in the diegesis.[25] Both are forms of animation, and Hammond's short film associates both of these with the historical marker of McCay's Gertie. The final parallel is that, like Gertie, the dinosaurs of Jurassic Park see their new environment as

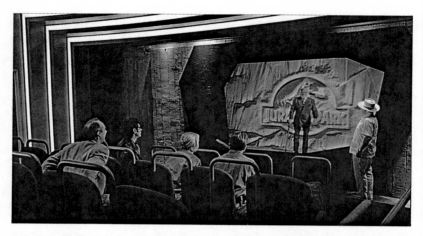

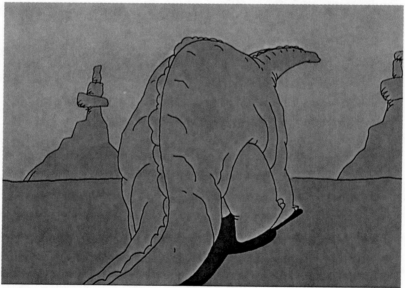

Figure 5 *(Top)*. *Jurassic Park* (Spielberg 1993). John Hammond as showman interacts with Jurassic Park's introductory short film. Universal Studios Home Entertainment, 2012. DVD.

Figure 6 *(Bottom)*. *Jurassic Park* (Spielberg 1993). The cartoon dinosaur in the park's introductory film resembles Gertie. Universal Studios Home Entertainment, 2012. DVD.

one that can be eaten. In addition to the drama of dinosaurs eating the human characters, the film includes a scene in which a triceratops has fallen ill after eating the nonnative plants in the park. The question of the dinosaurs' fit within the modern world is one of the film's fundamental tensions.

The thematic and visual parallels of these examples involve explorations of couplings between physical environmental rules and social, cultural, and artistic conventions. Focused on taste and eating, these examples are representative of how characters explore worlds through their senses. Furthermore, these examples—cross-species interactions, singing whales, cooking rats, and genetically engineered dinosaurs—highlight animation's association with the creation of life and an association with the transformation of life and all of the norms and rules we deploy to organize it. Animated worlds do not need to depict fantasy or science fiction, but when addressing aesthetic experience, they have tended to depict processes of becoming, of transformation, and of the failure of epistemological mastery. That is, not only do they depict the experience of learning the rules of an environment, or of a community (e.g., what to eat and what not to eat); they also depict moments in which characters discover that they have been wrong about what they thought the rules were. This builds on the humor and freedom associated with animated films. This is not the freedom of a sovereign subject permitted to act as she pleases, however. Instead, such depictions refer to the freedom of a subject who must use her imagination to reckon with a plural world, a world made up of things and relations that are not of a person's choosing. These characters are seemingly thrown into worlds, and they must use their perception and senses to learn about their environment and community. I am tempted to refer to *Jurassic Park* as an animated film given its themes about humans and dinosaurs misjudging their environment. As will become clear in the subsequent discussion, however, live-action elements ground the film in conceptually significant ways.

ANIMATION HISTORY: A FEW NOTABLE
EXPERIENCES AND THEORIES

Although I recognize that animation scholars are keen to avoid comparing animated film to live-action film because this obscures animated film's distinct vocabulary or film's status as a form of animation, I also recognize that animated film's distinct terms, conventions, and effects develop in dialogue with other media. The foregoing discussion of aesthetic experience in animated films emphasizes exploration and acknowledges rules and laws that are subject to change and revision. For some readers this treatment may evoke the role of animation in video games. While I trust that this discussion has purchase on that field, my current considerations do not include the complications raised by interactive gameplay. In fact, the scope of this project is decidedly narrow given the expansion of moving image media more generally, and this scope is informed by specific theories and commentaries from the history of animation. A brief survey of these, rather than working through a number of individual films and shorts, will better delineate how this animation tradition is generated through reception and production dynamics.

The current global, commercial, and convergent structure of popular entertainment provides its own series of suggestions for how to watch animated films. This includes building on the legacy of photo-indexicality and the myth of total cinema through the photorealism goals of computer animation and digital capture. But the emergence of computer animation into the feature film platform during the 1990s and 2000s did not serve these goals exclusively. It also presented an opportunity for challenging the fixation on simulating photographic cinema, but this tends to garner less attention from scholars and audiences given the marketing and media hype surrounding photorealism and the uncanny valley, or those presentations that trouble discernment between biological and mechanical movement. These foment a lucrative technological race to produce images that simulate human perception and discernment of photographic film or even real life. The pursuit

of photorealism through computer animation can be considered an ironic reversal of the early history of cinema in which the photographic nature of film prompted some audiences to question its status as an artistic medium. This in turn led many filmmakers to conspicuously display their craft and creativity through cinematic illusion and tricks. In reverse order many computer animators conspicuously simulate photographic realism to achieve recognition in visual media fields. Photography may have relieved human hands from the work of visually recording reality and enabled them to pursue abstraction, but the computer has renewed interest in the mythic quest to draw reality.

But then many studios, including Pixar, employ a stylized realism that utilizes cartoonish exaggeration as well as the simulation of naturally occurring movement. Pixar's stylized realism will at times simulate the look of natural phenomena, such as flowing water, with impressive precision but then feature anthropomorphic animal characters with caricatured features. The first act of *WALL-E* presents a meticulous level of photorealism in depicting a desolate, waste-filled Earth that functions in tension with the cartoonish humans who appear in the film's second act. This stylized realism differs significantly from straight photorealism, which is problematically exemplified by the 2001 production *Final Fantasy: The Spirits Within* (Sakaguchi and Sakakibara). *Final Fantasy* remains a prominent historical marker because it received significant attention from scholars and computer animation aficionados for claiming to fully commit to photorealism and then failing—in terms of aesthetic goals and box office.

Intrigued by this failure in juxtaposition to the success of other early computer-animated films, Vivian Sobchack asks: "If we're willing to accept animation's 'irreality' in its *representation* of human beings (a tradition that continues in the CGI of *Toy Story* and *Monsters, Inc.*), why, then, is there such a problem with accepting *Final Fantasy*'s 'hyper-real' *simulation* of human beings?"[26] In addition to identifying Pixar's productions as adhering to an alternative tradition from that of strict simulation, this question leads Sobchack into an analysis of audience

expectations and judgment and to two further questions: What do we want from animation? And what does animation want for itself? These are inferential questions in which general expectations and desires are derived from particular examples, but they also illuminate animation's address of aesthetics. To answer the first question, Sobchack quotes a comment by Miguel Angel Diaz Gonzales on IMDb that explains why *Final Fantasy* failed:

> Animation films are entertaining when we know that they are animation films. They are something different from reality, and all the imperfections we find in them don't count. All the holes we ... find are filled with our imagination.... But, when the level of perfection of an animation film crosses the line between animation and reality, then we change our scale of values, and we judge the film by comparing it with non-animation film. [This] is when we notice ... that there is still an abyss between a real and a virtual actor.[27]

Diaz Gonzales's comment offers a clear distinction in expectations between animation and nonanimation and how these expectations influence the way audiences assess what they view. This notion of different expectations runs through Sobchack's essay, and it runs through traditional distinctions between animation and live action within film studies and film theory. Sobchack's elaboration on Diaz Gonzales's comment is also worth quoting:

> What the majority of spectators seem to want and value from animation is not a gloss on "metaphysical effort" but rather, as film theorist Noël Carroll has said of "trick films," "metaphysical release"—that is, the vicarious playing out of the "plasmatic" possibilities for subverting and/or substituting the laws of physics (and here I might add, the laws of mathematical calculation) with the laws of imagination.[28]

Animation's substitution of the laws of physics for those of the imagination can certainly elicit something like "metaphysical release," but an animated world is of a larger spatiotemporal order than a momentary, situational gag. A sustained animated world, as Diaz Gonzales and Sobchack indicate, produces expectations that differ from films with

fantasy components or hybridized features with live action and animation.[29] The laws of a fully animated world are discovered over the course of the film to a substantially greater degree than live action. Sobchack's use of the IMDb comment reveals the functionality of distinct interpretive traditions for animated and nonanimated films, and it shows that this tradition of judging animation involves dispelling many assumptions about the givenness of physical laws and standards of measure—"the imperfections we find in them don't count."

To answer what does animation want, Sobchack, following classic animated films such as *Pinocchio* (Luske, Sharpsteen, et al. 1940), as well as *Final Fantasy,* concludes that it is either to become real or to become the ultimate illusion, indecipherable from reality. The rhetoric of ultimate illusion contributes significantly to the downfall of *Final Fantasy,* in addition to its internal diegetic contradictions, as Sobchack explains: "we, as viewers, also get caught up in the film's 'argument of unlimited (photorealist) development.' And thus we spend a large portion of our own time (dare I pun?) 'rendering' judgment and 'splitting' ontological hairs. Unfortunately, then, our attention—and that of the filmmakers— is greatly misdirected from a focus on 'the illusion of life' to the 'disillusion of life.'"[30] Given that the film's promotion and marketing hinged on interest in photorealism (especially the protagonist's hair), it was hyperbolically judged according to photorealism, which is incongruous with the animation tradition based on fewer or alternative laws and standards. Sobchack's focus on the effect of this rhetoric on viewing experience reminds us of the film's industrial context but also the tensions within film history around perfecting technologies of illusion and adhering to dramatic conventions. Clearly, studios and producers want to navigate this field profitably—they are supposed to know their audiences. The failure of *Final Fantasy* and its viewers to build on the illusion-of-life cartooning tradition to which Sobchack alludes is not simply a commercial failure. When considered in conjunction with the success of Pixar, it marks the perpetuation of an animation tradition that judges animated worlds differently from live-action worlds.

To delineate an animated film tradition with expectations and aesthetic experiences vastly different from live-action film perpetuates a narrow definition of animated film that overlooks the diversity of animated media forms. With respect to film studies the history that traces divisions between early trick films and live action, between fantasy and realism, and then between classical narrative cinema and those experimental or medium-conscious productions that expose their constructed artificiality has created a contradictory set of positions for animated film. Many animated films are described as naive fantasy, yet these films also make for efficacious propaganda and pedagogical material. Animation production is supposedly "other" to the photographic, indexical production of live action, yet profilmic animation (any mode of animation that utilizes frame-by-frame photographs of manipulated things—nonhuman or human) is ontologically equivalent to live action; it is equally photographic and indexical. As Suzanne Buchan observes, this state of affairs can be attributed to a confluence of dominant forces in film studies that include an ideology of realism, the industrial-backed dominance of narrative cinema, and the fact that the animated film canon taught and studied remains dominated by male animators and industrial production. Additionally, the digital shift in cinema has tended to conflate digital production with animation, which eclipses diverse animation practices.[31] This conflation builds on the misrepresentation of animation attributed to the popularity of animated cartoons and to the commercial and cultural influence of the Disney Company.

In addition to these factors the history of film theory contributes to this narrow animation tradition through the dominance of ideas about the photographic basis of cinema. On the one hand, a photographic understanding of cinema emphasizes the construction of history, a reconnection with the external world, and the ethical promise of the camera as a machine for historical specificity—a tool for record keeping and a witness to history. On the other hand, theories of cinematic motion or animation are typically more forward-looking and present-focused

than photo-indexicality or strict theories of correspondence, which privilege historical record and looking backward.[32] Complicating this bifurcation, however, is the fact that cinematic realism relies on both photographic historicity and cinematic motion in conjunction with artifice or aesthetic styling. Photography and film may have an affinity with historiography, but, as recent scholarship on André Bazin demonstrates, this does not preclude an equally prominent affinity with aesthetic styling, even within the domain of realism.[33] Not only are there numerous realisms, then, but they include various forms of artifice and fabrication.[34] The lesson here is that delineating the key attributes of the narrow animation tradition epitomized by Sobchack's discussion of Diaz Gonzales's IMDb comment is likely to be more nuanced than a simple distinction between nonanimated and animated film.

Consider, for instance, Bazin's analyses of long takes and depth of field. These aesthetic techniques are thought to enact a mode of realism by engaging the attention of spectators and enabling them to choose where and how to focus their attention. This mode of realism preserves the "ambivalence of reality" within the moving image, which is, inevitably, a framed and stylized production.[35] These aesthetics preserve the freedom to interpret a moving image that is ambiguous and indeterminate, and in doing so they approach a familiar, quotidian indeterminacy and freedom that we experience whenever we explore reality through perception. Hence, Bazin finds a philosophical expression of everyday life, with its uncertainty, ambiguity, and need for interpretation, through an examination of Welles's *Citizen Kane*. Without debating the extent to which the fictional reality presented in *Citizen Kane* is ambiguous and open to interpretation, I want to acknowledge that this formulation resembles the reflective, aesthetic judgment that escapes utilitarian logic and determinate procedures and, indeed, underscores the ambiguity of reality.

Animated films are equally capable of such philosophical expression, but the ambiguity experienced when watching a cel animation film, for instance, tends to function differently from that described by Bazin. In

Diaz Gonzales's IMDb comment and Sobchack's elaboration of it, animation's lawlessness is not described as ambiguous reality but as "irreality" or as "different from reality." The ambiguity of animated film, in terms of viewer experience, seems to exceed the threshold for cinematic reality. The philosophical implication is that instead of elucidating the ambiguity of reality at the core of everyday experience, animated films tend to elucidate ambiguity more generally, without as much or as many references to a concept of reality. Given that reality is not a neutral concept, this is a significant distinction. An experience of ambivalent or ambiguous reality, by retaining greater referentiality to a familiar reality or common world, does not interrogate reality or nature to the extent that media experiences that are not "of reality" are capable.

Animated films certainly bear a strong relation to reality. But within the traditions of animated cartoons and stop-motion cinematography the theoretical descriptors of animation often have more destabilizing connotations than the terms *ambivalence* and *ambiguity*. Sergei Eisenstein famously compared the protean quality of Disney's early animated films to plasma and to fire, which express the "unity of oppositions," forms of becoming and unbecoming. The dynamics of movement imbue the medium of drawn animation with a capacity to both continuously present a reality and subvert it.[36] Like Eisenstein, most contemporary animation theorists do not define animation in terms of movement alone but movement in tension with static elements. At the core of the animation tradition that I am mapping is the presence of a destabilizing, unresolved dialectic.[37]

Animation historian and theorist Esther Leslie uses Walter Benjamin's term *petrified unrest* to describe animated film's dialectical relationship with social, political, and economic formations. Since animators frequently use drawings and other static forms to indicate movement, their work relies on human perception mixed with the knowledge that makes sense of perception; for example, the contour shape of a flexed muscle can convey movement without any actual movement. Unlike the relative autonomy of photography, drawing emphasizes how human concepts and

understanding give vitality to images.[38] Since the movement of film and profilmic elements works with static markers of movement to convey a promise of possibility and change, Leslie concludes that this practice correlates with the alienating, industrial promises of capitalism and a contradictory expression of stagnation within movement: "Animation's petrified unrest is a formal sign of its ambivalent renderings of the real— it is stuck in a form of life and world simulation, which can be read symptomatically—or critically—as an inability to move on socially, to sketch out new lives and worlds."[39]

For Leslie animation is equally capable of interrogating nature— exposing the alienation of capitalism and modern life—and naturalizing those same cultural practices and ideals: "Animation is the medium that allows for a dramatization of a skirmish with nature. This skirmish is not the fascistic one of subjugation. It is rather a wrestling with what is natural about nature, and what is historical, which is to say, changeable, about it."[40] Leslie's theory of animation engages with the usual questions in film theory about artifice, history, nature, and reality, but instead of *photo-indexicality*, the primary terms are *movement* and *dialectics*. Drawn animation relies on human concepts to convey motion through static form, but animated drawings also rely on mechanical movement and automation. This gives drawn animation a different or other nature and this otherworldliness does not express age (i.e., the historicity of photo-indexicality) as straightforwardly as live-action film. Unless a technical innovation gives away the precise period of production, there are typically fewer historical markers, or indices, in animated film. Leslie does not deny the historicity of animated film but declares it messy and animated itself: "Animation evokes history, plays with it, undermines it, subverts it, but it does not have it, just as it does not have nature. It has second nature. Or different nature. It has different history. It models the possibility of possibility."[41] Animation, as an artistic practice, is capable of subversive forms given its mix of human concepts, perceptual knowledge, and automatic, technological processes, but this attribute also equips it to work in the service of dominant

ideology. In other words, when history and nature are thrown into obvious play—"a dramatization of a skirmish"—there is a temptation to acknowledge what remains as a stable, reliable, natural ground.

For Leslie animated film operates through a mix of conceptualized and unconceptualized forms. It is at once unfamiliar and strange and very familiar and natural. It invokes the phenomenon of not ever really being able to encounter the new because encounters rely on concepts and perceptual knowledge. The totally new is either unnoticed or utterly confusing. Animated worlds that do not seem to have the rules of reality or nature do end up having many of these rules. Hence, they naturalize as much as they denaturalize. Following Eisenstein and others, Leslie's dialectical approach connects the experience of viewing animation to social and political contexts that may not appear to be immediately relevant to an animated film that is expected and designed to be disconnected from reality. This disconnection from reality itself can provide artistic expression of modern forms of alienation attributed to industry, consumerism, or the pervasive technological mediation of digital culture.

Paul Wells uses a very similar articulation to define animated film's modernist legacy: "More than any other means of creative expression animation embodies a simultaneity of (creatively) re-constructing the order of things at the very moment of critically de-constructing them."[42] In the context of modernity the animated cartoon and the abstract, nonrepresentational animated film encourage audiences to attend to the medium of animation itself. The forms of transformation and becoming, and the comic elements of cartoons, effectively subvert and challenge the solidity of orthodoxy and convention. Wells claims that although grounded in artistic responses to the mechanization, urbanization, and commercialization of modernity, the modernist aesthetics of animated film have not been exhausted: "such art becomes a symbolic inflection of changing models of experience and is not confined to any one historical period, but social moments which insist upon revising existing rules and consensual guidelines which have arguably

been naturalised in a way that sustains outmoded ideological frameworks."[43] Here, then, the modernist tradition of animation can be understood as having a basis in "changing models of experience." Representational cartoons tend to incorporate these revisionary and transformational elements into narratives, as well as visual sequences.

When informed by the comments of Leslie and Wells, the specific tradition of animation under discussion can be defined as including an expectation that reality and nature will be thoroughly challenged, that there will be "a dramatization of a skirmish with nature" to use Leslie's phrase. And the dialectical challenge to nature offered, which frequently contains a narrative or series of gags that challenge the diegetic nature of the animated world, correlates with real-world contests over what is natural. Leslie focuses on capitalism's claims for naturalness, but any ideology that appeals to the status of nature can be addressed through animated film. As Wells suggests, this kind of animation is well-suited for addressing "changing models of experience."

Although not a theorist of animation, Stanley Cavell provides another famous, predigital example of an experience with animated film that reinforces this particular tradition of animation but also considers cinematic experience with respect to philosophical questions. Cavell's comments are like those of Bazin's in that they help delineate more precisely the subtle but significant distinctions between animated and live-action films. Focusing on cinematic experience more than technical specifications, Cavell omits animation from his reflections on film's ontology and its relation to reality. The omission is poignant because it indicates that he deems watching animated film a very different experience from watching live-action film, even though the modernist formulation of animated film as addressing "changing models of experience" approaches Cavell's interest in film as addressing the skepticism prevalent in modernity.

In the expanded edition of *The World Viewed,* in a dialogue of much interest to animation studies scholars, Alexander Sesonske questions Cavell about the world that animated cartoons bring into view. Cavell

is quick to explain that animated cartoons do not project the world and therefore, do not accord with his definition of cinema: "a succession of automatic world pictures."[44] They do not bear the same relation to reality and perception as live-action cinema. Nevertheless, when describing the "animated world" that cartoons do present, Cavell describes his experience in terms that evoke a more lawless form of aesthetic judgment: "The difference between this world and the world we inhabit is not that the world of animation is governed by physical laws or satisfies metaphysical limits which are just different from those which condition us; its laws are often quite similar. The difference is that we are uncertain when or to what extent our laws and limits do and do not apply (which suggests that there are no real *laws* at all)."[45] It is the uncertainty of applying laws that concerns me here. The first sentence accords with Leslie's dialectical understanding of animation: strange animated worlds have similar laws to our own and therein can contribute to naturalizing social contexts and ideology. But Cavell adds that the viewer's experience of not knowing when and what laws will be applied/naturalized indicates a real absence of laws. Comparable to Sobchack's analysis of *Final Fantasy*, Cavell locates an intense uncertainty in the animated film viewing experience that contributes to a general suspension of judgment of the animated world.

Cavell's emphasis on the radical lawlessness that he perceives in animated cartoons is informed by his experience of live-action film. It is unlikely that Cavell would describe live-action film as providing viewers with certainty in contrast to the uncertainty of animated cartoons, but the implication is that there is less uncertainty in live-action film. The viewer of an obviously animated world has less recourse to the concepts and perceptual experience that typically define a sense of reality—including the familiar ambiguities of perception. The hyperbolic absence of laws or nature explicitly invokes aestheticized judgment, a mode of making sense of experience with little direct application of concepts and procedures. Kantian aesthetic judgment has a significant role in Cavell's philosophy, which includes the study of art

and literature because, Cavell contends, philosophy is like aesthetic experience in that it aspires to objective answers through impossibly subjective means. Cavell turns to aesthetic judgment to explain how art and its criticism escape the logical positivism of analytic philosophy.[46] Cavell's neglect of animated film, then, is appropriately tied to experience because, for him, cinema's live-action projection of reality has the "force of art."[47] The projection of reality that Cavell experiences through film addresses the philosophical problems associated with modern skepticism that are exacerbated by logical positivism. As D. N. Rodowick explains, for Cavell, photography and film "pose both the condition of skepticism and a possible road of departure, the route back to our conviction in reality."[48]

We can understand this through Cavell's claims that film presents a "human something" in a way that is roughly analogous to how all humans are present to each other in a limited sense: "It is an incontestable fact that in a motion picture no live human being is up there. But a human *something* is, and something unlike anything else we know."[49] The moving image on the screen breaks an object or person from its worldly context while presenting it as an object or person to be considered by viewers. Since the experience is elicited through a screen, there is no reciprocation; the viewer cannot access the other presented, and that "other" does not know who sees him or her.[50] The time and space separation between actors onscreen and audiences exaggerates the basic separation between persons experienced every day. As political theorist Davide Panagia explains, for Cavell this correlates with the basic incommensurability that troubles subjective human experience: "our willingness to regard an other requires our admittance that we can never get at what is fully human in an other and that the best we can do is to see a human *as* a human something."[51] Cavell treats knowing the world in comparable terms: "Whereas what skepticism suggests is that since we cannot know the world exists, its presentness to us cannot be a function of knowing. The world is to be *accepted;* as the presentness of other minds is not to be known, but acknowledged."[52] Cavell's

comments about film describe the medium as a subjective opportunity for thinking about our objective, skeptical condition.

For Cavell film's world projections, its affected presentations of reality onscreen that are at once present but absent, are an exaggerated rendering of modern experience in which we know we have limited knowledge of each other and the world around us. On this topic Cavell also stresses the automaticity of the motion camera and its capacity to relieve a "burden of perception," to use Rodowick's phrase.[53] Film's automaticity fulfills the human wish to view the world as it is and remain unseen. Films do this "not because they are escapes into fantasy, but because they are reliefs from private fantasy and its responsibilities; from the fact that the world is *already* drawn by fantasy."[54] The experience of cinema that Cavell appreciates relieves humans from the expanded sense of artifice unleashed by a modern understanding of subjectivity as an epistemological problem. Perception becomes burdensome precisely when it is understood as a kind of personal fabrication, which, in the passage above, Cavell compares to drawing. Rather than settling for logical approaches that only resolve verifiable phenomena, film offers an opportunity to think about unverifiable and incommensurable knowledge and experience. The idea is not that film relieves humans from this condition but that film relieves humans from the burden of this condition by enabling them to experience it in an exaggerated, aestheticized form.

There are animation forms that approach reality in this way, but Cavell and Sesonske's discussion is focused on animated cartoons designed to do something different from conventional live-action film.[55] That something different includes building on the dialectical and modernist traditions of animated film already discussed. Cavell's experience of animated film as too lawless can be attributed to his overall approach to film, which works to relieve the burden of living in a world "drawn by fantasy." As a medium often used to produce drawn fantasies, animated film does not illuminate modern skepticism by showing the world, and Cavell's comments imply that there are simply basic laws

present in live-action film that are absent from animated film. The assumptions that take place when viewing live-action films, such as Cavell's contention that there is a "human something" onscreen, can become routine judgments (prejudices?) that constitute another burden that, in turn, is relieved in animated film. Elements of determinative judgment continually develop in concert with media environments; media practices become habitual and the particulars of perceptual experience do not disrupt general concepts and norms but reinforce them. The concept of a "human something," akin to Bazin's "ambivalence of reality," carries with it a host of rules about human bodies and personalities. Animated film, then, presents a something, but it frequently is less stable than the concept of human that Cavell finds valuable. The implication is that we have developed relative distinctions between different kinds of transcriptions of the human—graphic, photographic, digital motion capture, and so on.

I use the term *burden* loosely, but relief from perceiving a "human something" designates a conceptual release that affirms the numerous descriptions of animated film disrupting the rules that guide viewing live-action film. For example, animated characters relieve the tension of the mimetic paradox that exists within human performers who are at once a historical record of a person and a creatively imagined character.[56] Admittedly, this animated/nonanimated character distinction ignores the forms of micro resistance and nonhuman agency that exist within animated film and that work against the animators' intentions.[57] But there is a greater remove from the "flesh and blood" of the actor, and as Bazin noted when comparing cinema to theater, an audience's proximity to living performers results in a more demanding ethical relation.[58] In other words, whatever cultural and moral feelings of obligation or responsibility one has toward his or her fellow human, these are significantly influenced by proximity and perceptual recognition. This ethical distance is not consistent across animated forms, and animated films are not consistently departures from spectator embodiment. Documentary animated films such as *Waltz with Bashir* (Folman 2008)

explicitly express real historical events and people with pointed ethical, moral, and political messages. And, in accordance with body genres, animated films can be pornographic, horrific, and sad. In other words the address of the aesthetics of judgment under discussion is not intrinsic to animation techniques. It must be created through style, narrative, characterization, and audience expectations. It has its own norms and rules. Nevertheless, it is not clear how long these distinct interpretative traditions can last given the overlap of techniques within digital cinema.[59]

CRITICAL AESTHETIC ATTENTION

Animated films that meet expectations for irreality, ambiguity, interrogations of nature, and shifting modes of experience are not divorced from reality or ideological messaging. Their lawless ethos can, paradoxically, contribute to reinforcing very specific and harmful ideas and norms. For instance, the *Private SNAFU* educational films for World War II soldiers were designed to entertain young men (they contain many sexist depictions of women) and demonstrate dangerous behaviors that soldiers should avoid. The goal of this design was to partially relieve the angst and gravity of war, which would help audiences digest a variety of messages—be they sexist, racist, patriotic, or pragmatic. The relief that animated cartoons have offered during contexts of war relates to contexts of death and violence more broadly. The sting of death is certainly relieved when static elements are continually brought to life, but there is also the sense that the resilience and plasticity of animated cartoon characters expresses a kind of training in violence.[60] Furthermore, wartime propaganda expertly vilified enemies through racial and ethnic caricature, and cotemporaneous children's entertainment tended to retain a variety of these discriminatory depictions since many of the same animators worked on both forms.[61]

Within the history of animated cartoons there are numerous examples of hyperbolic sexist, racist, ethnocentric, and nationalistic

depictions. The roots of such depictions in the United States can be traced to the influence of burlesque, vaudeville, and black minstrelsy. The practice of caricature, for instance, mitigates the intense labor of drawn animation by quickly producing recognizable figures conducive to short films, and this has an immense capacity to perpetuate stereotypes and racist fantasies. As Nicholas Sammond details in his history of American commercial animation and blackface minstrelsy, cartoon minstrels (such as Felix the Cat and Mickey Mouse) appeal to racialized fantasies about blackness, otherness, commodified bodies, and slavery. A cartoon character's status as comic, rebel, trickster, debauchee, living commodity, and its metamorphic body and caricatured design owe much to minstrelsy.[62] Cartoons can connect an array of worlds associated with racialized American conceptions of blackness—for example, Africa, the plantation, the urban underworld, the ghetto—in a fluid, transhistorical fashion that could not happen as easily through the less malleable bodies of stage performance.[63] Even cartoon characters that do not evoke blackface explicitly often do so implicitly through a "vestigial minstrelsy" maintained through trickster behavior and design traits such as white gloves, bulging eyes, and pronounced lips.[64] The continuance of minstrelsy and racist caricatures correlates with the fact that animators in the United States have been predominantly white, but it also indicates competing aestheticized modes of judging newness and otherness.

Racialized fantasies about blackness and African Americans as borne out in commercial animation contain aesthetic judgments. As I have already mentioned, aesthetic judgments are never purely aesthetic or free from culture and history, even though they deal with particular encounters and subjective experience. In the case of racist caricatures, even if these include particular traits, they derive from and contribute to collective fantasies. Sammond refers to Richard Iton's concept of "black fantastic" and describes this collective fantasy as a "matrix of meaning" constituted by seemingly trivial media and references that are nonetheless pervasive.[65] This collective fantasy about blackness and

otherness bolsters systemic racism and quenches any distinct imaginative reckoning with that systemic racism. Cartoons that appeal to this collective fantasy, without any reflective, critical mechanism, do not help us imagine an alternative social reality. The collective fantasy, supported by stereotypes in cartoons and other media, secures social injustice and inequity by nullifying the more critical aspects of aesthetic judgment. Instead of disrupting the correlation between image and idea, the two become more entangled.

An animated world's distance from reality and determinative concepts, while emphasizing the aesthetics of judgment, also generates a space vulnerable to the perpetuation of prejudices. Critical attention requires a variety of skills and motivations, and aesthetic experience is an opportunity for critical attention, not an imperative for it. When encountering an artwork, for instance, a person typically benefits from knowing some history and context when making sense of the experience. This is in part because the work of art is frequently engaged in troubling the norms and rules at play in its context. In the case of watching animated cartoon stereotypes, the imagination may be fooled into thinking it is engaged in a fantasy that challenges norms and reality when precisely the opposite is happening. The fantasy is the norm. Here again the problem central to forms of animated film that have inherited a cultural legacy in which irreality and experimentation with nature are expected is that this distracts from normative and naturalizing elements within such films.

Popular audiences in particular tend to relax critical attention toward animated films that distance themselves from identifiable sociocultural contexts. Paul Wells believes this is one of the reasons classic Disney films have maintained an overwhelmingly positive popular reception despite a robust body of criticism.[66] Granted, the burden of critical aesthetic attention does not rest entirely on viewer or film given that movie watching is a relational, dynamic phenomenon. The storytelling that occurs in many Pixar features, for instance, incorporates the aesthetics of judgment into characterization and plot. In other

words the characters face epistemological confusion to a greater degree than any actual audience watching the film. With respect to the foregoing discussion of stereotypes, the film *Monsters, Inc.* demonstrates how a monster character's contact with a little girl reconfigures the monster's general assumptions about human children. This is experienced as ironic by audiences who know more about children than the fictional monsters even though the animated world of the film presents a fantastic cosmology in which our norms and nature need not apply. The film presents a particular experience that challenges generalized norms within its diegesis, while affirming norms that exist outside its diegesis. A variety of viewers may find that this structure prompts critical discussion, but it is likely that many viewers will not feel compelled to think critically about norms given the film's affirmative elements.[67]

Critical analysis of formal aesthetics is crucial to exposing subtle departures from stereotypes and prejudiced fantasies. Sianne Ngai's analysis of the stop-motion animation television show *The PJs* demonstrates as much through its explication of how an excessive "animatedness" undermines conventional racial constructions of animated characters.[68] Another example is the comic and animated series *The Boondocks*, by Aaron McGruder, which carefully subverts ethnic and racial caricatures and takes aim at racialized assumptions and fantasies. But McGruder's caricature of caricatures is at times subtle and overpowered by depictions of masculine violence. To bring the show's virtues into social consciousness requires thoughtful commentary.[69] Critical commentary is crucial in these readings of animation subverting animation because so much hangs on the critic's handling of the dialectics of animation's contestations between matter and movement and between its naturalization and denaturalization.

Pixar's films are not as ideologically consistent as a television series. They involve different writers and directors and seek to build distinct worlds and characters while maintaining commitments to conventional Hollywood storytelling, classical character animation, and stylized realism. Although several of their films perpetuate the tradition of animation

focused on transformation and aesthetic experience, a tradition conducive to the ethos of creative labor and digital modernity, Pixar films raise different cultural issues and distinct critical opportunities specific to each imagined world and story. By attending to the aesthetic concepts and cultural, historical contexts raised by individual films, the following chapters seek to disclose how these films "dramatize a skirmish with nature" and address "changing models of experience" but not necessarily in a fashion as consistent as the studio's creative philosophy and branding. Although Pixar's management has effectively exploited the creative freedom of its employees, its productions remain opportunities for critical analyses capable of expressing how their world, too, is an aesthetic one with rules that are also subject to change. This formulation submits that aesthetics does not strictly refer to encounters with art but refers to our sensorial and thoughtful integration with an environment, which is also a political integration since it entails judging that environment alongside others.

The Uncanny Integrity of Digital Commodities *(Toy Story)*

Many of Pixar's earliest animated shorts feature everyday objects—for instance, a toy in *Tin Toy* (Lasseter 1988), a unicycle in *Red's Dream* (Lasseter 1987), and the studio's iconic parent-child lamp duo in *Luxo Jr.* (Lasseter 1986). These were all practical characters for early computer animation with its plastic-looking textures and crisp, three-dimensional interiors. But the character choices also resonate with the continued proliferation of automated objects and animated images during the age of digital media. In 1992 the architectural theorist Anthony Vidler described the contemporary domestic world of things as uncanny. Traditional objects that filled houses had been redesigned and reinserted into a new technological order. Private space became public as objects were networked and acquired gazes of their own.[1] Vidler's description foreshadows the coming Internet of things, and it outlines the shift from modernist, clean living to a mechanistic home with a life of its own: "A 'machine for living in' has been transformed into a potentially dangerous psychopathological space populated by half-natural, half-prosthetic individuals, where walls reflect the sight of their viewers, where the house surveys its occupants with silent menace."[2]

This uncanny, technological domestic life contextualizes not just Pixar's shorts but many of the studio's feature films. It is a context

specific to more developed regions but is also constituted by global networks that facilitate the exchange of information, goods, and services. This kind of networked, cybernetic domestic space deprivileges the gaze of other humans as it approaches giving parity to the gaze of all objects. Given that humans in part know themselves and their worlds through the reciprocated gazes of other people and objects, computer-animated narratives about autonomous objects have a rich capacity to express shifting ideas about knowing oneself and world in the digital age. As many commentators have noticed, Pixar's productions address contemporary commercial and media landscapes, but the films also evoke nostalgia through depictions of older media, technology, commodities, and cultural and economic practices. The films' representational mode renders Vidler's uncanny observations less threatening and more playful. But what kind of aesthetic experience do these playful, uncanny depictions evoke when they portray uncertain moments that confuse past and present and biological and mechanical movement?

Since Vidler wrote about this personified homestead, digital devices have become more prominent and more interactive. At the same time, many theorists and philosophers have made new efforts to investigate the agency and vitality of the objects and environs that we live with and within in an effort to critique long-standing anthropocentric assumptions. This reality of interactive things and human assumptions can be addressed through the *Toy Story* trilogy (1995, 1999, 2010), through its lively toy characters that reciprocate the care of their child owners, and through its narratives about epistemological adjustments. These toy stories have thrived in this technological, posthuman, uncanny context, but they also bring to the fore an obvious component too often taken for granted: that the contradictory logics of consumer culture also thrive in this context.

Akin to other Pixar productions, the *Toy Story* trilogy ameliorates the technological fervor of digital culture through nostalgic references to old toys and technologies from the analog period of the twentieth century.[3] This prompts a comparison of the commodity logics of the

digital age to the commodity forms common to earlier parts of the twentieth century. The trilogy also maintains Pixar's adherence to popular gender/sexual conventions and stereotypes. While presenting characters with more complex identities than those in many family films, on investigation most of these identities are conventional and socially conservative.[4] In tension with these conventions the films also address traditions of animated film and modernization through depictions of characters that experience psychological and epistemological transformations as they adjust to a newly perceived reality. These transformations express an open space for reflective judgment when the characters learn they are mistaken about their world and its rules. But rather than leaving open the possibility inherent in this aesthetic relation to the world, these epistemological adjustments function within narratives that naturalize their premises and related social conventions. The films rely on forms of product essentialism and commodity fetishism to serve as logics used to give order and meaning to their animated world. The films, then, as popular entertainment, offer a valuable and rare opportunity to examine the cultural form of digital commodities in relation to previous commodity forms and in relation to recent posthuman questions about embodiment, personhood, and the agency of things.

. . .

The *Toy Story* films are built around two major premises: first, that toys are alive but tirelessly work to hide their animated world from humans; second, that the fulfillment of a toy's life comes through being loved and played with by a child. The first premise sets up recurring scenes in which toys come alive or wake up, in which they scatter like roaches across a bedroom floor to hide before a human enters the room, or in which they collapse and play dead beneath the gaze of human eyes. These scenes smack of a childish intuition—or a philosophical one—that our objects are keeping something from us or that there is some opaque field blocking

us from truly perceiving their world. The second premise, that a child's love defines the life of a toy, structures the films' narratives around the point of view of the toys. Instead of emphasizing the child's entertainment and fetishization of toys, the narratives emphasize the toys' pleasure in and loyalty to their child-owner. The child-owner becomes a stabilizing ideological or theological figure to which the toys express varying levels of fidelity and devotion. The drama of each of the three films unfolds through this structure as the toys find themselves in situations that threaten their secure place with their child-owner. In the first film the toy characters Buzz Lightyear and Woody find themselves separated from their child-owner, Andy, and must navigate back to his house before he moves to a new home with his family. In *Toy Story 2* Woody is abducted by a toy collector and faces becoming part of a museum exhibit. Buzz and Andy's other toys must rescue Woody and return him to Andy once again. Finally, in *Toy Story 3* Andy has grown up and is about to go to college. The toys find themselves donated to a daycare center, but this time Woody alone tries to get back to Andy while the other toys attempt to adjust to life at the daycare. The film is resolved when the toys are reunited with Andy and he donates all of them to another individual child-owner.

These narratives portray the tension between the different life cycles of humans, things, and commodities. The toys face the challenge of maintaining value as their child-owner ages and as they themselves wear down, which complicates their child-loving character and their mass-produced, market-based identity. The *Toy Story* trilogy portrays living toys as capable of reciprocating affection and recognition with humans, albeit surreptitiously. But it is significant that these agential objects reckon with their commodity status as well. They are not exclusively objects or things or commodities or persons but a tenuous combination of all of these. This combination aligns with the visual style of the films, which, from the point of view of the toys, explores a range of layouts from home interiors to stores, offices, restaurants, airports, daycares, and suburban and city streets. Since the toys themselves appear as smooth, hard plastic and tend to be gendered masculine, they are not

likely to be experienced as cute but instead present a more mature, adult toy-meets-world ethos.[5] The toys' self-awareness and clear articulation of the films' premise about toy-child relationships enhances the continuity between the toys' developed design and their sense of autonomy and capacity for mature feelings. Steve Jobs, CEO of Pixar during the production of *Toy Story* and *Toy Story 2*, maintained a product philosophy that aligned with the premise of the films and its toy characters, as his biographer Walter Isaacson relates:

> [*Toy Story*] sprang from a belief, which [director John Lasseter] and Jobs shared, that products have an essence to them, a purpose for which they were made. If the object were to have feelings, these would be based on its desire to fulfill its essence. The purpose of a glass, for example, is to hold water; if it had feelings, it would be happy when full and sad when empty. The essence of a computer screen is to interface with a human. The essence of a unicycle is to be ridden in a circus. As for toys, their purpose is to be played with by kids, and thus their existential fear is of being discarded or upstaged by newer toys. So a buddy movie pairing an old favorite toy with a shiny new one would have an essential drama to it, especially when the action revolved around the toys' being separated from their kid.[6]

The essentialism described in this summary locates the purpose of an object in its design; therefore, its essence is derived from its designer/ creator. More than physical properties, the essentialized element is the authority of the producers, and, according to the producers, toys' integrated designs are meant to entertain children. The toy characters in the *Toy Story* trilogy contemplate their origins to an extent, but most of their activity focuses on the future and their ability to live out their purpose of being toys committed to playing with a child. The drama of the narratives depends on the characters' (and audiences') acceptance of this purpose as the foundational ground of the *Toy Story* world. The epistemological adjustments depicted in the films are about characters coming to terms with this foundational principle.

As described in a promotional book authored by Lasseter and Steve Daly, product essentialism informs the characters' personalities: "The

task of bringing the *Toy Story* cast to life began with looking through each toy's physical and conceptual essence. How is it made? What was it built to do? What are its physical flaws and limitations? Out of this exploration came a cast of characters as diverse as the materials from which they were made. The key to defining each of the toys' personalities, says Lasseter, was to try always to derive their traits from the realities of their construction, respecting what he calls the 'physical integrity of the object.'"[7] This passage illuminates how Jobs's product essentialism can be combined with character animation. As an animator, Lasseter thinks through what happens to an inert body when it gains the movement of life but also how to relate that moving physicality to personality. Lasseter and his animators study the material reality of bodies in conjunction with commercial reality to discern the distinguishing traits that constitute character.

The two passages quoted above describe processes of anthropomorphization, and they demonstrate that such processes are not simply about imbuing things with human traits but that they also facilitate the contemplation of the materiality, design, and origin of those things. For Lasseter and the animators the instrumentality of an object is considered in combination with that object's autonomous existence. Developing a character with a respect for the "physical integrity of the object" is an imaginative practice interested in presenting nonhuman agency. This practice incidentally affiliates the animators with theorists such as Vidler and others attending to the nonhuman agency of networked things and matter itself. These different inquiries share the practice of closely attending to objects, but they also diverge in significant ways. In her investigation of the vitality of matter, political theorist Jane Bennett endorses moments of naive or childish realism and small amounts of anthropomorphism: "A touch of anthropomorphism, then, can catalyze a sensibility that finds a world filled not with ontologically distinct categories of beings (subjects and objects) but with variously composed materialities that form confederations."[8] While the animators are probably not envisioning their work as taking place within

material confederations, the idea that it is a "sensibility that finds a world" illuminates the practice of attending to objects that Lasseter describes. Using much more than a touch of anthropomorphism, the animators are deploying a sensibility that attends to objects and things for the purposes of creating a world and creating characters. The idea that a sensibility is a changeable orientation central to knowing the world resonates with the *Toy Story* narratives, which feature characters reconfiguring their knowledge of self and world.

Unlike Bennett's sensibility, the animators working on the *Toy Story* films retain the dominance of human modes of creation through characterization grounded in a product essentialist philosophy. The *Toy Story* films do not separate the consideration of nonhuman agency from the consideration of commercial culture; the films think these aspects together. Anthropomorphization ought to be distinguished from characterization in this context. The former refers to nonhuman bodies imbued with human attributes, and the latter refers to the process of making or presenting a character, which typically involves determining the character's essential attributes and presenting those through an artistic medium. In this sense anthropomorphization refers to a process of input whereas characterization refers to a process of extraction for the purposes of re-presentation, which accords with Lasseter's description of deriving personality traits from "the realities of [the toys'] construction." The two processes often coincide, but in this case the distinction highlights that the animators are not considering the commercial elements of the toys to be human elements peripheral to the objects. Instead, the commercial elements are presumed to be intrinsic, essential characteristics.

This form of characterization opposes philosophical attempts to contemplate an object apart from dominant discourses that distort human perception and experience. Consider, for instance, Martin Heidegger's famous essay "The Thing," which advances an understanding of the thing as opposed to the object through a kind of characterization that considers a jug's function along with its material shape and presence. The void of a jug holds the contents it contains, and this

holding of contents is oriented toward the act of pouring/giving: "The jug's jug-character consists in the poured gift of the pouring out."[9] The formal attributes of the jug—as a container, as something that pours—create a character apart from what it was produced or manufactured to be and do. In Heidegger's essay characterization displaces scientific or market definitions of the jug with the goal of apprehending the thing character of the jug rather than its object utility. The essay resists the dominant scientific and market discourses that for many modern individuals organize the world and its objects. The Pixar animators, however, do not use characterization to escape modernity and gain access to the world of things obscured by the commodity form and instrumentalist thinking; instead, their imaginative process caricatures and projects the obscurantist nature of the commodity form itself.

Given the ongoing discussion among scholars such as Bennett and Bruno Latour for expanding democratic politics to nonhumans, the *Toy Story* trilogy serves as a cautionary tale about the commercial forces that are quick to speak on the behalf of things. It is important to acknowledge this component of Pixar's oeuvre given the ease with which viewers can make explicit ties between animated film and vital materialism or animated film and posthumanism. It can be easy to overlook analyzing the obvious commercial elements. Such is the case when Kyle Munkittrick, writing for *Discover Magazine* in 2011, claims that Pixar films have been preparing audiences for new forms of personhood. Munkittrick's argument relies primarily on the narrative structures of the films and the worlds the characters inhabit. He notes that Pixar worlds are not magical; they are realistic, human worlds, and they feature at least one intelligent, nonhuman main character. The human characters and narratives present two recurring structures that lead Munkittrick to his thesis: the human as villain and the human as partner. *Toy Story* and *Toy Story 2* have human villains and present nonhuman characters coming to terms with their status within the human world. The common narrative that emerges through the human-as-partner structure is that nonhuman protagonists who deviate from

their communities are able to bond with humans who have likewise deviated from their communities. Munkittrick acknowledges what he calls "character teams," which are rewarded for forming new relationships with "others"—for example, Remy the rat and Linguini the human in *Ratatouille* or the monsters Sulley and Mike with the human child Boo in *Monsters, Inc.* His thesis demonstrates how Pixar films can be easily applied to discourses associated with posthuman issues. Munkittrick's account does not consider the longer history of representations of humans partnering with nonhumans, nor does it consider animated film's legacy of challenging static definitions of personhood and nature.[10] But more consequential is that the eagerness to utilize the cultural capital of Pixar's work results in a failure to attend to the precise forms of alternative personhood that the films present.

The personhood that emerges in the *Toy Story* trilogy is based on product essentialism, but this does offer insight into posthuman experience—specifically the development of virtual bodies composed of information. After all, what does it mean to respect the physical integrity of an object and translate that integrity, which includes commercial elements, into digital information? Foremost, the development of the commodity-characters builds on the antecedent logics of predigital consumerism. The nostalgia that most *Toy Story* commentators address relies heavily on a historical and personal familiarity with intimate consumer-commodity relationships. The twentieth century featured the radical expansion of the commodity form, which included the predominance of exchange value over other forms of value and the expansion of commodity fetishism into all aspects of cultural life. For Marx commodity fetishism refers to the seemingly mystical properties of exchange value that mask the human and material relations that contribute to the value of a commodity.[11] This condition in which the majority of objects are commodities first and tools or art second has been criticized for inducing social conformity and a dangerously regressive political consciousness among consumers.[12]

The *Toy Story* trilogy's focus on contrasting temporalities between products and persons and its focus on family and community draws

attention to questions of commodity fetishism's relation to cultural transmission. Modern consumerism marked the diminution of a cultural realm established through the production of traditional goods and goods capable of passing on tradition—for example, art, literature, and their respective commentaries.[13] Consumerism diminishes this force and becomes its own set of cultural practices, preserved and passed on to future generations through media forms like the *Toy Story* films, for instance. Theodor Adorno, in his well-known essay on the fetish character of music, gives numerous examples of everyday moments in which market value is used to mark enjoyment, resolve quotidian judgments, and assess intimacy. In regard to the familiarity of arranged music compilations, Adorno writes, "It is a compulsion similar to that which requires radio favourites to insinuate themselves into the families of their listeners as uncles and aunts and pretend to a human proximity. Radical reification produces its own pretence of immediacy and intimacy."[14] Although it is about music and not visual media, this statement adumbrates the uncanny domestic space described by Vidler in the 1990s, which suggests some continuity based on commercial efforts to make products familiar and intimate. It also highlights the casual inattention to mediation—"radical reification" amounts to consumers losing awareness of the commercial power structures that mediate and administer their experience. For Adorno, if a consumer recognizes a piece of popular music, then it is experienced as palatable and pleasant, and it confirms the consumer's knowledge of the marketplace, the new standard of measure. Instead of being a matter of taste and eduction, judgment of cultural goods and art objects becomes a matter of familiarity and market knowledge.[15] Consumers are able to feel empowered through their identification with the producers of the entertainment who have prestige in the marketplace. Hence, products and brands become intimately bound up with individual identity and self-esteem.

The long-standing intimate role of commodities in everyday life informs the nostalgic appeal of the *Toy Story* films and broader developments in digital culture. Digital culture involves accelerated commodity

consumption through the increased circulation of and access to digital goods in private and public spaces. This includes the recirculation of older media still in demand within niche markets—for example, vintage programming on YouTube. The demand for nostalgic media indicates the diminishing force of culture as an adequate means of preservation and tradition that would counter the transience of human life.[16] Digital culture's short-term thinking and attention is accompanied by enhanced modes of interactivity through networked devices and DIY production and distribution. In this context of intense global (re)circulation, original content continues to appreciate as a seed for producing an array of commodity progeny. The speed and scale of production and circulation contribute to overlooking both material and virtual waste— the things themselves are neglected.[17] There is also the uncertainty of the location of power and authority among networks surveilled by corporate, state, and independent actors, an uncertainty that, echoing Vidler's remarks, can be traumatic for the individual constantly engaged in online activity.[18]

The *Toy Story* films engage with these aspects through nostalgic themes, awareness of media convergence, attention to things and their fate, the depiction of commercial authority, and the recognition of the weight of relational intimacy. More specifically, the films' historical sensibility demonstrates how prevailing consumerist logics become a means for presenting a comprehensible digital and fictional world. As if responding to theorists like Arendt and Bauman, who warn of growing precarity and the loss of tradition, the toy characters rely on product essentialism and commodity fetishism as guiding logics to make sense of their own world and the relationships therein. In this form commercial forces maintain authority within everyday life, and digital goods still pursue "human proximity," as well as "immediacy and intimacy." Furthermore, the films offer insight into the contradiction between commodity disposability and fetishism, and how digital culture works to resolve this contradiction through brand building. Admittedly, the continuity of commodity forms through the shift to digital media contributes to the seeming permanence

of late capitalism, and the *Toy Story* films certainly contribute to this continuity. But there is a subtle suggestion that it could be otherwise in the fact that the trilogy's animated world does not immediately disclose its premises or commodity logics; the toys and human characters must test and discover what these are.

COMMERCIAL AUTHORITY AND COMMODITY INTEGRITY

Although they mark significant innovations in computer animation and digital cinema, these toy stories have numerous antecedents, many of which have a history of addressing philosophical questions about modernization, human development, and the physical properties of our world. Lois Rostow Kuznets's book *When Toys Come Alive*, published just prior to the release of *Toy Story*, makes a case for the enduring presence of the human desire for objects to come alive, and Kuznets relates this desire to the human impulse to create in general. Within her argument Kuznets reviews how toys and objects of personal significance tend to be involved in processes of transition, especially during early child development.[19] Representations of inanimate toys coming to life can "embody human anxiety about what it means to be 'real'—an independent subject or self."[20] This long-standing practice of relating toys to personal transitions and life questions renders toys appropriate for coping with modernization and rapidly developing technology. Objects from childhood, whether collected or passed on to one's offspring can mitigate the anxiety involved in transitioning into new phases of life and can symbolize an effort to perpetuate the meanings and practices of the past. Also, the miniature aspect of toys conveys the great vulnerability that people feel in the midst of social change, and their smallness is capable of suggesting the secret worlds that exist beyond our perception.[21]

In short, toy stories are associated with the metamorphic, developmental, existential, relational, technical, and spatiotemporal experiences

of life. Pixar's *Toy Story* trilogy certainly builds on this tradition through simulating the world from a toy's point of view, focusing on family and home life and examining how relationships change over time. The first *Toy Story* film focuses on the relationship boys have with their toys. The film introduces the boy character Andy, who owns the toys that the film is about and who lives next door to Sid, a boy whose name and demeanor allude to punk icon Sid Vicious. Sid serves as a foil for Andy; Sid is the bad child, and Andy is the good child. Sid's room is messy and dark whereas Andy's is bright and clean. Both boys are highly imaginative and enjoy playing with toys. Sid, however, prefers to blow his up or disassemble them and reconfigure them using different toy parts.[22] The juxtaposition of the boys has significant implications for reading the trilogy because they are the most developed human characters in the first film, although peripheral, and they contribute to the child-owner ideology at the center of each film. The boys' parents are even more peripheral, but their limited depictions provide crucial framing for the epistemological adjustments in the narrative. Andy's mother, for instance, briefly appears in a handful of short scenes—including Andy's birthday party and Christmas—but always in the background and with very little dialogue. The peripheral role of parents has facilitated other commentators reading the toys as comparable to stand-ins for parents since the toys are bound to the child by love and a concern for the child's well-being.[23] On the one hand, the insight of these readings, in which toys must learn to be domestic caregivers for children, is quite compelling. On the other hand, children have tremendous power over the toys in the films, and the characterization of the toys is strongly influenced by product essentialism. From their peripheral locations both the adult and child characters demonstrate that the story is about a family of things in which parental authority is subsumed by commercial authority—where the world of children and their toys is structured primarily by companies such as Pixar, not mothers and fathers.

The core conflict of the first *Toy Story* emerges from the relationship between two toys in particular, the space ranger Buzz Lightyear and

the cowboy Woody. Buzz is Andy's newest toy and threatens Woody's place as Andy's favorite. As a new toy, Buzz is not yet aware that he is a toy and, therefore, has not learned the basic premise that a toy's greatest desire is to be played with and loved by a child. Woody helps Buzz learn this but not before knocking Buzz out of Andy's bedroom window during a fit of jealousy. After his defenestration Buzz sneaks into the family vehicle before they leave for dinner and confronts Woody, who is accompanying Andy, when the family stops for gas. During their fight the family car pulls away, and the two toys are stranded. Their adventure to reunite with Andy at the local restaurant arcade, Pizza Planet, functions as a rite-of-passage narrative and buddy story. At Pizza Planet, however, Buzz and Woody are abducted by Sid and transported to his dystopian bedroom. With band posters plastered on the walls and a workbench with tools for modifying toys, Sid's room looks more adolescent and less supervised than Andy's room. Buzz and Woody quickly escape the room but find themselves in a house unlike Andy's. While Andy's father is absent from all of the *Toy Story* films, Sid's father, or at least an adult presence that I read as masculine, is partially depicted from Buzz's point of view, lounging in a chair in front of a television (Figure 7).

The implicit point here is that Andy's profound affection for his toys is supported by a home and family that differ from Sid's. Sid's pleasure in destroying and manipulating his toys is bolstered by his seemingly present but apathetic father. Most of Andy's toys are coded masculine, and Sid's destructive masculinity is carefully presented in contrast with Andy's. Sid's destructive propensities resemble those of a bully who afflicts others as a means for coping with his own vulnerability. The room where Sid's father watches TV is full of markers that can be read as working class as well.[24] It is possible to read an economic vulnerability being passed on from father to son even though Sid's violence seems to be a masculine privilege secured in part by the presence of his father. The room where Sid's father watches TV, like Sid's room, is juxtaposed with the clean, polished space of Andy's home (Figure 8). And

Figure 7 *(Top)*. *Toy Story* (Lasseter 1995). Buzz's point of view reveals a masculine presence when he encounters a commercial for the Buzz Lightyear toy. Disney-Pixar, 2010. DVD.

Figure 8 *(Bottom)*. *Toy Story* (Lasseter 1995). Andy's bright and well-kept house contrasts with Sid's dingy and dark house. Disney-Pixar, 2010. DVD.

it is in this former room that Buzz sees a commercial for Buzz Light-year action figures and learns that he is a toy.

The scene portrays an alternative mirror stage.[25] Instead of the subject experiencing a reflection that presents a coherent image of a self separate from but autonomous within the external world, Buzz's encounter with a visual representation of himself disintegrates his subjectivity. He is forced to convert epistemologically from knowing the world as a space ranger to knowing the world as a toy. This uncanny conversion and media spectacle literalizes the customs of the attention economy—namely, that viewers are products—and dramatizes the feeling that commercial media have a disturbingly large role in the construction of subjectivity.[26] Alluding to old claims that television desensitizes and corrupts passive viewers, this scene combines the TV with the peripheral presence of Sid's father sitting motionless in a recliner to mark a space of demystification. Buzz shares the view of the adult, Sid's father, as he watches the commercial. It is this demystifying rationality that is parodied by Sid, who repeatedly rehearses the process of demystification with each toy that he disassembles or explodes. In Sid's house masculine adult space secures a nexus of violence and knowledge, which contrasts directly with the fatherless space of Andy's house and Andy's obedience to his mother.

To escape from Sid's possession, Woody and Buzz must take advantage of the other captivating premise of the films—that toys are living agents. In the film toys can reveal their life and world to humans, but doing so is taboo. With multiple allusions to horror films, the escape scene unfolds in Sid's backyard as the toys come alive in front of Sid and disrupt his preparations to launch Buzz Lightyear into the air by way of an exploding firework (Figure 9). Sid is horrified by his toys emerging from the sandbox and elsewhere and by Woody, who speaks and demonstrates the full extent of his humanoid facial expressions. The toys' disclosure of their being to Sid destabilizes his knowledge of the world, and he learns that toys are not lifeless objects subject to his will. Observing the toys moving autonomously, Sid no longer has command over

Figure 9. *Toy Story* (Lasseter 1995). Sid's toys reveal their autonomous being while alluding to horror genre tropes. Disney-Pixar, 2010. DVD.

reason or matter, and he learns that the violent, adult masculinity he has inherited is not a force of demystification but of mystification. *Toy Story* pits the fatherless, imaginative play-space of Andy against the more destructive, masculine play-space of Sid. Despite the appeal of Sid's creativity and subversion, which likely resonates with many of Pixar's own animators, the character is portrayed as fundamentally misunderstanding his environment. The narrative champions a child-ish form of play more in line with the essence of toys—that is, the product essence as described by Lasseter. The narrative presents a reversal of adult rationality by way of childish imagination that reinforces the commodity fetishism at the center of mass-produced toys and children's entertainment.

The notion that a naive realism or fascination with objects can illuminate nonhuman agency and vitality is an idea that reinforces claims by animation theorists that animated media are ripe for philosophical study, not simply children's entertainment.[27] Although I agree with this contention, a close reading of *Toy Story* illuminates how a form of naive realism is very active in commercial production. The vilification of Sid's

unorthodox refashioning of toys aligns the toys' points of view with that of their creators/manufacturers. This creates an ethos of commodity integrity that opposes that of digital cultures that celebrate re-engineering, hacking, and remixing. Instead, the vilification of Sid reinforces the Disneyfication and fetishization of toy commodities as special and valuable just the way they are when opened from their packaging. The film relies on a justifiably pejorative nexus of scientific rationality-control-violence-masculinity-boyhood to champion a supposedly alternative boyhood that is playful, imaginative, cooperative, affectionate, loyal, and loving. But the latter is a fatherless form used to bolster commodity fetishism and the fetishism of production; in other words, what Pixar puts together, no one should take apart. Authority, in this case, resides with the producers and accords with a basic capitalist hierarchy.[28]

The ethos of commodity integrity supports commercial authority, which is reinforced by the parental framing, and this context provides the backdrop for a series of disturbances to the integrity of the personalities, identities, and bodies of the characters. The character Buzz, after seeing the commercial of himself as a toy, jumps from the top of a stairway in Sid's house in a final effort to determine if he can fly like a real space ranger. When Buzz crashes, his arm is completely separated from his body—a physical, material indication of his toyness. Buzz must adjust to this newly discovered reality and natural order of toys, owners, and producers, and he must contend with the limits of his plastic body. This is an ironic twist given the character's digital construction, but it also allows the character to metaphorically stand in for angst about disembodied information. As Katherine Hayles argues, the information age and the digital age have exacerbated the Western humanistic habit of disembodied thinking that neglects the significance of bodies in cognitive processes and social activity.[29] The more extreme forms of digital utopianism are usually criticized for reducing consciousness and life to codes and patterns, but there are also more quotidian concerns about digital media innovation outpacing our understanding of the developmental and physiological effects of increased contact with screens and

algorithmic automation. The body in *Toy Story* becomes a link to a natural order at a time when nature is, once again, interrogated and disturbed through technological innovation. But this reliance on the body to stabilize reality and order is also a reliance on commercial authority via product essentialism. Buzz begins to understand his toy essence through his own plastic body; he conforms to the product essentialist philosophy of Lasseter and Jobs.

Sid's psychological fragmentation follows that of Buzz and, likewise, has epistemological implications that can be related to posthuman discourse and digital commodification. Both Sid and Buzz are no longer sure about their ability to know the world and their place in it, but this uncertainty is more of an uncanny experience for Sid because the toys, whose vitality he pretended to give and take away, disclose their actual life to him.[30] This portrayal of the uncanny is probably received by most audiences as humorous and does not evoke uncanny experience in the audiences themselves. As Freud notes in his essay on the topic, to make a fictional sequence seem uncanny, an author must create a world that is commensurate with our reality.[31] Computer animation is capable of and famous for uncanny effects because it can simulate portions of our perception of reality and confuse our perception system.[32] But Pixar's stylized animation and the *Toy Story* narratives avoid this simulation and confusion through dramatic irony, when an audience knows more about the fictional world and action than the characters. Freud explains a comparable avoidance of direct uncanny experience in reference to a literary scene: "The audience, knowing what has led up to this scene, does not make the same mistake as the character; hence, what is bound to seem uncanny to him strikes us as irresistibly comic."[33] This kind of uncanny hinges on an audience's "knowing" the fictional world better than a given character.

Paul Flaig locates this "comic uncanny" in a variety of animated film sequences but points out that the sequence of toys coming to life and terrorizing Sid in *Toy Story* appears quite tame when compared to more plasmatic animation aesthetics "infused with a grotesque immortality

beyond realism or irony, a life lived by gelatinous ghosts, funny phantoms and absurdly mobile things."[34] *Toy Story* is not "beyond realism or irony" but based in irony. Aligning with Freud's explanation, the audience knows very well that living toys are a part of Pixar's fantastic, plastic world, but they enjoy watching Buzz and Sid discover a reality of living toys nonetheless. Uncanny experience suggests to a person that she might be wrong about the world and that an obsolete epistemology may not be obsolete after all. For Freud this space of doubt is opened up by a return of repressed childhood memories or forms of primitive knowledge. The comic uncanny, however, is an experience in which this epistemological slippage is presented within a diegesis, which highlights the audience's status as more knowledgeable than the characters. The status of the knowing audience is significant given that *Toy Story* was the first computer-animated feature film, and at that time computer animation was mostly reserved for specialists in computer science and computer graphics. Many audiences in 1995 did not know much about the animation they were watching—hence, the effectiveness of a sequence that enables an audience to laugh at a character's misperception of reality.

Toy Story does not present "gelatinous ghosts" or the plasmatic figures that famously interested Sergei Eisenstein. Instead, Pixar's aesthetics suppress the potential for exaggeration present in many animation techniques. Lasseter's imperative to respect the integrity of the object instills parameters for creating realism and character. This realism is commensurate with the goal of verisimilitude prevalent in computer graphics culture, but it is hedged by Lasseter's efforts to make computer animation a more familiar medium for large audiences outside the computer graphics industry.[35] Lasseter perceived the gap between the technoculture exemplified by groups such as SIGGRAPH (Special Interest Group on GRAPHics and Interactive Techniques) and that of audiences outside the computer graphics industry as an opportunity for mainstream animated entertainment. Lasseter's approach accords with the logic of remediation present in most new media at that time in that it involves a process of familiarization in which computer animation resembles

popular animated and live-action film, but it also involves promoting the newness of the visual experience of computer animation.[36]

Early on in the field of computer graphics, technicians and artists took particular interest in this balancing of old and new when generating detailed representations of textures and surfaces. Katherine Hayles relates her observation of skeuomorphs at SIGGRAPH (where Lasseter showed his early computer animation shorts) in her seminal work detailing the waves of cybernetics in the twentieth century. A skeuomorph, Hayles explains, "is a design feature that is no longer functional in itself but that refers back to a feature that was functional at an earlier time." A common example is the wood-grain finish that appears on many plastic and synthetic surfaces. As she goes on to say, "it calls into play a psychodynamic that finds the new more acceptable when it recalls the old that it is in the process of displacing and finds the traditional more comfortable when it is presented in a context that reminds us we can escape from it into the new."[37] Although concepts like the skeuomorph are common in writings about modernity, Hayles borrows the concept from archaeological anthropology, where material objects delineate transitions in technology and culture as they embody marks of a past and a future.[38] The abundance of these objects in everyday life indicates the strong psychological and social function of skeuomorphs and popular design that balances old and new elements. For Hayles's history of posthumanism each wave of cybernetic theory utilized skeuomorphic concepts in a series that increasingly disembodied information.

Pixar films are certainly skeuomorphic, with textures, lighting, characters, narratives, and worlds that resemble familiar film and video conventions and everyday physical objects. Lasseter's own insistence on respecting the physical integrity of objects when representing them digitally is akin to skeuomorphic logic. In animated worlds everything must be built from digital elements, and the rules governing these processes are those of computer space—software, hardware, and mathematics. Pixar's computer animation involves a process where an informational,

digital morphology is wielded to build a morphology that is representational of the analog morphology that humans perceive through photogenic media and in everyday life. Like cel animation, basic bodily properties, such as the laws of motion, are representational choices that are at times difficult to simulate. And such properties—for example, inertia or texture—can be simulated to convey the impression of watching an actual moving body. The reflexive narratives of Pixar, then, tend to operate in correlation with or analogously to the technical process of morphological conversion. The *Toy Story* films allegorically address the groundlessness of this context of disembodied information through characters that discover the reality of bodies and the sense of purpose and meaning provided by product essentialism. The character of Buzz presents a successful disillusionment and readjustment, and the character Sid presents a traumatic disillusionment without a successful readjustment. Proper to postmodern media conditions, skeuomorphic logic implies the need for a familiar foundational referent precisely when there is uncertainty about whether an original referent even exists.

Lasseter's approach emphasizes situating the audience in a position of knowledge, the idea being that an audience ought to recognize what they perceive especially when they may not know what they are, in fact, perceiving. A familiar order must be supplied even if fabricated. The impulse to respect physical integrity compensates for angst about digital disembodiment, and it accords with commercial authority, product essentialism, and commodity fetishism. Steve Jobs famously insisted that the original Macintosh computer look "friendly," and his "whole widget" or "end-to-end" approach to design and manufacturing tightly interwove software and hardware in an effort to prevent consumers from reshaping or retooling his technological products.[39] Although the irony and comic uncanny of *Toy Story* flatters audiences with the notion that they know better than children that toys are not alive and do not care about their owners, the pervasive presence of personified, black-boxed technical commodities produced by Apple, and Pixar's other Silicon Valley neighbors, suggests that the *Toy Story* trilogy should be read as a

more perverse ideological expression that addresses these technological toys. It is not that the irony points to audiences knowing better that toys are not alive but that, even more literally, audiences, as consumers, typically assume that their toys have a life and are quite capable of reciprocating a lively, personal gaze. The uncanny valley that scientists and engineers in robotics and animation production study marks a lag in the adaptation of the human perception system behind well-established, consumerist, fetishist norms. Another way of thinking about the push for verisimilitude in computer graphics culture is to think of it as an effort to align perception with fetishism. Can the look of computer graphics be as lively as our relational intimacy with commodities? The *Toy Story* films negotiate this question by using the anthropomorphic characterization of animated film to create a reciprocal fetishism in which the things we care about care about us in return. If a toy is capable of caring, then it need not look like a person or even move like one to become an entertaining and intimate relational object.

BRAND BUILDING: RELATIONSHIPS, VALUE, AND ABSTRACTION

This compounding of animated anthropomorphism with commercial authority, product essentialism, and reciprocal fetishism has a paradoxical relationship with mass production, planned obsolescence, and media convergence. The character Sid is a minor villain in the trilogy in comparison to the more systemic market, material, and social forces that determine the lifespan and value of toys. Even though the toys are haunted by their own disposability, the trilogy avoids becoming a critique of consumerism. The toy characters believe that if they break, wear out, or are displaced by other entertainments, then their child-owner will no longer value them and their lives will become meaningless, that is, if they continue to live at all. Furthermore, mass production and media convergence challenge the toy characters' unique identities and originality as they encounter duplicate copies of themselves in both

physical and representational forms. The premises of the *Toy Story* films contradict the consumerist principles of disposability and replace-ability. Consumers who care too much about a commodity are bad for business—they tend to collect rather than consume—and consumers who care about the uniqueness of a commodity are more sensitive to the alienating effects of mass production. The contradiction inherent to a consumer's intense valuing of a disposable, fleeting commodity is main-tained in part by the fact that many commodities are treated as never really alive or really dead, but their continual reappearance and circula-tion enhances their value. Here again the anthropomorphism of ani-mated film contributes to media and market logics that seek to build lasting brands and commercial icons that are deeply embedded in the memory and cultural life of consumers.

In *Toy Story 2* the character Woody undergoes a psychological trans-formation that parallels that of Buzz in the first film. This narrative is set up early in the film when Woody's arm is partially torn when Andy is playing with him. Andy's mother shelves Woody and reminds her son that "toys don't last forever." Worried about his future and whether Andy will still play with him, Woody feels compelled to rescue another toy from the family yard sale. During this rescue effort, Woody is abducted by a toy collector perusing the yard sale tables. The collector, Al McWhiggin, owns Al's Toy Barn and has collected massive amounts of memorabilia from a 1950s television show called *Woody's Roundup*. Woody learns that he is based on the show's protagonist, Sheriff Woody Pride, who was quite famous for a time. After Woody bonds with the toys based on the show's other characters—Bullseye the horse, Jessica Jane ("Jessie") Pride, and Stinky Pete the Prospector—he seriously considers living out the rest of his life as a collectible.[40] For Woody, life as a collectible becomes a legitimate alternative to life devoted to a child-owner because his newfound fame and family operate as a salve to his physical and psychological wounds. This new family reinvigor-ates Woody with a purpose and rescues him from the peril of becoming an undesirable toy.

Once again, the perspective is that of the toys, and it highlights a nonhuman temporality: Andy's mother is correct that toys do not last forever, but artifacts in a museum do last longer than their human associates. Al intends to sell Woody, Jessie, Bullseye, and the Prospector to a Japanese museum, where they can reside in a glass showcase with their iconic value secure for ages. *Toy Story 2* emphasizes collecting as a practice capable of recommodifying toys after they have been out of the marketplace and out of circulation. Of course, the sale to the museum is not completed, and Woody is rescued by Buzz and Andy's other toys. The rescue moves Woody to recommit to Andy and the child-owner, and Jessie and Bullseye join Andy's other toys as well. The narrative is reminiscent of the two masculinities in the first *Toy Story* in that two types of commodity value are pitted against each other: one is the enduring value of the pristine artifact, and the other is the fleeting value of a child's toy. Both types are distinct but involve the toy becoming unique (or gaining aura, which will be discussed momentarily), either through preservation or through play. The latter is a more personalized, interactive form of value and wins out in the film, but this form of value presents a significant complication in respect to the product essentialism and naturalized premises of the trilogy.

There are numerous scenes in *Toy Story 2* that illustrate an angst associated with competing origins and forms of value. Foremost are the toys' references to Andy's name, which the child-owner writes on the feet of his toys to mark his unique possession of them (a literal rebranding of the toys). Woody is tempted to renounce this possession when the mark of the child-owner is effectively erased during a sequence in which Woody is restored to "like new" condition by an elderly artist, Geri the Cleaner. The character Geri introduces a level of craft into toy making not explored in the first *Toy Story*. Modeled after the character from the Pixar short "Geri's Game," this aging artisan endows Woody with a unique, hand-painted newness. Geri also serves as an allusion to a well-known group of classical Disney animators, the nine old men, or Frank Thomas and Ollie Johnston more specifically, from whom Lasseter and

other Pixar animators learned much of their craft.[41] Geri is a restorer, not a producer, and although he is hired by Al, he protests Al's demands for urgency: "You can't rush art," he says. The joke about the market's demand for speed and efficiency conflicting with artistic production surely resonates with animators who work for high-profile studios like Pixar. But the sequence is also about a commodity regaining more than pure market value. Woody's value shifts from personalized plaything to handcrafted artifact and his purpose shifts from reciprocating a child's affection to returning the gaze of museum-goers.

Parallel to this scene is a sequence in which Buzz and Andy's other toys enter Al's Toy Barn in an effort to rescue Woody. Here they are confronted with their mass-produced, globally distributed origins. While Woody is being repaired, the other toys face shelves full of new toys and are reminded of their distance from being new. Becoming "like new" restores purpose to Woody; meanwhile, Andy's other toys have their old, nostalgic value juxtaposed with the commodity value of new toys. The group must face the lure of commodity value: of desiring to become like new or of envying the value of a new toy. The toys begin to lose their initial commodity value once they belong to a child, and that commodity value is replaced by the value and purpose of maintaining a relationship with a child-owner. Commodity value is derived primarily from exchange value and the desirous gaze of the consumer, but the reciprocal gaze of the toy takes on a more unique relationship after the toy is purchased and becomes the property of a single child. Hence, the toys reclaim a form of aura through their diminishing commodity value and increasing value as personal, fetishized property.

The pursuit of value (exchange value, the aura of a collectible, and the aura of a child's toy) complements contemporary media saturation and entertainment capitalism that threaten senses of origin and authenticity. For literary scholar Alan Ackerman, the *Toy Story* films demonstrate how this condition in which "images upon images are what we have become and all that we can hope to be" creates a need for new modes of perception.[42] Ackerman points to numerous scenes in *Toy*

Story and *Toy Story 2* that present diegetic confusion between media platforms—in these scenes versions of the toys appear on television or in video games and are visually indistinguishable from the actual toys owned by Andy. The computer-animated characters appear exactly the same across media platforms, and, in a comparable fashion to audiences considering the computer-animation medium as nonindexical, the toys must learn to cope with the lack of origin and authenticity that their production entails.[43] In respect to the medium, Pixar distinguished itself early on from other computer-animation studios working on film production for not overcommitting to the simulation of photo-indexicality, a process that can betray an effort to compensate for digital production's lack of photogenic origin or contact with reality.[44] Pixar has been successful at imitating cinematic camera movement and other effects through software to give the impression of a camera capturing an animated world, but its willingness to play with the inability to discern origin within digital media indicates an interest in establishing an authenticity that does not involve duplicating live-action cinema.[45] In the *Toy Story* films the animators' attention to the physical bodies of toys and the characters' acceptance of their toy bodies serves to naturalize the films' premises and to bolster commercial authority. Likewise, the toys become accustomed to their toyness by acknowledging that their value derives from interactivity and relationality, the direct consequences of being played with by a child.

Woody's dilemma between residing with his "original" roundup gang or returning to Andy underscores the constructed nature of family life. It is not clear which community is natural or right for Woody, but he is inclined toward that which provides him with value and meaningful relationships. This identity-community dilemma expresses how commodification reaches the core of the toys' being, and it leads Ackerman to read the film's themes of resurrection and redemption as about capitalism, not metaphysics: "The fantasy of resurrection that *Toy Story* and *Toy Story 2* depict is a fantasy of unlimited commodification and redemption (i.e., profit)."[46] Ackerman expands on this idea

via Walter Benjamin's concept of the decay of aura: "Apparently made of dead matter (plastic and chemicals), these toys enact a fantasy of continual resurrection, an idealizing revival of the dead, not only in the games of an individual child but also in the processes of production and marketing, of which both movies are highly self-conscious. Walter Benjamin's definition of aura, which withers in the age of mechanical reproduction, as the ability of the inanimate object to return the human gaze, suggests such an idealizing of humanity in the phantasmagoric return of toys."[47] Ackerman emphasizes the concept of aura as it is articulated in Benjamin's essay "On Some Motifs in Baudelaire," in which aura marks the instance in which an art object returns a person's gaze.[48] This version of the concept is applicable to the *Toy Story* films in that each film naturalizes the reciprocal, caring relationship between toys and their child-owners (even if the children characters don't know the extent to which their toys care, the audience knows). The toy commodity becomes most valuable through its becoming unique through an interactive, auratic relationship with an individual owner. This relationship brings the commodity to life, and without the relationship the commodity is reduced to pure exchange value. Reciprocation and interactivity are the drivers of aura and value as they cultivate unique relationships.

As Miriam Hansen shows, Benjamin's use of *aura* is not semantically consistent throughout his work, but his use of the term is an effort to recoup it from its earlier theosophical and metaphysical contexts and to redeploy the term in a Marxist discourse to help explain the effects of modern technology on the arts.[49] Likewise, the *Toy Story* films serve as foundational myths for reviving a form of aura as authentic relationship, which is well-suited for an age of global media, capitalism, and posthumanism. The digital constitution of the characters and images contributes to the idea of relationality becoming more valuable than physical materiality. The material distinctness of an object becomes less significant in a highly interactive relationship capable of producing unique forms of engagement and memory. The elevation of interactiv-

ity over materiality facilitates replaceability in that the object is not an auratic container of value, but the human relationship to the object is. Thus, for parties interested in profiting from the commodity, the relationship between consumer and commodity needs to be maintained through resurrection and redemption, to use Ackerman's terms. The commodity bodies can come and go as long as the relationship is kept alive and animated. The liveliness of the nonhuman-commodity-agent is cocreated through reciprocation and interactivity.

Even though thematically the *Toy Story* films do not endorse replaceability, the trilogy is part of a global brand and franchise that operates through forms of aesthetic continuity and media convergence. If anything, the films' explicit references to the horrors of replaceability betray their own digital economic reality. Lasseter's rhetoric about respecting the physical integrity of the object serves as ideological fodder for rendering palatable the disembodied ethos of digital representation and its conduciveness to media convergence and market logics. The fear and alienation inherent in consumerism, in which cultural goods are enjoyed for brief moments before their disposal contributing to a widening gap of meaningful experience, enhances the attachment to digital cultural goods that never die. The digital commodity is more fecund than the analog commodity. By the time this chapter is published, the *Toy Story* franchise will include additional films, television specials, shorts, and video games. By foregrounding their market aspects, the *Toy Story* films render obvious the contradictory presentation of integrated, embodied, personalized toy commodities that are simultaneously abstract, disembodied, mass-produced, media objects. The narratives show the disappointing and alienating lives of nonhuman commodities, but this condition is redeemed by the toys' unique characters and loving commitment to their child-owners.

This contradictory presentation becomes even more obvious in light of the fact that computer-generated feature films frequently share the practices and aesthetics of industrial product design and advertising—this includes three-dimensional modeling, the precise automation of

computer programming, and the application of lighting schemes and other practices used in product photography and product cinematography.[50] This is not surprising given that before Pixar produced feature films, the studio produced computer-animated advertisements. Furthermore, the computer animation of major studios, such as Pixar and Dream-Works, utilizes digital algorithms that enable detailed imaging and "dimensional consistency foreign to traditional live-action film and cel animation." This creates an "aesthetic of continuity" (unlike continuity editing) that in turn facilitates an experience of "viewing an impossibly continuous, impossibly complex world that nevertheless appears to adhere to the laws of physics."[51] These elaborate worlds feature aesthetics that are continuous across companies and platforms, generating a mediascape with consistent aesthetic principles based on design and advertising practices.[52] Thus, many of the visual effects in Pixar animation employ the stylization of product advertising and repurpose the processes involved in making three-dimensional products.

This is most obvious in the *Toy Story* and *Cars* films, which feature leading character-commodities, and it accords with Lasseter's approach of making computer animation familiar for general audiences. Of course, Pixar films are not simply ninety-minute commercials for merchandise. The feature-length platform itself allows for character development and storytelling significantly more nuanced than conventional advertisements.[53] But the continuity with commercial aesthetics does contribute to a particular form of advertising that does not sell a commodity but sells, instead, the unique relationship that the consumer can have with a series of commodities. In other words the aesthetics of Pixar's computer animation are highly conducive to brand building.

Computer animation effectively functions in this context in part through drawn animation's legacy of exploring the relationship between figuration and abstraction. Media theorists Scott Lash and Celia Lury are convinced of animated film's definitive position within contemporary media environments because of its capacity for expressing forms that are at once fixed and dynamic.[54] For instance, drawn animation can

present recognizable figures with nonrepresentational lines that disrupt those figures while maintaining some unity—think of an animal's neck becoming unbelievably long while remaining a neck. Building on this principle, *Toy Story* presents a tension between figuration and abstraction through characters' identities and narratives in relation to the media convergences facilitated by digital technology. The toys are abstract as iconic media objects—Woody is a cowboy and television star, and Buzz is a space ranger and videogame character—but unique as characters with personalities and bodies. The celebrity voices contribute to this contradiction because they are unique and traceable to a specific time and place of recording but also because they are extremely familiar, having been recorded many times and presented through numerous media forms. The tradition of animated film as protean, plasmatic, and unreal yet very much alive, engaging, and interactive provides a visual figuration of the contradictory logics of media products.

The integrated product of *Toy Story* is a particular arrangement of media parts.[55] Characters like Buzz Lightyear can become products and icons in their own right. Pixar and Disney benefit from the capaciousness of media products in that, like the toys children play with, the various components of their animated productions can be made to perform new roles in different contexts. This can include performances outside the direct auspices of the media conglomerate, as in the case of fan fiction. Play gives the user a sense of control and interactivity. But as the original film makes clear, there are forms of play more aligned with the essence of a toy, which is to say its design and purpose according to its producers. But unorthodox play does not necessarily undermine the company's brand building; in fact, it may facilitate it, as the brand is not actually a material inscription comparable to Andy's name inscribed on his toys. It is an amorphous concept that gains access to a subject's imagination by becoming a world-making cultural good that is at once consumable yet permanent, abstract but concrete enough to be played with—hence, Lash and Lury's comparison to the plasmatic aesthetics of drawn animation. It is the maintenance of the relationality

that is profitable, not the objects themselves, which, in a sense, remain more aloof than ever.

Branding aims to share a deep, personal structure with consumers and create a series of memories that will influence how new products, services, and slogans are interpreted by the public. This deep structure involves feedback loops in production, reception, and the strategies of both producers and consumers. This cultural embeddedness does not mean that the life of the franchise is entirely planned out, but it does mean that producers work to shape a profitable mediascape by responding to how their products exist in the social imaginary of consumers.[56] This is evidenced by the success of *Toy Story 3*, which was released fifteen years after the original film and depicted the toy characters coping with Andy's move to college, a narrative that resonated deeply with young adults who saw the first film when they were children.

The theme of redemption continues in *Toy Story 3* as Andy's toys are accidentally thrown away, but, able to escape their curbside trash bag, the toys stowaway in a box donated to Sunnyside daycare facility. The daycare presents an alternative social and political order since there are no individual child-owners but random groups of children who play with the toys for short periods of time. The toys who live at the daycare have organized themselves under the authority of a pink, stuffed bear named Lotso. Lotso presents a reasonable ideology to the toys: "no owners, no heartbreak." Through a flashback the film reveals Lotso's traumatic experience of being lost by his child-owner and then replaced by a new Lotso bear. But the Lotso at the daycare is revealed to be a ruthless dictator who tricks Andy's recently donated toys into confinement in a playroom for younger children. The young children are hyperbolically violent and chaotic when they play with toys, while, in an adjacent room, Lotso and his followers are played with by older children who are gentle and friendly. The juxtaposition is reminiscent of that between Andy and Sid in the first film, and it reinforces anxieties about the wear and tear of the toy bodies, which are even more

Figure 10. *Toy Story 3* (Unkrich 2010). The cute girl becomes monstrous through the toy point of view. Disney-Pixar, 2010. DVD.

disposable at a daycare, where children do not possess the toys but share them.

Throughout *Toy Story 3* there are gags about the toys' bodies that could be analyzed in a similar fashion to moments from the first two films I have already discussed, but *Toy Story 3* also amplifies the analogy between toys and parents and emphasizes an uncanny uncertainty about the goodwill of children. The film features many more child bodies than the other films—marking advances in animating soft and fleshy figures—and this leads to depictions of children as cute little monsters torturing the toys. A virtual camera placed over Buzz Lightyear's shoulder, for example, enables viewers to share the toy's point of view and read Buzz's profile as expressing trepidation (Figure 10). The shadow and pronounced teeth on the young girl enhance her shift from cute to threatening. The full commitment to the toy point of view generates an opportunity for audiences to contemplate their own distrust of cuteness and fetishized relationships.

In her analysis of cute as a category of aesthetic experience prevalent in late capitalism, Sianne Ngai discusses the dual aspect of cute

experience, which includes the appealing lure of small, soft, round, amorphous, vulnerable creatures and then the fear this lure elicits when it is perceived as a means of manipulation and even predation. Following Marx and Adorno, Ngai affirms that the fetishization and personification of commodities is a process that seeks to reclaim some part of the object intimacy and relationality that becomes alienated and obscured through mass production and abstraction. Cute objects, such as toys, can be understood as accommodating this effort, but cuteness often raises doubt about sincere intimacy and relationality. Ngai notes that a form of violent frustration can be inferred from the durability of cute toys designed to be squished and squeezed, and cute experience can be described in terms that invert sublime experience: "The subject confronting the cute object thus experiences a sense of both mastery and surrender."[57] The initial feeling of dominance over the cute thing that melts into subordination can turn to resentment as the subject feels coerced by the object to care for it. Ngai aptly compares this to the feelings we often have about commodities that seem to manipulate our emotions, and this aspect of commodity-life is alluded to in the numerous torture sequences in the *Toy Story* films.

Such sequences, especially in *Toy Story 3*, remind us that the abstraction of commodity culture (value determined primarily by the exchange of unrelated things) destabilizes our ability to judge relationships. While Ngai discusses the cute's powerful powerlessness with respect to avant-garde poetry, she also observes that representations of cute faces are subject to their own kind of uncanny valley. They must be mimetic enough to return the human gaze but not so mimetic as to appear as equals to human observers.[58] In *Toy Story 3* our point of view becomes small, and the desirous gaze of children looms larger than ever. This perspective fulfills the disorientation of commodity culture and unleashes the uncanny instability latent within the countenance of cute commodities. As the distinction between the gaze of the thing and the gaze of the human disappears, the cute visage of a child is no longer a guarantee of affection (as for toys so, too, for adults). When cuteness

becomes this unstable, it indicates the loss of recognizable forms of dominance and subordination. And when there is no stable perspective among persons, things, and commodities, external laws are needed to maintain basic levels of order. The joke in the film is that Lotso's regime is disregarding the standards of age-appropriate play, and toy self-government transgresses the authority of commercial design and regulation. This joke proposes that the rules used to regulate consumption (e.g., "For ages 3 and up") ought to extend to relationships more generally.

The final film of the trilogy features climactic brushes with disposal and death for the toys, which elevates the tension between disposable commodities and relational characters and culminates in a happy ending, with the digital characters being preserved for future appearances. This narrative contributes to the perpetuation of the intimate, familial commodity form that has its roots in the early and mid-twentieth century. But the most interesting aspect of *Toy Story 3* is the explicit effort to relate the premises of the trilogy to political order. While the narratives dutifully affirm their premises in order to secure a happy ending and thorough resolution, the audience gets to enjoy watching the toys discover and explore the limits of their bodies, personalities, and various social and political organizations. Throughout the trilogy toys and humans misperceive and misjudge their world and its natural order. But through these uncanny aesthetic experiences the toys develop a keener awareness of that order, which retains a humanistic and commercial hierarchy. These stories are historically significant given their circulation in the midst of a digital and posthuman context in which norms and assumptions about nature, technology, and humans are being interrogated. Despite the attention given to the physical integrity of objects, the product essentialism at the core of the trilogy bolsters commercial authority and a reciprocal fetishism that more closely ties the consumer imagination to the abstract vitality and power of a brand. This idea is present in the animation production and in the narratives that feature characters reconfiguring their knowledge of self and world. Such

depictions express processes of becoming, of transformation, but they are also uncanny depictions that suggest the failure of epistemological mastery. It is not the case that product essentialism and commercial authority are natural laws. They are cultural logics employed to give order to an abstract world without laws.

From the Technological to the Postmodern Sublime *(Monsters, Inc.)*

Whereas the *Toy Story* trilogy presents epistemological vulnerability through portrayals of the uncanny, *Monsters, Inc.* presents a comparable instability through the category of the sublime. As Scott Bukatman observes, "The sublime and the uncanny are closely related: both stage a confrontation with the limits of human power and agency, and both are heavily freighted with the weight of the unknown."[1] One area in which they differ is that the uncanny refers to perceptual confusion frequently produced by automata, by mechanical creations of life that tend to be smallish, whereas the sublime is aligned with the gigantic and excessive. Monsters Incorporated is portrayed as sublime through a vast industrial landscape illuminated by sunlight (Figure 11). Bukatman notes that both phenomena are associated with the technological spectacle that was a major draw of early cinema and was in some respects relegated to the domain of animated film.[2] And Bukatman insightfully recalls numerous literary and film examples in which the uncanny becomes sublime in the sense that creation rebels against its creator and becomes an overwhelming, monstrous force—such as Frankenstein's monster.[3] The notion that the uncanny, with its misperception and eerie undecidability, is one step removed from terror supposes that perception and judgment are integral to a subject's sense of security

Figure 11. *Monsters, Inc.* (Docter, Silverman, and Unkrich 2001). The sunlit Monsters Incorporated industrial park evokes the sublime. Disney-Pixar, 2013. DVD.

and self-assurance. Unlike the uncanny, the sublime typically entails a double move in which a person endures that which is overwhelming and, in turn, gains insight into her sense of self.

This basic formulation is primarily derived from Kant's "Analytic of the Sublime" in his *Critique of Judgment.* The sublime has a much longer, diverse history, however, which includes Longinus's *On the Sublime* from the first century AD. Kant's "Analytic" is more in conversation with Edmund Burke's *A Philosophical Enquiry into the Origin of Our Ideas of the Sublime and Beautiful* (1756). These texts by Kant and Burke mark the rise of interest in the sublime during the eighteenth century before and then during the romantic period, and they capture several of the major tensions that arise in discussions of the concept more broadly. These include oppositions between representation and experience and between the experience of the beautiful and the experience of the sublime. Longinus's text is concerned primarily with rhetorical devices, a sublime style so to speak, but by the time the concept is taken up in the eighteenth century, the sublime refers to profound, overwhelming, or terrifying

experiences that may or may not be representable through language and art.[4] Subsequently, the propensity for abstract experience to challenge representation regains relevance in postmodern theories of the sublime articulated during the late twentieth century.[5]

The opposition between the beautiful and the sublime, however, involves considering the negative feelings of pain and terror instead of restricting aesthetics to pleasant experience. It also involves theories about the social function of these different aesthetic experiences. For instance, sublime experience, for Burke, reveals the human condition as one in which the submission to authority is natural. This means that an overwhelming, frightful experience can be indicative of a divine creator's arrangement of the human body and spirit. It also suggests that subordination within society is a necessary counter to the more compliant sociality embodied in experiences of the beautiful.[6] The French Revolution ultimately changed Burke's mind about the sublime since it relied on the fervor generated through the grand spectacle of revolution to disrupt social hierarchy and authority.[7] This mode of social commentary concerned with aesthetics continues through contemporary efforts to describe economic, technological, and cultural contexts using alternative aesthetic categories, but it also persists in descriptions of the overwhelming force and spectacle of information and media as sublime.[8]

As Bukatman notes, cinema has been at the center of studies of modern spectacles. This has been attributed to the expanse of visual media during the eighteenth and nineteenth centuries and theories explaining how this expanse indicates an effort to cope with modernity through forms of "scopic mastery."[9] Bukatman has this context in mind when he relates contemporary effects-driven films to the presentational mode described by Tom Gunning as astonishment or a cinema of attractions. The prevalence of large screens, conspicuous technological innovations, and entertaining illusions continue the tradition of presenting and experiencing moving image media as a spectacular attraction rather than a primarily narrative medium.[10] But the idea of cinematic

spectacle perpetuates the sublime tension between experience and representation. A feature film can be a sublime spectacle that elicits terror or awe in audiences, but it can also represent some sublime experience in a tame form (e.g., a character-oriented, framed view of the pyramids in Egypt). Finally, it can remind us that these need not be separate and distinct media forms.

The imagery of *Monsters, Inc.* is not scary by any means, but it celebrates a vast, industrial scale that evokes a predigital technological sublime while its narrative and characters emphasize the intensity of interpersonal bonds.[11] *Monsters, Inc.* has been read by geographers as an allegory about peak oil and about children's independent mobility; it has been read by queer theorists as an allegory about the energy of bodily contact.[12] Reading the film in terms of sublime experience, in contrast, enables commentary on both agency and structure. It illuminates the relationship between persons who are vulnerable to change and systems of technology, economics, and culture that are markedly more resistant to change. This reading has the capacity to address both environmental exploitation and the power of interpersonal intimacy, which is significant if we want to think about how the two are related. With this in mind I investigate in this chapter how *Monsters, Inc.*'s address of aesthetic experience facilitates the expression of historical transitions in the formulation of the sublime. This includes a technological sublime that bolsters an integrated ego apart from nature and a postmodern sublime that at once promises radical possibility and perpetual vulnerability to power and ideology.

MONSTERS VS. HUMANS: "OUR OWN FEARS ARE AFRAID OF US!"

Monsters, Inc. depicts a world of monsters parallel to our human world and presents a comparable technological, industrialized, monster society. The monsters, however, present characters with incredibly diverse morphologies. No two monsters look that much alike, yet all

are monsters. The premise of the film provides an explanation for why monsters hide in bedroom closets and emerge at night to scare sleeping children. According to the film's tagline, "What [children] don't realize is that for these monsters, it's nothing personal. It's just their job." The job requires that monsters enter the human world through closet doors, scare children, and harness their screams to provide the city of Monstropolis with energy. In turn the monsters are terrified of human children, whom they believe to be toxic—"Our own fears are afraid of us!" the director Pete Docter quips, describing the film's central irony.[13] Docter's comment and the tagline suggest that *Monsters, Inc.* is about the fear and energy produced through contact with the other but also that it is about the narratives created to rationalize and control the forces of that contact. It is about how we cope with our fears by watching our fears cope with us.

The action of the film revolves around the monsters' ignorance about children and how their belief that children are toxic facilitates their exploitation of children. The doors that connect the human and monster worlds are regulated by the company Monsters Incorporated, which is overseen by the Child Detection Agency, whose job is to contain any child material that passes through a door before it spreads its contagion like a virus. When a child finally sneaks into the monster world, chaos and terror ensue. The invader, a two-year-old girl, immediately bonds with Sulley, the monster responsible for letting her in. In this scenario, what was "just their job" becomes personal. The story, after this event, is driven by the main characters, Sulley and Mike, as they overcome their fears of children and develop feelings of affection and attachment toward the cartoonish and lovable child that Sulley names "Boo," an onomatopoeic name signifying the child as the object of monster fear. In the process of returning Boo to the human world, Sulley and Mike discover that their deceptive coworker Randall Boggs and the CEO of Monsters Incorporated, Henry J. Waternoose, are developing an even more violent means of extracting energy from children. After exposing this villainous plot, Sulley and Mike reform

Monsters Incorporated, utilizing their discovery that a child's laugh is ten times more powerful than a child's scream. The monsters' new job is to sneak into children's bedrooms to make them laugh.

This narrative, in addition to its treatment of labor and exploitation, alludes to angst about globalization, network technologies, and connectivity through the closet doors and diverse monster bodies. The door system provides a visual metaphor for the instantaneous contact with disparate places that globally networked media provide. This renders strangers close even when far away and renders them capable of impinging upon and influencing local culture through media and economics, as well as migration. In contrast, *Monsters, Inc.*'s fictional monster world serves as a hyperbolic representation of a multicultural fantasy in which a diversity of bodies with various skin colors, furs, horns, and various sizes and shapes form a community through social ties, not birth. The diverse morphologies of the monsters suggest a utopia without racialization—a place where physical appearances are not overwritten by discriminatory practices. This globally inclusive utopia is then contrasted with the overt othering of the human world, which is held in parallel to the monster world through a technological infrastructure.

Reading *Monsters, Inc.* allegorically about networks and contact with others relates to debates about regulations over the peer-to-peer infrastructure of the Internet, an infrastructure that contributes to global connectivity and online community. In the film the door system is controlled by the monsters through corporate management, the Child Detection Agency (CDA), and the cultural myth about child toxicity. Despite this effort to regulate and control the system through policy, protocol, and ideology, the infrastructure of the door system enables contact that is inherently unpredictable given that it facilitates interactions between autonomous agents. This echoes the claims of media theorists who believe that corporations and states do not have the capacity to control communication and media networks across vast regions and diverse communities given the easy, individuated innovation offered by digital technologies and networked infrastructures.[14]

Nonetheless, one important element that disrupts this allegorical reading is that the contact between monsters and humans mediated by the door system is face-to-face, embodied contact, which distinguishes it from the mediated contact, the partial detachment from spatial location, offered by today's communication technologies.

In the most recent phase of globalization brought about by information machines, global networks, and the spread of capitalism, less embodied contact can be beneficial for global business. Many exploitative practices are maintained by ignorance and distance. Elizabeth Freeman acknowledges this in her prescient reading of *Monsters, Inc.* as an allegory about higher education besieged by neoliberal business practices (it is prescient because in 2013 Pixar released a prequel, *Monsters University*). Freeman argues that the drive for efficiency and profitability, in combination with the co-option of humanist values by market logics, dissolves the relational impact of face-to-face, corporeal pedagogy. Freeman reads the child character, Boo, as particularly libidinal and therein capable of freeing the monsters from their fear of the other. In short, Freeman's reading illuminates the film's presentation of market logics invading humanist values but not without humanist values also undermining market logics. Comedy may become the new mode of resource exploitation, but Sulley's intimate, embodied relationship with Boo disrupts the dominance of the company in his life. The physical contact and exchange of affects that takes place exceeds and disrupts the monster ideology and protocols outlined by the corporation and the state.

Freeman's reading is not entirely supported by the film's conclusion, however. At the film's end, even though child laughter has replaced child screams, not much has changed.[15] From this point of view *Monsters, Inc.* is about cultural and material reproduction, and it presents corporate power as natural and suggests that the "weak have what the strong [corporations] need." This leads to the "child is oil" metaphor and the naturalization of the exploitation of others, whether through instruments of fear or pleasure.[16] Consistent with Pixar's other productions, and many

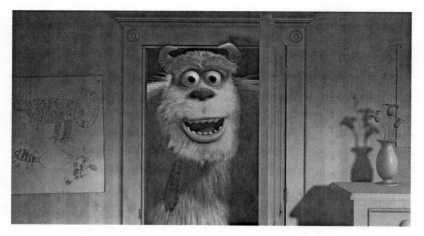

Figure 12. *Monsters, Inc.* (Docter, Silverman, and Unkrich 2001). Sulley's large cartoon body challenges the containment of Boo's room and alludes to the tradition of cartoons defying their built environments. Disney-Pixar, 2013. DVD.

children's films, this conclusion works to maintain a status quo system of exploitation and simultaneously maintains the radical alternative capable of disrupting those conditions—in this case, the relationship between Boo and Sulley.

The film's ending does not actually resolve the tensions that the narrative creates. Doing so would entail depicting the overthrow of the means of production, which is a violent prospect and probably explains why producers opted for a prequel instead of a sequel. During *Monsters, Inc.*'s denouement, after Boo returns to her world, her door is shredded to prevent any future access to her bedroom. Then, in the final sequence, Mike reveals to Sulley that he secretly rebuilt Boo's door by reassembling the shredded pieces, and Sulley is then able to use the door to see Boo again (Figure 12). The last shot of the film is of Sulley's face as he enters Boo's room and we hear Boo joyfully exclaim "Kitty!"—the name she had given Sulley. This final image of Sulley's gaze marks his response to Boo's interpellation of him, and Mike's

rebuilding of the door indicates his own resistance to corporate proto-
col, as well. It is significant that the film ends with Sulley and Boo being
secretly reunited while the shift to extracting laughter establishes a
more modern form of exploitation through entertainment—the idea
that pleasure is more effective than pain as a disciplinary tool. This
resolution presents both radical change and the preservation of tradi-
tion and social order. The system of power that emerges at the end of
the film has eliminated the displeasure of the previous practices but not
the inequality between monsters and children, and the affective atten-
tion of the children remains a metaphor for energy resources.

The final scene of Sulley emerging through Boo's door emphasizes
how Pixar has continued the animation tradition of cartoon bodies
emerging from impossible places and containers—for example, Max
Fleischer's Out of the Inkwell series. Once again, the cartoon body's
plasmatic nature enables it to squeeze in and out of confined spaces as
Sulley's bulk is too large for the doorway and requires some squeezing
for him to cross the threshold. Furthermore, the child's drawing on the
wall next to Sulley's face suggests comparing the cartoon body's limit-
lessness to the primordial nature of the line and figural representation.
While the child's drawing shares an orange hue with the flowers across
the door frame, the rough sketches contrast with the linear patterns of
the wallpaper and the symmetry of the vase and doorway. The carica-
tured quality of the cartoon body challenges the containment enforced
by the built environment, and it harks back to the child's raw, untrained
creativity that likewise challenges the impending cultural constraints
of development and socialization.

The limitless potential of the cartoon body resonates with the libidi-
nal force that appeals to Freeman, but this body and force exist in ten-
sion with the built environment and the practices that perpetuate dis-
tance and exploitation. Furthermore, the monsters are less beholden to
recognizable morphologies than the child characters. We have fewer
criteria with which to judge their bodies in terms of aesthetic judgment.
But Docter's comment that "our own fears are afraid of us" indicates a

fundamental commonality between the humans and monsters. The reversed point of view generates ambiguity about where the infinite possibility of animation resides—is it with the monsters or with the children or both? As Sulley's gaze addresses the audience in the final shot, we are prompted to analyze the film's point of view, which seems to depart from the toy/parent point of view in the *Toy Story* films. From a monster's point of view the children are a dangerous environmental resource. But from the child's point of view the monster is a frightening threat from an unknown realm. As the points of view elide over the course of the film, a more prominent divide emerges between the technological sublime and the sublime subject/object.

THE TECHNOLOGICAL AND DIGITAL SUBLIME: CONTINUITY AND FRAMING

Conventional histories of the sublime have emphasized the concept's usefulness in combating predominant modes of thinking; for example, the romantics deployed it against forms of rationalism, and postmodernists deployed it against modern positivism.[17] In the United States, however, the technological sublime often refers to rhetoric that romanticizes large industrial constructions as part of a progressive discourse. And such rhetoric has frequently sought to generate public support for projects designed to promote private companies in the form of structural advertisements and symbols of power.[18] This latter form indicates an amplification of the ego-affirming potential of the sublime, at least in its Kantian formulation. With respect to ongoing theoretical and philosophical debates in aesthetics, *Monsters, Inc.* expresses a reluctance to choose between a Kantian sublime that emphasizes the integrity of the subject and the superiority of reason or technological progress, and a postmodern sublime that emphasizes the disruption caused by sensation and unknowability. In the former, Kantian mode the film presents grand views of the monster factory, and in the latter, postmodern mode

it depicts the psychological and sensorial drama of contact with unknown others.

In *Monsters, Inc.* children serve collectively as a metaphor of the natural environment in their capacity as an energy resource, and they allude to the sublime through their presence as objects of fear. The threatening toxicity of children supports the monsters' rationalization of scaring children to extract energy. The threatening environment calls on the monsters to become threatening themselves, not just to survive but to thrive and build an advanced industrial society. Docter's summation of the film's core theme, however, with its first-person plural pronouns, treats the entire fiction as a rationalization for the presence of fear in the lives of children. The story about monsters is simply a reversed point of view that performs the empathetic task of imagining the perspective of the Other. But this is not a case of interpersonal empathy. It has more in common with a parent telling a child frightened by a spider that the spider was more terrified of her. Likewise, the film's narrative negotiates the domain of difference between monsters and children. It seeks to incorporate and rationalize otherness. The film literally features two distinct worlds becoming one world for the leading characters—the monsters Sulley and Mike and the child Boo. The technological infrastructure of the door system facilitates this process and the sublime encounters between monsters and children.

This resolution of otherness by way of a point-of-view reversal is an instance of anthropomorphism that resembles traditional Kantian formulations of sublime experience in the sense that it reckons with the terror of an encounter with nature and contributes to ego and identity formation. This approaches the basic formulation of the sublime in which a person is utterly overwhelmed by some large or powerful phenomenon—possibly a storm or a mountain—but then the person's reasoning is ennobled by the experience. It meets the challenge, so to speak, and the person gains insight into her sense of self through the discord of the experience. Kant considers two types of sublime in his

Critique of Judgment: the mathematical sublime refers to experiences in which perception is overwhelmed by the view of some immense thing, while the dynamical sublime refers to the fear raised during an encounter with nature's might: "nature can count as a might, and so as dynamically sublime, for aesthetic judgment only insofar as we consider it as an object of fear."[19] For Kant, sublime experiences are those in which nature overwhelms the mental faculties of imagination and perception, but the mind responds by relying on the faculty of reason to comprehend the unimaginable and unperceivable experience.

The experience of fear in the presence of the natural environment has served humanism and the discourse of progress particularly well. This is because in its Kantian formulation the experience of the sublime at once reminds humans of their vulnerability and affirms their strength in respect to the faculty of reason. Many postmodern readers of Kant have criticized this formulation for emphasizing the subject's ability to overcome the overwhelming aesthetic experience of nature and to judge oneself independent of, if not superior to, one's environment.[20] The technological sublime only exacerbates this assumption by replacing nature with the second nature of technology. This enables a person to become doubly impressed with human reason, and it fosters further detachment from the natural environment. It is not too difficult to extend this critique to a variety of cultural habits in which otherness is treated as an occasion for self-serving affirmation—whether sexist, racist, or ableist.

The disruption of perceptual norms that occurs in Kant's formulation of the sublime could suggest a common bond between animated films and the sublime, but animated film's capacity to interrogate nature, as in Leslie's "dramatization of a skirmish with nature," suggests that an animated sublime is more properly understood as an interrogation of sublime experience.[21] *Monsters, Inc.*, for instance, contributes to a mode of representing the unseen elements of the technological environment. This includes enlarging and opening small, invisible, and black-boxed technologies and rendering them as entire worlds in which characters can disrupt the standard operations of those technologies

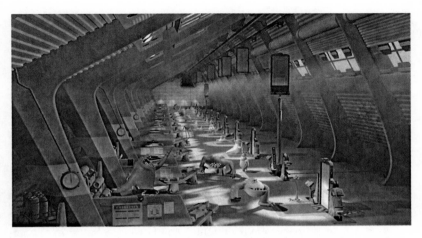

Figure 13. *Monsters, Inc.* (Docter, Silverman, and Unkrich 2001). The scare floor evokes the sublime again through scale and lighting. Disney-Pixar, 2013. DVD.

through their own agency. In *Monsters, Inc.* the heroes effectively hack the door system and reveal its hidden structures. Visual representations of cyberspace or electronic networks have taken various forms in a variety of recent animated and effects-driven films such as *The Matrix* (1999), *Tron* (2010), and *Wreck-It Ralph* (2012). These films, like *Monsters, Inc.*, depict small spaces as large (wires and cables become tunnels), or they portray bodies as immaterial (characters have electronic, digital bodies). These depictions attempt to offer a sublime correlative to the relatively small technical devices that we interact with every day. But this representational mode remains a framed, contained version of the sublime without expressing much threatening force.

The sublime visuals in *Monsters, Inc.* feature a built environment, not a natural one. This built environment, the factory containing the door system, encloses the monster characters in a seemingly infinite network that connects to the human world. This sublime, technological infrastructure mediates monster interactions with humans. Rendered in three-dimensional computer animation, the scare floor in the factory resembles an airplane hangar in terms of scale and shape (Figure 13),

but the door system is by far the most sublime element in the film. The space storing the doors resembles the vast circuitry that large network servers contain, but the scale is much larger, and the structures appear to be made of concrete. Critical to this sequence is that the storage space for the doors renders the characters incredibly small in comparison. The space houses an endless network hidden within the factory walls that at once diminishes the protagonists but then enhances their courage and agency as they intrepidly jump in and out of doors and ride them as they speed along convoluted tracks.

The sublimity of the technological environment in *Monsters, Inc.* can be understood as a means of orienting audiences within their own complex, technoconsumerist environment. Leon Gurevitch's notion of computer animation's "aesthetic of continuity" is pertinent here. Gurevitch observes that even in more naturalistic productions such as *A Bug's Life*, "the teeming masses of animated objects betray a certain industrial and mass-produced nature."[22] Animated film has frequently tried to mask its industrial underside, but as Gurevitch points out, the three-dimensional worlds generated through computer animation are so detailed and impossibly continuous that they betray their own complex industrial automaticity regardless of the naturalism employed to mask it. This aesthetic of continuity (again, not continuity editing but the continuity of detailed digital design) leads to complex industrial settings prominently featured in many animated film narratives, and in Pixar's oeuvre this includes a chase sequence on luggage conveyors at an airport in *Toy Story 2* in addition to the door system in *Monsters, Inc.* Gurevitch notes that there are also numerous scenes of big-box retail stores that occur in computer animation features across studios. This mise-en-scène is conducive to the industrial aesthetic and consumerist ethos of the studios and their products.[23] Interestingly enough, these automated industrial processes and places are frequently depicted as adversarial in the films, which, Gurevitch argues, distracts from the animated film's positioning of the viewer within an "industrially fabricated roller-coaster ride" that reinforces a consumerist logic and worldview.[24]

It seems obvious enough that Pixar's features are designed products that build on the practices of industrial design and advertising, and therein they provide a kind of consumer training for audiences. But the subtle point related to *Monsters, Inc.* is that the film betrays a desire to make visible the common technological environment that drives both consumption and production, and this visualization process relies on antiquated, industrial imagery. The rehearsal of the narrative of the individual surmounting the adversarial forces of the system registers the desire of the consumer or producer to exercise agency through or over the system whether by way of hacking or mastery. This popular narrative presents the built environment and the technocultural system it facilitates as weaker than individual agency. This notion is visually reinforced by the animated characters—as in Sulley's bulky, uncontainable body and Boo's small, surreptitious body. The animated characters simply cannot be contained, and as they explore more and more of the door system, they increasingly challenge its normal operations.

The door system's familiar industrial design mitigates the challenge of representing capitalism's digitally supported networks, and this correlates with an effort to simultaneously express the complex machinations of digital animation production. Computer animation's combination of hand-drawing, automaticity, and mechanical reproducibility is not only well-suited for making moving image products; it also continues the cinematic tradition of making the invisible visible or representing that which is unrepresentable. Quite often animation techniques come into play when the desired moving image presentation cannot be recorded.[25] Such is the case when representing the many invisible, microscopic, and technical aspects of digital media. Animated film becomes a critical means of representing the digital environment that mediates our lives yet remains largely unseen. *Monsters, Inc.* demonstrates how the impossibly complex continuity of digital animation lends itself to taming the sublimity of digital systems. As has been the case with various forms of the sublime, adding a frame enables further contemplation of the phenomenon.

The aesthetic of continuity of digital animation does not necessarily expose the inner workings of black-boxed technology, but it does present complexity more generally through its impossible continuity. The animation presents an immense amount of data in an apprehensible form. The visualization of data flows through computer animation betrays a desire to glimpse the complex digital systems through which power is wielded.[26] An animated presentation, such as that in *Monsters, Inc.*, renders complex, systemic power more palatable and manageable from the point of view of the little guy. As with the reversed point-of-view narrative in *Monsters, Inc.* that mitigates the fear of the other, this aesthetic of continuity, as a kind of technological sublime, neutralizes the alien menace of the system. The animation provides a frame for contemplating digital media at the overwhelming system level. Furthermore, in cinema studies the concept of the frame has been theorized as a force containing the moving image and limiting its potentially sublime effects. For Anne Friedberg the cinematic frame unifies perspective and spatiality even more so than narrative: "It is the consistency of the frame that performs the unity of space, not narrative," and "the frame of the screen serves as the boundary demarcation between the screen world and the material world of the spectator."[27] This line of reasoning leads Friedberg to compare the graphical user interface (GUI) of computers to CGI in films more generally. And although CGI is an expression of digital information, it is, like the GUI, a semiotic layer between human users/audiences that reduces and limits human interaction with digital information, processes, and applications.[28]

Gurevitch's notion of an aesthetic of continuity emphasizes the function of framing and representation to perpetuate technocapitalist habits of thought and perception, but this overlooks the point made by the inadequacy of such representational efforts: that it is actually very difficult to represent the conditions of a technocapitalist environment—hence *Monsters, Inc.*'s industrial look and its metaphorical treatment of globalization and networks. This distinction acknowledges that the delimiting functions of frames and screens vary depending on the

broader discourse or logic to which they belong. For instance, this discussion of frames and framing echoes Martin Heidegger's concept of Gestell, or enframing, which addresses how technological thinking constructs instrumentalist ideas about the natural environment.[29] The door system, in addition to being a material structure that advocates for its persistence through its own functional existence, is also part of a technoideological ensemble that includes a history of social practices. The monsters embedded in this history understand children through that lens. The intervention of the child Boo disrupts this material, historical enframing for the monsters Sulley and Mike. She challenges how they think about children and forces them to develop another mode of framing children.

In a more aesthetic articulation framing facilitates the contemplation of sense experience by crystallizing and objectifying it in a limited, distorted form—for example, space and color in a landscape painting or space and time in a cinematic long take. In this way *Monsters, Inc.* enables the contemplation of a technocapitalist environment and its resistance to representation, even though the film is a direct manifestation of commercial interests and practices. With this in mind it is noteworthy that the door system presents a third conception of frame through its very doors. The monsters and the children are presented as dynamic characters that change over time, but the door system is a more permanent force that organizes space and interpersonal contact. The door frames are delimiting elements in themselves, structuring space and movement, and the systemic network of doors as a whole is depicted as sublime. The transition to laughter extraction at the end of the film suggests that the materiality of the system is not likely to change. Not only does the exploitative relationship between monsters and children remain, but the doors and factory continue to function as before.

Comparable to the toys in the *Toy Story* films, the materiality of the system constitutes a different temporality from that of the monsters and children. Although presumably built by the monsters, this technological infrastructure exercises its agency through its enduring

material existence. The door is an example of a technical mediator in the sense that the activity of structuring space is delegated to it. In this way it restricts and opens up possibilities to those acting in association with it.[30] In contrast to an allegory about Heideggerian enframing or technological thinking, the door system in *Monsters, Inc.* amounts to a cautionary tale about material structures operating in conjunction with economic and social structures that are "built to last." This delegation to automated processes and habitual practices suppresses, or at least restricts, aesthetics and politics, or the fundamental possibility of the new. This point resonates with discussions surrounding the deterioration of structures and practices from industrial modernity. While lightness and speed continue to displace heaviness and permanence and cheapen time and space, this transition becomes an opportunity to debate and critically analyze the liquid infrastructures and habits that have gained prominence.[31]

In short, *Monsters, Inc.* presents digital complexity in a reduced, nostalgic form, which renders it available for contemplation. More particularly, the presentation makes available for contemplation the agential capacities and interactions of both the characters and the environment. The technological infrastructure facilitates a space of contact that is conducive to both the reproduction of exploitative practices and the disruption and reconfiguration of social practice. The distinction of the doors from screens is most significant in this regard. Their capacity to eliminate distance alludes to the compression of space-time during the electronic and digital eras, but the embodied contact and transgression of geopolitical boundaries facilitated by material doors designates a qualitative difference from social media and its predecessors. Thus, in addition to expressing the desire to make visible the complexity of digital media environments, the film also expresses the desire to eliminate that complexity via embodied contact. This desire seeks to overturn the technological sublime maintaining a given status quo by locating a postmodern sublime that does not affirm technological progress or individualism.

THE POSTMODERN SUBLIME: INTERPERSONAL, UNKNOWABLE, AND UNFINALIZABLE

Perhaps the most obvious allusion to a postmodern cliché in *Monsters, Inc.* involves the role of television. As in *Toy Story,* television is depicted as a demystifying, corrupting medium. Sulley and Mike, for example, watch a television advertisement for Monsters Incorporated that attributes children's increased tolerance for scary things to the violent and horrific programming they watch on television. The numbing effects of television disrupt the human-monster system by diminishing the threat of monsters. Because they have seen numerous monsters on television, children are not afraid of real monsters, and by no longer recognizing the monstrosity of the monsters, children are effectively threatening the existence of the monsters. The monsters' job is becoming even more dangerous as children are becoming more difficult to scare. The desensitization of children has caused a scream shortage, and it threatens monster identity. The monsters' exploitative relation to their environment has become constitutive of their identity. If they can no longer act effectively on that environment through scaring, then they lose their sense of self and the sense of superiority it relies on.

It is significant that it is television that has thrown a wrench into the system by derealizing the monster threat to children. Within the film, television marks an earlier expansion of electronic media into domestic and public spaces that serves as a bridge between older electronic media and the new media of computer animation. Television is also associated with postmodern aestheticization or the growing cases in which media refer only to other media and audiences are entertained by the indiscernibility and convergences among platforms. Examples of this occur throughout Pixar's oeuvre and include the wallpaper sky at the beginning of *Toy Story* (it appears indistinguishable from a cartoon sky), the Buzz Lightyear video game at the beginning of *Toy Story 2*, and the staged bedrooms and video monitors in *Monsters, Inc.* For children in *Monsters, Inc.* the monster as a unique, real manifestation has lost its

aura now that monsters appear on their screens whenever they want to see them. On the one hand, children are losing their belief in monsters and are left with representations of monsters only. On the other hand, monsters are suffering from a transition to a postmodern context in which they no longer can rely on the technological sublime formulation that supported their terrorism of children.

This point about the desensitizing force of media gestures toward a larger point about the technological sublime and its self-defeating logic. In short, the technological sublime, by being technological, becomes too safe and familiar to maintain its sublime function. When media environments become second nature, their aesthetics shift toward the experience of the beautiful rather than the sublime. Sean Keller, for example, proposes that the algorithmic structure of design software tends to pursue a form of intuitive usability akin to the beautiful: "the use of algorithms in the design process produces a new solution to the dilemma presented by Kant's demand that a beautiful form stimulate a search for a determining concept, but without ever allowing itself to be captured by that concept. With computational design, the concept determining the form is concealed—literally encoded—so that, standing before one of these forms, we are left in precisely that searching state described by Kant as the experience of beauty."[32] Keller's reasoning illuminates how the database ontology of computers and software is made familiar and less overwhelming. This process retains a Kantian subject as long as the human subject intuits a pleasing but undisclosed accordance between software functionality and his or her own thinking. The digital technological sublime is effectively circumvented when the only perceived contact is through the culturally approved graphical user interface (GUI). Through this comfortable, illusory interface the sublime not only becomes manageable and safe; it becomes beautiful and natural.

The standardization of screens and frames, and other black-boxing components, emphasizes a naturalized, technological beauty as opposed to the sublime. This beautification occupies a central place in the work

of Jean-François Lyotard, and it influences his rethinking of the sublime for a postmodern context. Lyotard, for instance, describes the paintings of Jacques Monory as parodying the beautification of the sublime typical of postmodernity: "It is only through *too much beauty* that [Monory] attracts attention to the essential fact of post-modernity, the incorporation of the sublime into the beautiful, the synthesis of the infinite and the finite in the figure of experimentation."[33] This experimentation refers to the postmodern condition, where ideals and sensory experience have diminished as technology, science, and capitalism render everyday life more abstract, instantaneous, and less reliant on the human faculties of memory and sensation. The feelings of accord and purpose associated with beauty lend themselves to a culture of expertise void of the transcendental associations of Kantian aesthetics. Gaining expertise entails a fundamental comfort with and confidence in the given world and the tools that define it, which contributes to maintaining the logics of that world.

The science and technology used to map, scan, measure, and reproduce the world are sublime in their own infinite capacity and rationality, but this technological sublime is not transcendental in the Kantian sense. It is an immanent sublime and subsumable by the beautiful. Without transcendental Ideas—God, the Good, Freedom, and so forth—and when heavily dependent on machines for information about the world, the subject does not experience the sublime or the beautiful as they were formerly conceived, but only the rationality of the technoscientific, capitalist, abstract machinery. Lyotard writes, "The experimentation resulting from capitalist techno-science leaves no place for the *aura* of memories and hopes."[34] In these apparatuses the infinite is deposited within finite, axiomatic, operational arrangements. Without sensing the infinite, technical experience is derealized, and this contributes to the nihilism of contemporary life in that it devalues sensory experience. Lyotard criticizes semiotics and representations in general for contributing to postmodern nihilism. As with the GUI already mentioned, Lyotard is sensitive to media practices that seemingly narrow cultural

knowledge to a series of technical skills that, unbeknownst to a user, contribute to the collective maintenance of the larger media culture and technoeconomic system.

In relation to Lyotard's critical comments about the beautification of the sublime, *Monsters, Inc.*'s use of industrial imagery supports the idea that the sublime's association with transcendental experience has been relegated to the past. We see sunlight, for instance, beaming through a glass ceiling and illuminating the massive concrete structure housing the door system (Figure 14). The sunlight gives a transcendental connotation to the scene, which, as a scene expressing the difficulty of representing digital complexity, also expresses the difficulty of maintaining the technological sublime's transcendental associations. The scene is nostalgic in the sense that it presents the hope of industrial progress as otherworldly or simply irretrievable. To alleviate such instances of postmodern nihilism, Lyotard advocates finding new ways of activating the sensible, and this involves a revised formulation of the sublime. Ashley Woodward concisely glosses this reformulation: "while Kant seeks to show that the feeling of the sublime testifies to the power of Reason and the moral law through the experience of the superiority of Reason over imagination (the faculty of the presentation of sensations), Lyotard insists on the irresolvable 'differend' between the two faculties. For him, the feeling of the sublime is the experience of incommensurability itself. Such a feeling breaks with the ideal of consensus because it is an experience of *dissensus*."[35] For Lyotard the sublime is an aesthetic feeling that validates sensory experience without the Kantian overtures of transcendence or commensurability—that is, the *sensus communis*. Rather than interpreting the experience as reason's domination of that feeling, Lyotard claims that the feeling marks the triumph of the sensible over reason; the agitation of sublime experience promotes the health and vitality of the subject.

The child character Boo in *Monsters, Inc.* approaches a more postmodern, aesthetic sublime that at once supports but also challenges Lyotard's reformulation. This revised formulation of the sublime,

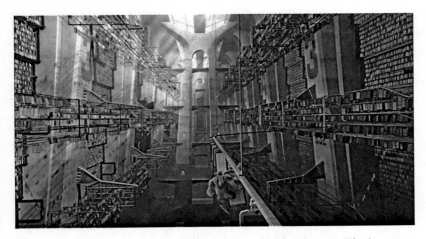

Figure 14. *Monsters, Inc.* (Docter, Silverman, and Unkrich 2001). The immense door system, illuminated by beams of light once again, presents an overwhelming number of doors that threatens the agency of the protagonists. Disney-Pixar, 2013. DVD.

which we find in Lyotard's essay "Anima Minima," for instance, approaches the role of Boo in *Monsters, Inc.* "Anima Minima" presents a theory of the subject produced through aesthesis or the sensation of contact with an outside world: "sensation is also the affection that 'the subject'—one should say: the body/thought, which I shall call: *anima*—feels on the occasion of a sensible event." The anima or soul is dependent on outside contact/sensation and is terrified of an absence of sensation, which is death. The precarity of this subject correlates with a precarious sublime: "Either it [the soul/anima minima] is awakened by the astonishment of the other, or annihilated.... [The soul is] precarious, unprepared, like the sensible event that awakes it."[36] In these terms Lyotard locates at the base of aesthetic experience a profound vulnerability as opposed to the transcendental strength of the Kantian sublime. The idea here is that aesthetic experience involves a fundamental energy or innervation, and if not resolved or rationalized by discourse, it remains incommensurable, sublime, and capable of

countering postmodern nihilism. It is an expression of the infinite that is other to the subject and therein presents an ethical demand on the subject. The character Boo can be read as presenting this kind of sublime. That is an experience of encountering the Other, appreciating the aesthetic vitality of contact, and acknowledging that her being exceeds or escapes the ideological scripts used to integrate her presence into a sociopolitical order.

Obviously, as an animated girl character Boo does not present abstract sensation through her moving figure, but she does function in the narrative as a more primordial form of sensory contact, a form of contact with the unknown. Her enigmatic, childish presence resembles Lyotard's efforts to strip down aesthetic experience to its most basic level of agitation and discord. But Boo is a narrative version of a postmodern sublime, which is distinct from Lyotard's rejection of semiotic representation. Lyotard explicitly favors avant-garde art that challenges the sense of mastery over time that accompanies modern ideas of development and progress. For Lyotard, Kant's sublime contains an idea of indeterminacy and discord between human experience and the environment, which sharply contrasts with Kant's definition of beauty and its reliance on an accord between mental faculties and the natural environment. In cases of the sublime, the imagination fails to account for a given perception of might or scale; it cannot harmonize with reason. Lyotard directly compares this minimization of imagination and elevation of reason to abstract and minimalist art: "optical pleasure when reduced to near nothingness promotes an infinite contemplation of infinity."[37] The virtue of avant-garde art, then, is its capacity to peel back the correlations between image and concept or sign and referent that result from education and socialization. Even though Boo is not an abstract figure, as a child she is able to represent abstraction. After all, she is responsible for the doodles paired next to Sulley's visage we saw in Figure 12.

In the introduction to his book *The Inhuman*, Lyotard takes issue with definitions of *human* that emphasize culture—those customs and

values that are passed on between generations. In a postmodern situation in which metaphysics is no longer appealed to in arguments about nature (i.e., the definition of *human*), the given system gains de facto metaphysical status over such questions.[38] This is a serious problem for thinking about alternatives to capitalism or any entrenched system, for that matter. Lyotard appreciates avant-garde, sublime art specifically because it challenges the permanence of any status quo by bearing witness to the "native indeterminacy" that persists within humans. Lyotard's examples include paintings by Barnett Newman and Paul Cezanne, which seek to express the overlooked and inexpressible subtleties of perception. Lyotard admits that the avant-garde approach for which he advocates undoes all systemization. It does not appeal to a *sensus communis* as in the case of Kantian beauty: "The task of having to bear witness to the indeterminate carries away, one after another, the barriers set up by the writings of theorists and by the manifestos of the painters themselves."[39] This statement seems to indicate a contradiction between Lyotard's preference of avant-garde art that expresses native indeterminacy, and therein resists theorization, and his own writing about art and his appreciation of the texts and statements produced by the artists. Contradictory or not, the discourse and criticism that discusses (or frames) avant-garde minimalist art remains valuable even when the interest of the art is pure presence, not theory or interpretation.

This point can be explicated further through the role in *Monsters, Inc.* of sublime subjects and objects, which function as abstract, unknowable elements within a narrative and a representational world. Given that the technological sublime amounts to a beautification of sublime experience and that the sublime no longer marshals significance through its transcendental associations, theories of the sublime tend now to focus on the infinite domain of subjects and objects. Lyotard turns to the basic agitation of sensation, the *anima minima*, but *Monsters, Inc.* turns to the basic alien presence of otherness. This is most succinctly described through the anthropomorphic reversal described by

Docter: "Our own fears are afraid of us!" Just as the meaningfulness of experiencing and contemplating the sublimity of stripped-down sensation relies on the demise of metaphysics in philosophy and the breakdown of cultural values and traditions in the realm of art, so, too, the narrative and world of *Monsters, Inc.* provide a frame that makes the mutual fear and ignorance of monsters and children conducive to contemplation. The unknowability of the other emerges as a final vestige and source of hope for change within a highly rationalized, automated, and exploitative world. In this respect it is significant that the domain of unknowability afforded by subjects and objects is also a resource for the reproduction of this rationalized and exploitative world.

The character Boo demonstrates how a postmodern sublime is grounded in an experience of the unknown that reflects back to the subject her own absolute negativity (unknowability or unfinalizability), which contributes to a vulnerability toward change. This form of the sublime relies less on a subject/environment model of experience, but it assumes that every object, which includes subjects, presents a basic unknowability or negativity beyond material existence. In *Monsters, Inc.* children exemplify this form of the sublime in that they are an empty threat, are toxic yet valuable, are mysterious and unable to communicate with the monsters, and are filled in with ideological content. The child-as-ideological-object remains empty and unknown but is treated as a complete subject or character with a full personality.

The compulsion to imagine a character as an authentic or full personality is not necessarily a process of projection—whereby a subject projects onto a character the integrated complexities that constitute her own experience of subjectivity. Instead, the affinity for totalized aesthetic others can be driven by a need to imagine one's self as whole, stable, and finalized.[40] Treating an other as a full, finalized personality enables a subject to receive the other's reciprocal gaze and use it to stabilize her own precarious subject position. This process of constituting the self through the gaze of the other pervades *Monsters, Inc.* A monster's ability to evoke a scream from a child contributes to the monster's

Figure 15. *Monsters, Inc.* (Docter, Silverman, and Unkrich 2001). The monitors show Sulley's scare demonstration and reveal Boo's point of view, which reconfigures Sulley's identity and perception. Disney-Pixar, 2013. DVD.

identity as a monster. The toxicity of children and their fearful gazes affirm the corporate-monster identity.

A reconfiguration of this dynamic can be read quite literally in a scene in the latter half of *Monsters, Inc.* in which Sulley gives a scare demonstration to a group of new employees. When Sulley demonstrates his scariest roar, Boo, who is standing nearby, shrieks in terror. Upset that he has frightened Boo, Sulley looks at the monitors that recorded his scare demonstration and sees himself anew—that is, as the scary monster from Boo's point of view (Figure 15). This scene is a critical moment in which Sulley sees his own monstrosity and begins to understand the perspective of the exploited other.[41] This formulation establishes Boo as a powerful ideological object capable of reconfiguring Sulley's identity and defying the corporate-ideology apparatus. The monitor sequence at once demonstrates Boo's interpellation of Sulley—she has called him toward another identity—and exemplifies Docter's point-of-view reversal thematic.

Boo's potency derives in part from the excessive othering of children in the film, which is an exaggerated form of how children are commonly

othered in a range of societies. For many adults children are not simply vulnerable and dependent on caretakers. They can also appear threatening in their unpredictability, incomplete socialization, and embodiment of becoming. In many cases they are not yet subject to law and only become subject to norms gradually. This exceptional status and treatment makes adults vulnerable to the desires and fears of children and contributes to the valuing of innocence associated with childhood. This is one reason the concept of the child tends to be co-opted by power, where the child represents the future of a given sociopolitical order.[42] In other words, the child represents the perpetuation of specific forms of adulthood, and adults repeatedly leverage this potentiality against political rivals while simultaneously filling the concept of child with their preferred ideological content. Debates about children as proxy arguments for possible futures structure the institutions and discourses responsible for education and socialization. But, as Lyotard mentions, during the process of socialization it is inevitable that an alien remainder surfaces in a child. The unsocialized queerness of childhood is exaggerated in *Monsters, Inc.* through its separate monster and human worlds and the comparison of children to the human-defying agency of the environment.[43] This condition sets up children as alien entities about which the monsters actually know very little, although their society depends on the everyday exploitation of them.

Boo's characterization as alien is compounded by her inability to talk. The inability for the child and the monsters to communicate maintains their mutual fear and the film's irony in that the audience understands the little girl more than the monsters do, and it understands the monsters more than the little girl does. In an interview for *Creative Screenwriting* Andrew Stanton tells how he and director Pete Docter were set on Boo being too young to speak. They thought this would enable characters to project more onto the child, as people do with pets.[44] In this case, then, a human child has human characteristics projected onto her by anthropomorphic monsters. The language barrier assists in depicting the process of projection as Sulley and Mike's

fears dissolve along with the myth of child toxicity. Boo's girlhood contributes to a similar divide between her and the masculine monsters Sulley and Mike. The divide derives from their separate worlds and from different levels of socialization and gendering. This enables an audience to read Boo's immediate affection and bond with Sulley as an affinity that overcomes difference and for Mike and Sulley to be read as stand-ins for adult parents.

Significantly, Boo uses a few words, including referring to Sulley as "Kitty," which operates as an alien interpellation of Sulley. Again, this new call, vaguely alluding to a child's initial reference to Mom, Dad, or another family member, effectively offers Sulley a new identity that he clearly accepts in the film. This new identity is a significant conversion from the corporate-monster identity developed through fear and the daily business or performance of scaring. This interpellation and reconfiguration of identity is visually represented through the monitor sequence, which also demonstrates the sublime nature of Docter's thematization. "Our own fears are afraid of us!" alludes to the characters' overcoming their shared fear and unknowability.

This turn to the sublimity of the individual person as subject and object sheds the transcendental overtures of earlier sublime formulations, but it lends itself to absurd and pernicious ideological constellations. As Slavoj Žižek argues through his Hegelian-Lacanian theory of the subject, the space of the sublime unknown serves capitalist ideology particularly well. Again, rather than expressing a Kantian transcendental notion of the sublime, Žižek formulates sublime experience as indicating the absolute negativity of subjects and objects. For Žižek the distinction is one between Hegelian and Kantian understandings of representation: whereas Kant claims that the Thing-in-itself exists beyond the field of representation, Hegel claims that there is nothing beyond the field of representation. Sublime experience under these terms loses its transcendent capacity. In this formulation the subject is not threatened by an external, overwhelmingly powerful environmental phenomenon, which then prompts the subject to discover an inner

power, as in Kant's dynamical sublime. Instead, the subject experiences her environment as unknowable beyond a series of representations and materials, and the subject finds herself likewise unknowable.[45] The object, as unknowable beyond representation, gains meaning and force through its lack, that is, through the parts of it that are not symbolized through language, which is comparable to Boo's preverbal character. The sublimity of an object comes from the impossibility of symbolizing its Real, preverbal content.

One of Žižek's famous examples of how an object's sublimity functions ideologically is Coca-Cola, which as a desirable object betrays its own meaninglessness and points the subject to the Real of desire with advertising slogans such as "Coke is it!" or "It's the real thing, Coke." This absence of useful qualities—the product's caffeine, sugar, or other contents are not its selling points—actually makes its advertising more effective, not less.[46] Žižek's analysis of ideological objects attests to their psychical potency more than to their historical specificity or cultural tangibility. He is interested in their sublime or excessive quality foremost because it is this form that causes repetition in various historically specific moments. Thus, Žižek is prone to follow an analysis of Coke with a corollary analysis of anti-Semitism under the Nazi regime. In this latter instance the more abstract the figure of the Jew becomes, like the abstract advertising slogans of Coke, the more effectively it serves the Nazi's pseudoscientific, racist ideology.[47] In this vein children in *Monsters, Inc.*, and Boo specifically, represent an amorphous, unknown threat that is as harmless as Coke is ordinary. But it is this unknown, amorphous, sublime quality that also enables ideological effectiveness.

Boo's otherness, as presented through her incomplete socialization and through her humanness in a monster world, gives her character a sublimity—an excessive alien quality with which the monsters must reckon, especially when they come into contact with her. The crisis of Boo's presence disturbs the entire symbolic order of the monster world and its myth of child toxicity. A large part of the film's humor revolves

around the joke that the audience (and presumably some of the monsters) knows that children are not toxic. It is also a relatively familiar trope to assign the unknown and unfamiliar thing sublime weight in a film as it is in a given ideological system.[48] That said, *Monsters, Inc.*, as a narrative about a mythical threat used to organize society, demonstrates how physical contact with the threatening object can disrupt its sublime efficacy. Žižek makes a similar point in his Coke analyses when he suggests that all one has to do is drink Coke when it is warm or flat to experience the full absurdity of its sublime advertising. Nevertheless, this sensorial disappointment has not stopped many people from drinking Coca-Cola. Žižek acknowledges that many consumers practice a cynical, fetishistic ideology that enables them to admit the absurdity of Coke's sublime advertising and prefer to drink it all the same.[49]

Boo, as the uncontainable, animated, toxic child character, defies the technological infrastructure of the monster world and its cultural practices, which is more dramatic than Žižek's Coke example. Perhaps children in the film are toxic but not in the way the monsters thought. The toxicity of children alludes to the unknowability of subjects and objects, which can support or disrupt a given system. This unknowability figures as a more relevant sublime experience than the technological sublime of the industrial era and its legacy of beautification that persists in the digital era. *Monsters, Inc.*'s contribution to theorizing sublime relations emerges through its depiction of contact outside the parameters of a given ideological script: Sulley's contact with a child who does not scream but laughs and calls him "Kitty." This demonstrates how objects and subjects are never finalized by ideology, and their sublime emptiness grants the capacity for new characterizations and identities. But *Monsters, Inc.* also demonstrates how a single subversive event must contend with ongoing cultural practices operating in conjunction with technological infrastructure. Hence, Monsters Incorporated makes the transition to exploiting children through laughter, while the promise of further social transformation resides in the secret, ongoing friendship between Sulley and Boo.

By turning to the sublime unknowability of its characters, the film expresses dissatisfaction with beautification and an antiquated technological sublime. This expression is at odds with computer animation's aesthetic of continuity, which presents a polished, industrially manufactured example of beauty incorporating the sublime. *Monsters, Inc.,* however, is an example of coping with fear not through reflecting on our reason or transcendental ego but through anthropomorphization, through making our fears in our own image. The postmodern sublime, here represented by Lyotard and Žižek, has its corollary in character animation that dramatizes the uncontainability and unknowability of personalities and animated bodies. Such characters effectively express aesthetic openness, and even though this openness seems inevitably filled in by commercial slogans and familiar human qualities, it remains an unstable variable that troubles those monstrous structures that are "built to last."

The Exceptional Dialectic of the Fantastic and the Mundane
(*The Incredibles*)

Whereas many of Pixar's features explore alternative family formations, such as Sulley and Mike and Boo in *Monsters, Inc., The Incredibles* (Bird 2004) explores a traditional definition of family in American, patriarchal culture, albeit the traditional family central to the film consists of exceptional characters. The film's narrative follows a family of superhumans (Supers) who have been forced to retire from their superhero vocation because of public discontent. After several lawsuits, the state passes legislation outlawing superpowers and demands that Supers blend in with ordinary society. Out of all of Pixar's films, this is the most explicit depiction of juridical laws changing within an animated world, and it raises the question of how the animation used in *The Incredibles* contributes to this depiction of a liberal society under the rule of law. Although the film portrays social and cultural transitions, its narrative, themes, and aesthetics are actually well-suited for thinking about the maintenance of social order as an ongoing dialectical process. The computer animation aesthetics of the film analogously serve its themes of the fantastic and the mundane, which exemplify the logic of exceptionality at work in maintaining social order. These themes are accompanied by the juxtaposition of melodramatic family life with the danger and violence of superhero life. The latter is presented primarily as a male fantasy that

perpetuates competitive culture and the desire for individual achievement. Finally, this juxtaposition forms a dialectical set of themes that address biopolitical governance within technologically enhanced individualist culture, and these themes demonstrate how the superhero genre can express a desire to escape it.

The Incredibles presents a liberal society in transition, and it is a society that has become boring. The lawsuits against the Supers result from the public's perception that the Supers' freedom to exercise their powers infringed on the personal freedoms of ordinary humans. After the Superhero Relocation Program, ordinary humans no longer have to worry about being saved against their will or becoming collateral damage in a rescue operation. Following the legislation, the Supers do not live double lives as civilians with alter egos but are forced into mundane lives without the glamour, celebrity, and danger of superhero life. Rather than dramatizing the complications that Supers pose for the legal system and political economy, the film dramatizes this lost, suppressed identity by juxtaposing it with depictions of everyday, humdrum, middle-class American life. Concealing their powers in order to blend in with society, the protagonist family of Supers suffers from a series of frustrations, including the repression of their desire to achieve recognition through their talents and crime-fighting heroics. The most negative effects, however, are more pronounced in Mr. Incredible and his son Dash. The resolution to this conflict emerges through the family's encounter with the threats unleashed by the villain Syndrome, whose envious feelings toward Mr. Incredible turn into malice toward all Supers.

This narrative mostly follows Mr. Incredible (a.k.a. Bob Parr), who, to satisfy his longing for heroics, secretly begins to carry out missions for an unknown weapons developer. The weapons developer turns out to be Syndrome (a.k.a. Buddy Pine), a talented inventor who as a child had sought to be Mr. Incredible's sidekick. Mr. Incredible rejected the boy's assistance, which led Pine to become the villain Syndrome. Elastigirl (a.k.a. Helen Parr), Mr. Incredible's Super spouse, discovers her husband's secret after he is captured by Syndrome, and she and two of

her Super children, Dash and Violet, must rescue Mr. Incredible and stop Syndrome, whose plan is to destroy all the Supers.

The family names Parr and Pine correlate with the characters' situations: the Parrs struggle to fit in as equals in society, and Pine longs to be a Super. The film repeatedly emphasizes the personal and psychological effects of social situations, and, as writer and director Brad Bird explains, *The Incredibles* uses the superhero genre to explore the tensions of family life:

> At its heart, I saw *The Incredibles* as a story about a family learning to balance their individual lives with their love for one another.... It's also a comedy about superheroes discovering their more ordinary human side. As I wrote, I wanted to create a world filled with pop culture references—with spy movie gadgets and comic book super powers and outrageous evil villains using ingenious devices—but at the same time, to create a story within that world that is very much about family. I really poured everything in my heart into the story. All these personal things—about being a husband, being a father, the idea of getting older, the importance of family, what work means and what it feels like to think you're losing the things that you love—all of these are tucked into this one big story.[1]

I appreciate Bird's description not for its autobiographical detail but for its sociological and cultural insight. It explains how the film can be read as an attempt to address a series of tensions typically formulated as the work-life balance or, in the case of superheroes, public welfare versus the well-being of loved ones. The other modern concept dramatized here is self-realization, or the imperative to discover happiness and satisfy one's personal desires. In the world of the film these are liberal problems embodied most directly by Mr. Incredible and Dash. As the two white male leads, they are character types associated with high levels of social privilege.

Before examining the characters, however, there is more to say about the cultural and philosophical implications of the overall themes of the film, which have been succinctly described in aesthetic terms by Brad Bird as "the fantastic and the mundane."[2] This refers to the

juxtaposition of superhero life with that of ordinary humans, but it also expresses a more fundamental dialectic. Amplifying a trope within the genre of fantasy at large, the film presents fantastic events, people, and places as interruptions or exceptions to mundane, everyday life. As an exception to normalcy, the fantastic has an aesthetic structure rather than a generic one, but, as an exception, it nevertheless defines norms through a process of presupposition. To identify and designate an event, or person for that matter, as exceptional, it must clearly exceed the parameters of general norms. Thus, achieving the designation of "exceptional" weds presupposed norms to a historical reality.[3] As readers of Agamben's famous articulation of the state of exception have noticed, exceptionality's presupposition of general norms bears some affiliation with aesthetic judgment. The exception, as a phenomenon that suspends norms or laws but offers an opportunity to establish norms or laws as well, can facilitate considering both as "pure means," as opposed to instrumentalized means-to-an-end.[4] This is comparable to thinking about how a feeling-based judgment that claims universal validity but remains particular and subjective contributes to the formation of norms through language.[5] Tracing norms back to their subjective and arbitrary roots diminishes their naturalized permanence and utility. This deconstructive work displays how judging something to be fantastic, incredible, or super integrates aesthetic and conceptual modes of thought. In short, the dialectic themes, figures, and depictions analyzed in this chapter present aesthetic and determinative elements as closely entangled and mutually informative.

The incredible bodies and bodily attributes of the Supers, for instance, resist determinative forms of judgment at least until the question arises about what a body is for. The youngest Super, Jack-Jack, epitomizes this in that his morphing powers, which are disclosed late in the film, have an indeterminate, almost random appearance. Before being instrumentalized and categorized, such bodies are judged aesthetically. Of course, the categorization of the uncategorized is precisely what the superhero genre and the notion of superpowers provide. They give pur-

pose to exceptionality. Super strength is not confined to a sensory domain but is an ability conducive to instrumentalization. In the worlds of superhero films and comics exceptional abilities are often used to reestablish social order. Superheroes deemed "incredible" can be understood as establishing norms in two directions: through presupposing norms by way of antinormative, exceptional behavior and ability but also through the instrumentalization of their exceptional talents.

Superheroes, in this reading, provide stability to social order by returning a clear hierarchy. The superhero genre presumably relieves a serious social burden given that modern democratic society suffers from an obfuscated hierarchical structure and a lack of social mobility. In short, it can be frustrating living with ideological discourses that emphasize equal opportunity and meritocracy while living with blatant static hierarchies at the same time. Furthermore, the ideals of freedom and equality persist largely in discourses that emphasize entrepreneurial and technological savvy, which tend to facilitate self-blame over structural criticism. When searching for an explanation for personal failure, a person who has internalized these messages is likely to look inward at their own strengths and weakness. The superhero genre is able to mitigate this self-criticism through an obvious escapism and by offering a clearer, external delineation of ordinariness and normalcy. To put it plainly, the inability to climb the social ladder and achieve distinction appears much more reasonable in a world with superheroes.

Granted, many modern superhero stories play with the social order formula by portraying mundane concerns interrupting the fantastic elements of superhero life; for example, the hero must choose between serving the public welfare or honoring personal relationships. These disruptions of the superhero vocation prevent the hero's exceptionality from becoming too routinized and normalized. The normal returns in these instances as an exception that presupposes the exceptionality of the superhero. The poles of this dialectic narrow in *The Incredibles*. In many ways the fantastic is the mundane and vice versa. For example, despite the obvious conservatism of their family structure, the Supers

find their home and domestic space a respite from social norms and laws, and it is where they are able to use their powers. And, more important for the project at hand, the animated film aesthetics function analogously to the exceptionality of the superheroes on multiple levels. The animation aesthetics offer a fantastic corollary to the exceptional abilities of the Supers, and the animation is an example of building the mundane with fantastic technological tools.

The film's computer animation enhances this fantastic-mundane dialectic through a distinct fantasy-realism balance. Each term in the fantasy-realism binary refers to and differs from each other: visual fantastic elements emerge in contrast to realistic elements and vice versa. In *The Incredibles,* fantastic imagery and movement correspond to the exceptional abilities of the Supers. Mr. Incredible's caricatured figure features an enormous upper body to signify his super strength. But the limits of the cartoonish exaggeration are equally important to the diegesis and tone of the film. Within the history of representational animated films, fantastic elements that convey a sense of emancipation or utopia are accompanied by realistic elements that give the story weight and stakes. Fairy tales, for instance, have found animated film to be a suitable home for their more fantastic elements.[6]

The superhero genre has been a fruitful space for innovations in presenting fantastic and realistic elements through animated film, as was demonstrated by the Fleischer brothers' use of rotoscoping and the Stereoptical process in their Superman cartoons of the 1940s. In these shorts an enhanced realism elevates the stakes of superpowers, which informs Superman's dual identity and the overall tone and aesthetic palette of the world. Supporting Superman's capacity to blend fantastic abilities into a normal-looking human figure, the animated world blends fantasy elements—for example, monster robots—with anatomically precise rotoscoped characters. The world becomes more like a comic book than a Disney cartoon. In addition to aesthetics the recalibrated balance in the Superman cartoons is indicative of a series of decisions made in respect to available technology, trends in other media, and market strat-

egy.[7] In *The Incredibles* the powers and caricatured bodies of the Supers exist in tension with a recognizable 1960s, American setting. In this context the fantastic elements of the Supers disrupt the standardization, rationalization, and bureaucratization of mid-twentieth-century life in the United States. The caricatured humans and superhumans in *The Incredibles* also distinguish the film's realism from the photorealism of other computer-animated films.

The twist that *The Incredibles* employs, however, with its themes of the fantastic and the mundane is that quotidian moments in the lives of the Supers disrupt their own fantasies and fantastic abilities. The convention of fantasy disrupting the boring and oppressive parts of reality is in turn disrupted by the inexorable return of reality. This dialectic can easily be read in terms of the historical divide between animated and live-action film, in which animated film is associated with illusionistic effects in contrast to live-action realism, but then computer animation's capacity for photorealism serves as a means for another level of realistic effects to enter animated film. Furthermore, what was once the exceptional domain of animated film—cartoon physics, plasmatic bodies—is now more readily available to live action by way of digital production. The fantastic-mundane and the realism-fantasy dialectics illuminate how the distinctions made between modes are historically contingent. The difference that makes a difference when distinguishing (judging) between animated and live-action film can change. At a historical moment when computer animation is defining itself, the mundane-fantastic theme of *The Incredibles* counters exclusive associations between fantasy and animated cartoons.

This more mundane animation helps to make the biopolitical point that bodies, and their everyday life processes, are technological targets and subject to the tools of governance. The maintenance of social order through quotidian biological processes is a bottom-up approach to governmentality, to use Foucault's term, and in the animated world of *The Incredibles* the rules and laws that hinge on the attributes of bodies are also personal, family matters. Animated films are conducive to biopolitical

readings through their capacity to influence which movements and bodies are recognized as living and indicative of personhood.[8] In *The Incredibles* the computer animation reinforces the significance of the moving, living body within the animated world; it is focused on generating embodied characters. This focus necessitates that the characters' bodies are subject to many of the rules we assign to bodies. For instance, Brad Bird initially planned on killing off one of the film's developed characters—a pilot and friend of Elastigirl named Snug. Bird cut this element out to save screen time and labor, but he wanted it because it bolstered the theme of the mundane and the fantastic. He thought it would give an adult, serious tone to an animated, family film that presumably would avoid depicting death altogether.[9] In other words the death sequence would extend the mundane to refer to the mortality and vulnerability of everyday life and everyday bodies. This is also why Mr. Incredible is shown to experience pain, fear, and bleeding.

In addition to narratively treating the characters as having mortal, human bodies, the film features characters that are digitally constructed through software that simulates basic skeletal frames and working muscles that are then covered with digital skin. In the film's production notes Bird describes this process: "We used a fantastic new technology called 'goo,' which allows the skin to react to the muscles sliding and sticking underneath in a very true fashion."[10] Bird's use of the word *fantastic* is ironic since the fantastic element is the new animation technology used to produce images that are materially and dimensionally realistic—closer to the mundane.

The reflexive relation of Pixar's technics to its narratives in this case presents another twist. In the narrative the fantastic elements of the Supers are suppressed by law, but when the Supers use their powers, they are interrupted by mundane cultural and bodily events—for example, Mr. Incredible throwing out his back. In the production of the film, technological innovations are used to generate and compose mundane reality, with its bones, muscles, and blood. In the production process the materiality of the body, with its limitations, seems less like an

interruption than a target. And the innovations in computer animation, as Bird's comment indicates, become the fantastic components targeting the mundane. In other words, when fantastic technology targets mundane human bodies, the body is not a helpful, therapeutic break in an otherwise technological condition but is a mere model and something that can be technically reproduced and manipulated. Underneath the superpowers of the Supers and the realistic aesthetics of their world lurks a technoutopian ambition that resonates with Pixar's cultural position. Building a mundane world is also a fantastic technological achievement.

It is remarkable that within this biopolitical gesture, in which the animators' technological work of building digital bodies facing quotidian problems might serve as an analogy for governance through the management of biological processes, the role of economic competition is depicted as an inferior form of competition. In the film individuals compete with each other physically and violently, achieving distinction through athleticism or combat. Entrepreneurship and economic ambition exist in the film, but they are not depicted as satisfactory substitutes for the interpersonal violence and danger that the Supers engage in when fighting crime and Super villains. Furthermore, the world of the film lacks systemic, apocalyptic threats, and the violence that does threaten society is wielded by individuals. As tends to be the case in many superhero narratives, collective power is hardly present. Instead, individuals of great ability fight and compete against each other.

This depiction accords with Slavoj Žižek's observations in his book *Violence*, which describes how in economically prosperous and secure regions of the world, subjective violence is more jarring than objective violence. Subjective violence includes the subject-versus-subject form of conflict typically found in Hollywood films and on local news. Objective violence is often more difficult to depict and includes "symbolic" violence, as in that which occurs through language, and "systemic" violence, which exists as background conditions or the "normal" state of affairs. Systemic violence and its capitalist social order are

maintained by constant activity.[11] But, and this is the overarching lesson of Žižek's book, our attention to local, subjective violence blinds us to the systemic violence of our social order and how quotidian, personal activities sustain it.

A similar dilemma preoccupies Bird's fantastic-mundane thematics of *The Incredibles*. Building the mundane in the film involves more than the characters' bodies. It also includes building a series of familiar domestic and public spaces, and it includes developing the personal motivations of the characters. It is common for a Hollywood action film to have melodramatic elements at its core, but *The Incredibles* parodies this convention as it depicts the domestic life of the Supers and demonstrates how psychologically vulnerable they all are. It also builds on the melodramatic role of a stylized mise-en-scène. In melodrama the emotionally afflicted characters struggle to address the social and systemic issues contributing to their misfortunes. The people and objects nearest to them become substitutes for these alienating forces. Furthermore, this psychologized, melodramatic mode has many of its roots in the popularity of Freudian psychoanalysis in the United States during the mid-twentieth century.[12] Thus, *The Incredibles'* setting alludes to this melodramatic mode almost as much as the superhero genre. This mix of genres contributes to the film's focus on subjective violence and personal desire, and it facilitates the narrowing of the fantastic and mundane dialectical poles.

In the real world, in which the dialectics described above are less exaggerated, there are plenty of counterexamples in which people demonstrate sensitivity toward and engagement with systemic social issues and are not blinded by intimate relationships and contexts but think of these as always related to broader contexts. But in *The Incredibles* the focus on superheroes and family and on the maintenance of social order through bodies living and pursuing personal interests caricatures the more narcissistic side of modern liberal culture. The film invokes the premise that the modern aspiration for individual autonomy, security, and prosperity leads to conformity and nihilism or, at the very least,

boredom. *The Incredibles* is not a formal intervention into a debate about politics in today's globalized, capitalist societies, but it does address the stagnation of consensual politics and the triviality of an individualist state of mind in which the good life is reduced to "narcissistic satisfactions."[13] Without grand ideological causes that demand individual sacrifice and collective action, or without substantial debates about the good life, society slips into a state of political stagnation. This is a politics reduced to management, administration, and pragmatic problem solving, and a culture ill-equipped to critique this politics because it suffers from fragmentation by way of an obsession with self-gratifying pursuits and an individualist, entrepreneurial market economy.

The film addresses this context through distinctions between normative/stagnant space and aesthetic/politicized space; in the film the latter is typically the space of home or fantasy, and the former is the space of bureaucracy and mundane life. As with Bird's synopsis, which opens this chapter, the role of family is critical in this context as it is often the site where norms are contested and reproduced. Perhaps even in our neoliberal context—where the market is the primary motivator for daily activity, and individual life and autonomy look increasingly like a technologically mediated form of governmentality wielded by states and corporations—familial and communal space can appear for many people as bastions for political significance and meaning. Nevertheless, the film seems to echo Žižek's observations in that it is difficult not to find mundane personal and familial activities complicit with a systemic culture of competition and violence.

FAMILIAL SPACE

Family has long served as a model for society and government, in part because power differentials exist in families and have been thought of as occurring naturally. To be sure, the use of families as theoretical models has tended to gloss over the major differences and disagreements that persist within families, which, as Kennan Ferguson notes, misses their

major contribution as models for study. Ferguson considers how families function with and through incommensurability and that "the fact of human differences, of the reality that two people never fully understand one another, is closely tied up with the differences in their motivations, valuations, and histories." He then adds, "*The family is where people have the highest level of identification with one another, but also where their differences and distances seem most important.*"[14] Thinking of families as sites of heightened intensity and intimacy and sites of open conflict and contestation challenges models of successful politics as consensual and agreeable. Furthermore, a less idealized examination of family as a political model illuminates differences between micropolitics and macropolitics. In other words it recognizes the intensity of a parent's authoritative command as distinct from orders that come through institutions or from the state. Micropolitical contexts can be uniquely compelling given the loving and affectionate attachments involved.[15]

This is familiar terrain for superhero stories that tend to rehearse the drama of the hero neglecting or relinquishing familial, intimate attachments to serve a larger public entity—the city, the nation, or humanity. Adhering to convention, *The Incredibles* ends with the Supers being able to uphold both family and public duty, but the fantastic-mundane theme and the caricatured bodies and distinct superpowers give figural representation to family dynamics and their intersection with social norms. This animation reinforces the role of aesthetic experience in politics by presenting certain spaces as open to new experiences and conducive to challenging rules. But as a model of politics open to incommensurability, this Super family, with its caricatured figures, demonstrates the limiting effects of socially inscribed power differentials. In accord with Ferguson's insight, the family and the domestic scenes in the film serve as sites for these differences to surface and become open to debate.

For the family of Supers, their different powers are exaggerations of character type: Elastigirl has nearly infinite stretching capabilities and becomes a mother stretched to care for four other people; her husband,

Figure 16. *The Incredibles* (Bird 2004). The Supers struggle to adhere to dinner table norms, and the sound of the doorbell disrupts the security of their home. Walt Disney Home Entertainment, 2005. DVD.

Mr. Incredible, is athletic, strong, disproportionately muscular, and literally struggles to squeeze his body and his ego into the settings of home and work; their daughter, Violet, a shy teenage girl, can generate force fields and turn invisible; their son Dash can run at amazing speeds and is a rambunctious young boy; their infant Jack-Jack meanwhile shows infinite possibilities and in a sequence near the film's end discloses the ability to morph into a host of forms. This mix of powers generates hyperbolic family dynamics epitomized by the physical comedy of the film's well-known dinner table scene (Figure 16).

The dinner table scene gives physical and material expression to the Supers' inability to fit into normal space and spatial norms. The suburban house in which they live features a typical dining room for an American, middle-class home. But the family's dinner quickly gets out of hand when Elastigirl explains to Mr. Incredible how Dash was sent to the principal's office at school for placing a tack on his teacher's chair. Dash avoids disciplinary action because he moved so fast that the teacher's video camera could not capture him placing the tack (the reflexive joke here is that Dash's blurring speed is better represented by animated film than live-action recording). This dinner-table anecdote impresses Mr. Incredible, whose reaction is met with disapproval by

Elastigirl. Distracted by the story, Mr. Incredible cuts through a plate and the dinner table. Then Dash and Violet get in a fight—Dash runs around the table until he runs into Violet's force field, Elastigirl's arms get wrapped around the table as she tries to separate them; finally, Mr. Incredible picks up the table altogether. Then, their friend and fellow Super, Frozone, rings the doorbell and brings the chaos to a close.

As Figure 16 shows, the family's looking at the door where Frozone is about to enter projects their fear of being discovered directly onto the audience in the form of a reciprocated gaze. Audiences can identify with the society outside the home capable of judging the Super family, or they can identify with the Supers themselves, who caricaturize the differences at play within a family. The home serves as a safe space for the disclosure of the distinct bodies and personalities of the Supers. The interpersonal conflicts taking place within the home exist within a productive political domain—the children are not afraid of fighting with each other and using their powers; the parents' disagreement demonstrates a basic freedom to disagree. The conflict with the society outside their home is more threatening and demands greater conformity—hence, their relief when they discover that it is only Frozone at the door.

According to the DVD commentary by Brad Bird and producer John Walker, this dinner table scene was challenging to animate because the action and movement are depicted by several shots from varying points of view, requiring precise spatial-temporal calculations. Each object on the table, for instance—the food, plates, glasses, and so forth—had to be adjusted accordingly to maintain continuity throughout each point-of-view shift. Bird describes this process in terms of fighting the tendency for computer animation to look small, plastic, and clean. In the dinner table scene this challenge of adapting computer animation to perceptual norms correlates with the challenge of the Supers adapting to everyday, civilian life. It is the tension of adjusting to norms that is analogous, and the analogy follows throughout the film as the Supers use more and more of their powers and computer animation shows off more and more

Figure 17. *The Incredibles* (Bird 2004). Syndrome's island provides a fantastic space for Dash to discover his powers. Walt Disney Home Entertainment, 2005. DVD.

of its capacity to portray the dynamism and force of those powers. In other words there are spaces in the animated world in which the characters explore their own rules and limits, and these aesthetic spaces can allegorically refer to the animation production process.[16]

Again, Dash's blazing speed is exemplary. According to Bird, one of the reasons he wanted to make the film was to see what it would look like for a character with superhuman speed to "go all out." Here Bird refers to the sequence of Dash racing through the jungle of Syndrome's island and then running on top of the water surrounding the island (Figure 17). We witness Dash's pleasant surprise as he learns how fantastic his powers are. Furthermore, his exploration of his powers analogously refers to animators exploring the capacity of their medium, and Syndrome's island serves as a larger space for discovery and self-expression than the Supers' home, which the dinner scene shows as limited by the society just outside.[17] Dash's speed, which the film suggests cannot be recorded on camera but is better presented through animated film, exceeds the bodily social norms of his school but not the less restricted space of Syndrome's island or the safe space of home. Domestic space and fantasy space are the properly aesthetic and animated spaces of the film where rules can be discovered and contested. These

aesthetic spaces contrast with the public spaces, which have become more restrictive for the Supers and are less animated in the sense that the fantastic actions of the Supers no longer occur there. Furthermore, these aesthetic spaces contribute to a patriarchal gesture in that Dash and Mr. Incredible experience the loss of public space more acutely than Violet and Elastigirl. Dash's speed and Mr. Incredible's bulk and strength are not easily concealed, whereas Violet's invisibility and Elastigirl's flexibility enable them to conform to the rules of public space more easily. If freedom in a liberal society is thought about through spatial metaphors, then the film effectively shows certain bodies demanding more space, and therefore more freedom, than others.

This treatment of space and difference evolves over the course of the film, but it is poignantly expressed in a domestic sequence featuring the character Frozone (voiced by Samuel L. Jackson and one of the few black Pixar characters), whose cool personality is complemented by his powers to generate ice. As a giant robot unleashed by Syndrome begins wreaking havoc on the city of Metroville, Frozone frantically searches his high-rise residence for his "super-suit."[18] In the scene Frozone's wife, Honey, remains offscreen, and the couple's dialogue consists of them yelling at each other from separate rooms:

FROZONE. Honey ...

HONEY. What ...

FROZONE. Where's my super suit?

HONEY. What ...

FROZONE. Where is my super suit?!

HONEY. I, uh, put it away.

FROZONE. Where?

HONEY. Why do you need to know?

FROZONE. I need it.

HONEY. Uh-uh, don't you think about running out doing no derring-do. We've been planning this dinner for two months.

FROZONE. The public is in danger.

HONEY. My evening is in danger.

FROZONE. You tell me where my suit is woman! We are talking about the greater good.

HONEY. Greater good? I am your wife. I am the greatest *good* you are ever going to get.

While humorously playing with the superhero convention of family sacrificed for the sake of the public, the amusement of the scene emerges from the rendition of the depersonalized, shouting exchange that cohabitants of a large dwelling often engage in. But the absence of the wife's body diminishes the unique force of their domestic, intimate attachment. The latent suggestion is that the computer-animated body would be real enough or believable in such a way as to be capable of interrupting social, civic obligations with the obligations of fidelity and love represented by the wife's body. The scene explicitly contrasts the gravity of public duty with the holds of private commitment, but the mundane is coded familial, female, and invisible, while the fantastic is coded masculine, heroic, and public. The scene implicitly acknowledges the potency of the visible body as a political marker.

This treatment restricts women from public space and macropolitical concerns, and it reinforces the film's narrative, in which the female Supers have less trouble conforming to social norms. Unlike her brother Dash, Violet does not want to achieve public distinction but desires to fit in with her peers. Mr. Incredible's integration into civilian life undermines his masculine identity. Elastigirl foreshadows her conversion to life as a homemaker from the beginning of the film.[19] It is also important that the black character, Frozone, is a token sidekick character, and as much as he misses superhero work, he has adjusted more easily to civilian life than has his friend Mr. Incredible. These distinctions contribute to depicting the loss of freedom and status to which Mr. Incredible and Dash are sensitive, and presumably, audiences are too, as bound up with privilege. The racial, sexual, and gender norms of the film are obviously not so distant from contexts in American life. The rebelliousness of Mr. Incredible and Dash smacks of privilege to which the other characters do not have access. Is it not equally unfair

that Frozone and Elastigirl are deprived of using their powers for recognition and serving the public welfare? The aesthetic freedom of animated film, the capacity to explore and contest the rules of the world, is not equally accessible to all of the Supers even though their very bodies are marked by it.

The characterization of the Supers blatantly discriminates along racial, gender, and sexual lines, and the film attempts to evoke sympathy for the privileged characters by focusing on the freedom that they have lost, namely the use of their talents to achieve distinction and pursue their superhero vocation. The father and son's loss of individual freedom can be read as a disruption of the democratic cultural norm of competition. In a democratic society that does not stabilize itself through traditional or religious hierarchies, citizens normally expect to compete with each other as equals. To demonstrate that one is equal to others or to achieve distinction among one's peers requires a person to exercise autonomy and self-determination and to be able to use his or her talents. Thinking about democratic culture as highly competitive illuminates democracy's relationship with capitalism. In philosopher Stephen Gardner's words, "the money-driven economy affords a social mechanism by which the passions unleashed by equality, negative passions usually destructive of society such as envy or resentment, can be turned into sources of prosperity."[20] Gardner's point is that this competitive climate has contributed to the rise of debt as people vie for distinction and security through the means of credit. The animated world of *The Incredibles* depicts the insecurities and competitiveness that proliferate in a society of supposed equals but displaces a market-based resolution with a mythical one facilitated by the return of superhumans and clear social distinctions.

The film's focus on family interactions shows how this competitive context has formal and informal rules that each family member negotiates differently. For instance, after his trouble at school, Dash has an exchange in the car with his mother, Elastigirl, as she drives home. In a recognizably domestic space, the dialogue addresses Dash's lack of

discipline and his inability to find what his mother calls a "constructive outlet." Dash wants to try out for sports, but his mother will not allow him:

ELASTIGIRL. You are an incredibly competitive boy, and a bit of a show-off. The last thing you need is temptation.

DASH. You always say "Do your best," but you don't really mean it. Why can't I do the best that I can really do.

ELASTIGIRL. Right now, honey, the world just wants us to fit in, and to fit in we just got to be like everybody else.

DASH. But Dad always said our powers are nothing to be ashamed of, our powers made us special.

ELASTIGIRL. Everyone's special Dash.

DASH. Which is another way of saying no one is.

The exchange in this scene echoes very similar language used by Syndrome when he describes his plan to eliminate the Supers and enforce a bland, equitable society in which no one is distinct or special. But the logic is ambiguous. The phrase "everyone is special" could mean that everyone is unique, distinct, or intrinsically valuable. Dash's interpretation equates "special" with distinction or recognition achieved through individual ability. Dash's father, Mr. Incredible, is the source of this interpretation, and this interpretation opposes that of Elastigirl, Violet, and even Frozone, who are more interested in fitting in than achieving distinction. Nonetheless, Dash and Mr. Incredible express the nuance that fitting in does not amount to belonging in a society that values individual freedom and self-determination. To experience belonging in a competitive culture, a person must be free to compete.

THE MEGALOTHYMIC MODE

The foregoing analysis has discussed how the film's themes of the fantastic and the mundane integrate aesthetic and conceptual thought and help us think about computer animation as a fantastic technology

capable of portraying ordinary and extraordinary life.[21] This capacity resonates with descriptions of biopolitical governance as a technology of everyday, micropolitical maintenance that targets bodies and mundane processes. Personalized technology and individualist, competitive culture fit into this regime of governance in that social order is effectively maintained by way of individuals pursuing their own desires and striving for socioeconomic distinction. *The Incredibles*, however, presents a liberal society in which individualist competition has been rendered boring because Supers have been deprived of their privileged status by law. The film asks audiences to sympathize with privileged characters who have been knocked down a peg. The animation itself enhances this presentation through fantastic and familial spaces in which such laws do not apply. By rendering family and fantasy spaces as highly animated and safe from the coercive laws of equality, the film works to mitigate the "existential inferiority complex" that follows from a competitive democratic culture.[22] This formulation can be observed in the film's ordinary human characters as well. Both Edna Mode and Gilbert Huph are ordinary humans with small bodies and large egos, and each is competitive and aggressive in her or his own way. While Huph represents the incorporation of competition, danger, and risk into market activity, Mode represents an alternative call for a return to more mythical forms of conflict and achievement.

Edna Mode is a petite woman who is half-Japanese, half-German, a fashion designer, and, according to Brad Bird, the only non-Super character capable of making the Supers uneasy.[23] Despite her tiny stature, Edna is dominating, self-assured, and competitive (Figure 18). When Elastigirl finds Mr. Incredible's old super suit repaired, she visits Edna, the only person capable of such tailoring. Elastigirl learns from Edna that Mr. Incredible has lied about his work and his whereabouts but also that Edna has made new suits for the entire family. Suspecting an affair, unsure of what to do, and personally devastated, Elastigirl weeps in front of Edna, who, voiced by Bird himself, responds with German-accented, California flair: "What are you talking about? You are Elas-

Figure 18. *The Incredibles* (Bird 2004). Edna Mode's power stance, enhanced by linear perspective, affirms her ideological role as she encourages Elastigirl to fight. Walt Disney Home Entertainment, 2005. DVD.

tigirl! My God, pull yourself together. What will you do? Is this a question? You will show him you remember that he is Mr. Incredible and you will remind him who you are. Ah, you know where he is. Go! Confront the problem. Fight! Win! And call me when you get back darling, I enjoy our visits." Edna plays an explicit ideological role in the film, and her "fight" speech continues the thematization of domestic space as a safe space for nonnormative behavior. The kitchen counter serves as a stage, and the linear perspective distorts her small, benign appearance and amplifies the force of her power stance. As an informal adviser, counselor, and ideologue, Edna reminds the Supers of who they are supposed to be and what they are supposed to do. At the same time, the power-stance shot reminds viewers of the cartoon bodies that frequent the world of the film. This short speech redirects Elastigirl's energies and prompts her to go on a mission to confront Mr. Incredible and rescue him from himself or whatever danger holds him. Her two oldest children, Violet and Dash, sneak onto Elastigirl's jet and force their mother to take them along on her mission. This sequence sets up the film's resolution in which the parents are reunited, the children learn more about who their parents really are, and they learn how to use their own powers.[24]

This call to action counters the role of Gilbert Huph, Mr. Incredible's supervisor. A caricature of a small man and foil to Mr. Incredible, Huph manages an insurance company and repeatedly berates Mr. Incredible for being too lenient with claimants. The insurance business offers a competitive field where a man of Huph's character and stature can thrive. Huph demonstrates how Edna Mode's exhortation to "Fight! Win!" can be absorbed by ruthless capitalism. The tiny manager endorses violent practices—such as denying claims—to keep his company competitive and profitable. Mr. Incredible finds this form of competition antithetical to his superhero vocation and eventually assaults his boss out of frustration. The workplace for Mr. Incredible is literally and metaphorically claustrophobic. His bulky body hardly fits in his cubicle, and his position in the agency is so low that he has no credible autonomy.

The irony of the insurance company sequence is that it deals directly with modernity's response to danger and risk. This is doubly frustrating for Mr. Incredible, who has no patience for the machinations of insurance when formerly it was his job to singlehandedly help people during times of crisis, misfortune, and victimization. In addition the bureaucracy of the company creates an alienating distance from the violence and chaos that afflicts the lives of the people the company is supposed to help. The commodification of protection and the quantification of risk depersonalizes and monetizes what was once a personal, visceral, and magnanimous duty performed by Supers. The film juxtaposes the intimate danger and violence of superhero life, with the bureaucracy, security, boredom, and alienation of modern life.

The danger that Mr. Incredible seeks is not necessarily in conflict with the administered, market-oriented logics of the insurance company, although in the animated world it is presented as such. In *The Incredibles* the law against the use of superpowers that demands that Supers blend in prevents them from seeking out danger. Their superpowers make them less vulnerable than other humans and an average, middle-class life does not expose them to the kind of danger to which

they are accustomed. This contributes to Mr. Incredible's boredom and depression, Dash's frustration, Violet's confusion, and Elastigirl's weariness (mostly a result of helping her spouse and kids with their problems). The normal license to compete and take risks in the marketplace seems a feeble comparison to fighting crime and rescuing people from catastrophes. *The Incredibles* serves as a hyperbolic representation of how meaninglessness and boredom follow from modernized security and prosperity when the marketplace does not satisfy these individualist desires. This characterization evokes Nietzsche's "last men," who emerge amid the prosperity and security of modernity. Nietzsche rails against the life of the last men, whose devotion to comfort has displaced the passion and tragedy of a Dionysian worldview, and he offers the figure of the *Übermensch* in opposition to the last man.[25]

A crude Nietzschean reading of the film could amount to an argument for a society open to the conflicts and inequalities that would arise from granting the same freedoms to all humans—super or ordinary. This reading would sympathize with Mr. Incredible's resistance to insurance since Nietzsche endorsed "liv[ing] dangerously" in order to counter the bourgeois pursuit of contentment or progress, a holdover from the Christian pursuit of redemption and presupposition of universal guilt. Nietzsche's call to live dangerously also appeals to the individual to face the indeterminate cosmos and commit to authoring a part of his or her own life. But the film, in accord with its 1960s spy-thriller mise-en-scène, maintains a cooperative connection between danger and a bourgeois existence. Exemplary here are the James Bond–like sequences on Syndrome's beautifully exotic and technologically sophisticated island, complete with an attractive female assistant who seems to exist to serve powerful men. It is in this space that Mr. Incredible learns the market value of his abilities as he is paid to fight Syndrome's robots under the guise that they are prototype weapons that have gone out of control. While these sequences do not dominate the entire film, they mark the incorporation of danger and personal risk into the bourgeois system that Nietzsche bemoaned.

As Marcus Bullock describes in an essay on what he calls the "danger market," there are many forms of danger that are readily incorporated into modern democratic, capitalist life. Foremost, the market provides forms of universal risk through competition: "we can rise and fall with equal freedom according to the law of competition. In its invitation to all comers to try their luck or their skill according to that law, the bourgeoisie can claim to be the universal class."[26] The market carries a democratic promise of competition for all, and the law of competition supplies a continuous, low-level, universal danger that primes people for crises and crisis ideology while uniting them through the universalization of market risk. But the incorporation of danger also includes the commodification of thrill-seeking and, in turn, its contribution to subject formation.[27] Akin to the relationship between disobedience and autonomy, and the sublime, an encounter with danger can generate a heightened awareness of oneself. In some cases the feeling of endangerment prompts a person to become dangerous. Such is the case for the Supers in *The Incredibles* when they are threatened by Syndrome and must defend themselves and their family and friends. But this is precisely where the film's action departs from the market's inclusion of danger; it is where the Supers regain their dangerous identities and their status as superhumans. Through these fantastic sequences of violence and action, the Supers depart from their mundane, middle-class working life and therein from market society, its universal risks, and "narcissistic satisfactions." Within this "return of the Supers" narrative, however, we can see that this is precisely the form of danger and Nietzschean living to which Gilbert Huph and Edna Mode do not have access. They are resigned to compete in the marketplace or vicariously through the Supers.

SYNDROME AND ELASTIGIRL

When Scott Bukatman claims that "maturity is held in abeyance by the superhero comic," he is referring to the genre's primarily adolescent-boy

audience and the superhero trope of the origin story.[28] First, there are
the explicit parallels between the superhero discovering his powers and
the bodily and body-conscious development of a boy. And second, the
origin story trope refers to the genre's commentary on the lack of tradi-
tion passed on between generations. The origin story reverses the *bil-
dungsroman* narrative in which the protagonist must learn to overcome or
shed the weight of the past.[29] The implication is that there has been a
rupture with the past that superhero origin stories address. While
Bukatman is right in his observation that superheroes "tap strongly into
older traditions of animistic power and possibility," he does not examine
how "playing" with superheroes through comics and films also alludes
to a calcified aspect of our social lives. Bukatman describes his position:
"I'm convinced that the overt concern with issues of law and order is
something of a red herring in the superhero cosmos—these flamboyant
figures are more easily aligned with a pleasurable chaos than with
restrictive order."[30] I am less convinced that the genre should be
approached this way, and I think *The Incredibles* addresses a similar senti-
ment. Inseparable from the light amusements of these fantastic depic-
tions lurks a comment about the restrictiveness of a pleasurably chaotic
order. Even if the superheroes supposed to reconnect us with "older tra-
ditions" turn out to be pleasurably chaotic, the surface gesture of the
genre remains significant. As analysis of the fantastic-mundane shows,
aesthetic tropes function in concert with determinative measures in the
maintenance of social order. The superhero genre indicates that the
individualist and aesthetic qualities of modern identity and culture,
which are at once liberating and chaotic, are also burdensome and
precarious.

The return-of-the-Supers narrative, like an origin story, reconnects
past and present, but in doing so, it also offers a critique of a competi-
tive, liberal democratic culture. Critics of this competitive culture fre-
quently highlight how it contrasts with older social orders, as Gardner
does: "Democracy strives to replace what once appeared as a 'natural'
and 'divinely legislated' order with a 'cultural' or 'aesthetic' one in

which individuals are free to invent themselves, a virtual reality predicated on individual will or imagination."[31] This kind of self-invention is embodied by the villain Syndrome, who believes he can become a Super, without having superpowers, through his technological inventions. Syndrome's villainy is based on the same cultural logic of narcissism and competition that drives the other white, male characters, but Syndrome expresses his identity through his technoentrepreneurism. But it is this self-invention and technological ethos that is seemingly critiqued by Supers' innate powers and return to primacy.

Before becoming the aptly named Syndrome, Buddy Pine was a boy who believed that he was as capable as any Super, but when Mr. Incredible rejects his assistance, Pine's inability to join the ranks of the Supers and enjoy their glory becomes a desire to destroy them. Pine's envy is about the desire of the Other, or in Žižek's phrasing, "The subject does not envy the Other's possession of the prized object as such, but rather the way the Other is able to *enjoy* this object, which is why it is not enough for him simply to steal and thus gain possession of the object."[32] It is this kind of envy that drives Pine to become Syndrome, and it is grounded in a sense of equal entitlement to the enjoyment of recognition. The subject who presumes she is equal to or better than the Other is disappointed when her accomplishments and capabilities and enjoyment appear as somehow less than the Other's. Envy, then, can be understood as a subject's self-criticism redirected toward the Other. The Other operates as a reminder of one's failure—a kind of inverted narcissism. Envy, in this formulation at least, indicates a belief in an illusory level playing field in which the construction of one's identity relies overmuch on comparative logic. The examination of the injustices and inequities of the system do not come into focus through this logic.[33] After all, a critique or reformation of the system would likely not help the envious subject attain the enjoyment that she or he seeks.

For Syndrome, satisfying his envy takes priority over his grandiose scheme for power. This is rendered obvious through jokes about villains having the bad habit of "monologuing" and revealing their evil plots to the

heroes. Villains' monologues are not included solely to inform audiences and generate suspense. A villain driven by envy takes far more pleasure in depriving his nemesis of heroic glory than in acquiring the material rewards of his victory. After he captures Mr. Incredible, Syndrome discloses in a brief monologue that once he has destroyed all of the Supers, and he grows tired of being the world's only superhero, he will retire and sell all of his technologies to the masses. This will ensure that everyone can be super, which, Syndrome reminds the audience, means that no one will be super. This plan threatens to exacerbate the nihilism and narcissistic competition of society through the democratization of advanced personal technology. But Syndrome will not consider implementing this plan until his enjoyment is satisfied under a more hierarchical system with him at the top. It is difficult not to read this as a critique of technoutopian positions that argue that personal computing and networked technologies will enable individuals to pursue their own independent interests while simultaneously creating a self-organizing, democratic system.

Syndrome's plan is also a loose reversal of the conclusion to Alan Moore's comic-book series *Watchmen*, which features a plan to reorganize society through the creation of a new myth.[34] Political theorists from Plato to Machiavelli claimed myths to be fundamental to social order and law, and the comic suggests that a foundational myth is precisely what postmodern society lacks.[35] In *The Incredibles*, however, Syndrome's myth-making effort fails. His plan is to unleash a giant, destructive robot into the city of Metroville to terrorize the defenseless public and then defeat the robot singlehandedly, establishing himself as the lone remaining superhero. As one might expect, the giant, artificially intelligent robot turns on its creator and escapes his control. The Supers, then, must defeat the robot and restore social order, not through technology but through their innate powers and exceptionality.

But what exactly is the appeal of this return to mythical order, and what is its relation to our contemporary, technological order? Syndrome's failure seems to be a targeted critique of the comparative, competitive logic that pervades the animated world of the film and structures his

envy. Syndrome's proposal to sell his technologies to enable everyone to be super would exacerbate this condition. Thus, the return of the Supers to defeat Syndrome's robot is the film's resolution to this competitive cultural order. Furthermore, the portrayal of Syndrome's technological genius as somehow less intrinsic than the powers of the Supers supports the impression that the Supers are part of an older, more stable, and less abstract order. This neglects the idea of technogenesis, which posits that humans have always developed technologically in a kind of creative negotiation with their environment.[36] The use of implements external to the body for thinking and acting is an old human tradition in itself. But this technological tradition, caricatured by Syndrome, seems too protean and even too democratic to lead society to return to a more stable, less aesthetic order. Unlike natural superpowers, technological powers are shareable and rooted in invention.

Possibly betraying its own origin in a technology company with many ties to Silicon Valley's technoutopian culture, *The Incredibles* finds the democratic promise of technology as more problematic than utopian. As Vivian Sobchack notes in her discussion of the rise of fantasy and the superhero genre, these films often propel a desire for technological enhancement to become equivalent to natural ability, and this desire is grounded in a kind of magical thinking encouraged by advanced technological environments.[37] But the democratization of access to technologies and the personalization of technology prominent in the electronic era feed both aesthetic identity and governmentality. This condition gives individuals more tools for self-invention and more opportunities to develop skills that can earn social and market recognition. At the same time, this technological skills race and competitive marketplace for self-expression generates a vast infrastructure for the maintenance of populations—as consumers and as citizenry. Perhaps this insight is afforded to animators with experience building the mundane through fantastic technological tools, whether they acknowledge it or not. From this vantage point superheroes do not express a culture's technological aspirations but its frustrations with a social order in

which agency and creativity are constantly hijacked and distorted by systemic forces. Personal technologies, in this case represented by Syndrome, are part of this liberal problem, not a solution to it.

Furthermore, the caricatured animation of the Supers with their incredible bodies and powers brings the restrictiveness of a liberal order into greater relief. Dash is an obvious example of this once again. His desire to act out and be his best, while deeply personal for him and his sense of identity, is in a substantive way not about him but about reproducing a cultural norm of competition and comparative distinction. Nonetheless, Dash's excessive speed could actually disrupt this norm more than reinforce it. He would no longer be a boy with whom others would compete and to whom others would compare themselves, but perhaps become a godlike superhero to which other boys may be glad just to have some affiliation. In a strange instance of what Žižek might call "overorthodoxy" the Supers' caricatured bodies and fantastic superpowers challenge the norms of the social and physical environment by following the cultural norms about competition and comparative distinction.[38] They implement one set of norms so thoroughly that they destroy other norms. If society would simply let them play its game by following the same rules as everyone else, they would break the game.

The character Elastigirl presents a more nuanced version of this point that can be mobilized in a progressive direction. Even though the roles of the female characters, Violet and Elastigirl, expand significantly over the course of the film, Elastigirl maintains a rather stereotypical woman's role. In short, Mr. Incredible risks losing his family over individual pursuits while Elastigirl risks life and limb to maintain family relationships. These are typical, gendered notions of individual freedom—the man fears the burden of relationships, and the woman fears isolation from losing relationships. Furthermore, Elastigirl's flexibility alludes to feminized labor and the multiplicity of roles associated with women's work. As Ngai observes, such forms of flexible, affective labor have expanded in post-Fordist conditions and find corresponding representations in zany characters that can be simultaneously funny and angry.[39] Elastigirl is

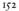

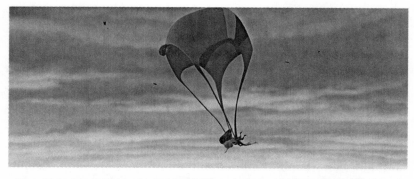

Figures 19 and 20. *The Incredibles* (Bird 2004). Elastigirl's body transforms into a parachute and a boat. Such transformations challenge the discursive concept of a "woman's body" and exaggerate the indeterminacy present within discursive norms. Walt Disney Home Entertainment, 2005. DVD.

zany in this fashion, but her shape-shifting, animated body presents a kind of aesthetic indeterminacy that at once supports and subverts the individualized innovation of flexible labor.

Elastigirl's redeeming elements involve her departure from the melodramatic space of the film, in which her character suffers from paranoia, confusion, and doubt in her own judgment.[40] When Elastigirl uses her powers to rescue Mr. Incredible, her character challenges a variety of norms and conventions, both physical and social. As Elastigirl's body takes on alternative shapes—for example, a parachute or boat(Figures 19 and 20)—her character shifts from that of a woman subject to melodra-

matic norms to a more cartoonish action hero. This does not mean her body is no longer sexed or constructed as a woman's, even in her limited capacity as a character. If anything, animated cartoons demonstrate how identity construction perseveres during metamorphoses and deliberate performances. A woman can turn into another animal altogether and still retain her character's identity. As long as the narrative and the other characters help point out who has turned into what, audiences rarely lose track of identity through metamorphosis.

This construction of fictional character identity demonstrates how identity is much more than the visual presentation of a body, which resonates with Judith Butler's comments on the discursive process of materialization. For Butler a body does not materialize through deliberate performative action but through a discursive process that involves norms. Understanding the matter (in both senses) of bodies occurs through the reiterative and referential activity of discourse (i.e., citationality). In short, bodily attributes (such as sex) require repeated references to earlier instantiations to build on authority and give meaning to the norm's current usage. It is not that bodies don't exist without discourse and culture, but they are less thinkable and communicable without discourse. The reiteration involved in the materialization of bodies, however, is a contingent and vulnerable process, which enables the possibility of new formations. Even though materialization may be in the service of heterosexual norms, rendering some bodies as outside and excluded from cultural intelligibility and from qualifying as life, this materialization provides the potential for change.[41]

Elastigirl's body materializes differently from a woman's body as she deploys her powers; these sequences rely on a different series of visual references. That is, her body takes on the characteristics of elastic materials, including becoming a parachute and then a boat. This is part of the suspense of her action sequences—we don't know how far she can stretch and if the diegesis will permit her injury. Given the fantastic-mundane theme, it seems possible for the character to overextend or damage her body. In this way the character Elastigirl highlights the

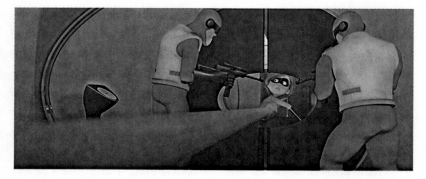

Figure 21. *The Incredibles* (Bird 2004). Elastigirl's body remains subject to familiar displays of objectification and segmentation. Walt Disney Home Entertainment, 2005. DVD.

indeterminacy of the rules governing the movements of her body, which in turn challenges the rules governing the discursive concept of "a woman's body." By visually evoking materials and images that seem other to a woman's body, while maintaining her identity as a woman with a body, the character Elastigirl exaggerates aesthetic experience, which disrupts the normal process of materialization. Basically, instead of a normal materialization, Elastigirl presents an alternative materialization that explores the rules about the concepts and references that we should use to understand her body.

This indeterminacy is not a straightforward emancipatory or progressive gesture, however. For some viewers Elastigirl's elasticity may reduce her character to a purely metaphorical plane. This metaphorical and metamorphic capacity raises Heather Warren-Crow's concern that plastic, mostly digital, images contribute to a series of biases based on associations between girlishness and lability and malleability.[42] We can also contrast the Elastigirl-as-parachute and Elastigirl-as-boat shots to a later scene in which her body is literally segmented between doors as she infiltrates Syndrome's headquarters (Figure 21). This sequence depicts her body in sections vulnerable to the attacks and looks of several male guards, thus evoking familiar sexualized referents that objec-

tify segments of a woman's body or that threaten a woman with overwhelming masculine force. In short, while Elastigirl's body seems capable of surprising significations, this does not preclude her elasticity from being used to generate familiar displays. These familiar displays effectively stage Elastigirl's action sequences and enable audiences to take pleasure in watching her subdue multiple armed guards with a combination of creativity and strength.

The example of Elastigirl helps illuminate how the logic of exceptionality raised by the fantastic-mundane dialectic is served analogously by the film's animation aesthetics. And although these aesthetics are themselves part of a technological apparatus, they also express a desire to escape the governmentality facilitated by personal technologies. The designations of fantastic and mundane, or normal and abnormal for that matter, always include a level of aesthetic indeterminacy. Perhaps Butler's point is precisely that materialization, because it is discursive, always contains aesthetic indeterminacy. Again, such indeterminacy is explicitly presented through the youngest Super, Jack-Jack, who as an infant has not yet disclosed his superpowers. During the final moments of the film Jack-Jack demonstrates that he can morph into a host of shapes and bodies. The natality embodied by this character captures the unpredictability and disruption figured by superheroes who not only challenge social rules and conventions but demonstrate the aesthetic experience of discovering what a body can do within a world.[43] The exceptional body gains significance in this formulation because it has not been co-opted by systemic administration of culture as in the case of personal technologies. The Supers in *The Incredibles* at once disrupt the narcissistic, competitive, and aesthetic culture by reintroducing a more hierarchical social structure, but the Supers themselves also demonstrate aesthetic experience and self-invention without technology as they discover how to use their powers and challenge conceptions about what a body is and can do. Although superpowers in the superhero genre are rationalized as instruments for doing superhero work, the dialectic themes and aesthetics of *The Incredibles* reveal the instability of this rationalization. The

young superhero does not necessarily assign a purpose to his abilities, nor does the elder superhero restrict herself to bodily norms. This contradictory formulation presented by the film helps deconstruct the competitive, individualistic culture to which critics on both the right and left are sensitive (in this case Gardner and Žižek respectively). The point is that the Supers' bodies and the film's fantasy spaces serve both the reproduction of norms and the disruption of these very same norms.

The deconstructive analytic used by Butler and Agamben is an appropriate tool for analyzing *The Incredibles* given the mundane-fantastic theme articulated by Brad Bird and by the film itself. The Supers emerge as characters who are both mundane and fantastic, and their exceptionality illuminates the contradictions that constitute the competitive, individualistic culture that the film depicts. The appearance of an exceptional individual, such as a superhero with super powers, presupposes a reality full of individuals who do not exceed the norms of that reality; they are not exceptional. The exceptional individual, then, provides a referential anchor for a social order that clarifies the distinction between normal and exceptional. The exceptional individual reconfirms the norms governing the nonexceptional. The character Dash cannot complain about the category designated by the term *special* losing its applicability without referring to a time when it was applicable to people like him. Elastigirl and Frozone, however, do not complain because their history has a different set of references (a fictional history that intersects with our real history), and this enables their superhero activities to challenge social norms.

This point counters Bukatman's claim by showing how the popular fascination with superheroes can be read as a popular desire to see exceptionality in order to stabilize and define the nonexceptional. Thus, critics are bound to find questions about the definition of the human addressed by the superhero genre, and this is not too obvious to be significant. Within this genre every instance of the superhuman at once reinforces the definition of human and contains the possibility of challenging it (e.g., Elastigirl, Violet, and Frozone). This is an aesthetic activity, and serious criticism of the genre can help interrogate what its

aesthetic spaces are reproducing and inventing. For instance, *The Incredibles* may counter the technoutopian ideal embedded in fantastic-mundane technology, but however amusing the family of Supers appears, and however emancipatory their aesthetic spaces seem, their obvious powers are not ours; we are left to the fate of Syndrome, Gilbert Huph, and Edna Mode—relying on technology, the market, or vicariousness to satisfy our individualist desires.

Disruptive Sensation and the Politics of the New *(Ratatouille)*

The world of *Ratatouille* explores how sensorial events, such as fine dining and physical comedy, contribute to radical changes to communities and individuals. The film presents representations of sensation and explores how sensation disrupts representation—that is, how the everyday aesthetic experience of sensation can disrupt and reconfigure the systems of meaning that individuals employ to understand the world around them.[1] Like other Pixar productions, *Ratatouille* participates in the cultural transition to digital media and rapidly advancing intelligent technologies by presenting allegorical narratives, but *Ratatouille* is distinct in its focus on sensation and mediation. Furthermore, its explicit concern with introducing and defending "the new" can be read as a political allegory for including formerly excluded elements within democracy.[2] The category of "the new" pertains to Pixar's historical position at the forefront of an expanding animated film industry, and these allegorical readings are supported by the film's three themes—"anyone can cook," "the new needs friends," and "change is nature." Through these themes the film expresses how sensation, creativity, and vulnerability are central to transitions to new media and new democratic formations.

This thesis relies on an understanding of sensation as a form of aesthetic experience and aesthetic experience as having a political

dimension. This treatment of sensation differs, however, from the *anima minima* described by Lyotard, in which aesthetic sensation at its most basic level is an unrepresentable infinite that amounts to an ethical connection with the Other.[3] Instead of such a sublime effect, sensation in *Ratatouille* approaches what Jacques Rancière refers to as dissensus. That is, it disrupts a given social and perceptual order determining what bodies are allowed where and what they are allowed to do. Rancière refers to this as the aesthetic dimension of politics, and it illuminates how *Ratatouille* addresses democratic theory.

Democracy, for Rancière, is not simply a state ruled by the many or by a sovereign collective of representatives but, more precisely, involves the activity of disrupting what he calls the police order and altering a given distribution of the sensible through instances of dissensus. The police order refers to the forces sustaining the hierarchical organization of society. The partitioning or distribution of the sensible refers to "the implicit law governing the sensible order that parcels out places and forms of participation in a common world by first establishing the modes of perception within which these are inscribed"; it determines who or what is perceptible.[4] Dissensual events interrupt a given distribution of the sensible and enable a reconfiguration of perception, or what is perceptible, and thereby the coordinates of any political debate. In democracy dissensus neutralizes the logic of the *arkhè*—that is, when "the exercise of power is anticipated in the capacity to exercise it, and this capacity in turn is verified by its exercise"; in other words, because you can, you will, and because you did, you can.[5] This logic legitimates hierarchy and the activity of the police order. Paradoxically, democracy calls for the dismissal of dissymmetrical positions and disrupts this logic.

Rancière writes, "Democracy is this astounding principle: those who rule do so on the grounds that there is no reason why some persons should rule over others except for the fact that there is no reason." This structure facilitates political community. There are many ethical structures within this community where one party dominates another, but

because the democratic principle exceeds all of the other principles governing social organization, a political community develops.[6] This is what Rancière refers to as the democratic supplement. The demos supplements dissymmetrical structures. In regard to the demos Rancière writes, "I have called it the part of those without part, which does not mean the underdogs but means anyone. The power of the demos is the power of whoever."[7] The "anyone" of the demos designates a heterological element but one that is endlessly substitutable. In Rancière's formulation the ethical order, the police, which operates by *arkhè* logic, is supplemented by the demos and the notion that anyone can rule. Democracy "can be said to exist only when those who have no title to power, the *dēmos*, intervene as the dividing force that disrupts the *ochlos*," that is, the community obsessed with pursuing its unification.[8]

As we will see, the proposition that "anyone can" is central to *Ratatouille* and contributes to the sensorial disruption and reorganization experienced by the characters. The emphasis on sensorial effects, transmission over representation, is not new to cinema, but in this case the animated feature builds on animated film's tradition of addressing aesthetic experience explicitly. As *The Incredibles* demonstrates, in order for fantastic animation to disrupt realism, there must be a given amount of realism in the animation beforehand, established through representations, images that are recognizable and correspond to something else. This ensures that animated film maintains the ability to interrogate and disrupt the conventions of realism in moving image media.[9] Animated film in such cases remains representational, but the humor and pleasure typically derive from the breaks with representation and resemblance—when the animation breaks rules and conventions. In light of this, *Ratatouille* holds a prominent place in Pixar's oeuvre since it is about a new technical and bodily aesthetic that radically reconfigures the way individuals and communities function, and within that narrative, sensation provides the critical moments of disruption that lead to reconfiguration. This narrative continues Pixar's tradition of

reflexivity in that it, too, can be read as an allegory for the sensorial and social effects of new digital technologies, particularly computer animation.

Ratatouille presents a world similar to our own that is changed radically by forms of the new. The first form is the rat protagonist, Remy, who can comprehend human language and has highly developed senses, attributes that enable him to pursue his passion of becoming a chef. Then there is the unusual partnership that Remy forms with the human Linguini, a struggling garbage boy working at the former five-star restaurant, Gusteau's, in Paris. After Linguini and Remy learn that they can communicate, that Remy is a talented cook, and that Linguini's job is in jeopardy, they develop an arrangement in which Remy controls Linguini's movement by pulling on his red, curly hair. Through this Remy-Linguini apparatus, the two become a great chef and temporarily restore Gusteau's to its former glory. The food cooked by the pair serves as a third form of the new that amazes patrons and leads to changing the life and philosophy of notorious food critic Anton Ego.

ANYONE CAN COOK AND THE POLITICS OF SENSATION

The democratic thematization in *Ratatouille* is developed through the cookbook written by the chef Aguste Gusteau ("gusto"), titled *Anyone Can Cook*. Sensation is critical to the anyone-can-cook ideology propagated by Gusteau; it provides it with a sense of fairness and democracy since everyone can participate. The idea that anyone can cook generates the possibility for Remy the rat's adventure and the social changes it initiates. The claim that cooking is not reserved for a certain class or artistic elite is controversial among the food critics in the world of the film, but it garners hope in Remy, who learns to read and to cook through Gusteau's cookbook. Chef Gusteau, who apparently died after receiving a bad review from food critic Anton Ego, becomes an apparition of

Remy's imagination and guides Remy when he is separated from his family and clan. Thus, Gusteau's philosophy literally brings Remy into the kitchen, and it is the Gusteau philosophy that keeps him there.

Beyond the development of Remy's character, the anyone-can-cook ideology informs the drama of the film's kitchen sequences. When Remy makes a delicious soup that is attributed to the garbage boy Linguini, the head chef, Skinner, fires Linguini for cooking without permission. But since the customers love the soup, Colette—Linguini's love interest—reminds Skinner and the other kitchen staff of Gusteau's maxim "anyone can cook." The reminder elicits believing smiles from the staff and forces the villainous Skinner to allow Linguini to stay. Linguini then pursues a partnership with Remy, the real cook. In a later scene Colette relates to Linguini the diverse backgrounds represented by the different cooks at Gusteau's restaurant. Apparently, the Gusteau philosophy had a significant influence in bringing a diverse range of people and backgrounds into the same kitchen, which includes Colette, the only female cook (and one of the few female characters in Pixar). These scenes demonstrate how Gusteau's anyone-can-cook philosophy serves as the ideology holding the kitchen together. This ideology is something felt and cherished by the cooks, and it is tied to sensation—Remy's soup saves Linguini's job through its deliciousness.

In proper ideological form "anyone can cook" is a reduction that holds together inconsistencies. The food critics despise it because they interpret it literally and do not believe that just anyone can cook. Explicitly, Gusteau's cookbook and anyone-can-cook ideology set up the action of the film through a basic syllogism that challenges the elitism of the critics: if anyone can cook, then a rat can be a chef. Or, taking the film as a political allegory, if we live in a free democratic society, then anyone can be ... anything. Part of the film's tension comes from discerning how precisely to interpret the reductive mantra "anyone can cook," which becomes differentiated by Anton Ego from the more egalitarian *we all can cook*. Ego reinterprets the message in his final review to mean that a great cook can come from anywhere, which

encourages equal treatment despite known differences and inequalities because there is no means of determining who is and who is not a fine cook beforehand. The unknown future, potentiality, serves as the equalizer, because it creates a context of ceaseless substitutability, which is precisely how Rancière describes the logic of the demos. In the case of *Ratatouille,* however, there is one definitive measure of status in addition to this form of equality through substitutability: the sensation of taste.

Part of the theoretical appeal of thinking about sensation, including taste, is that it seems to consist of unrepresentable intensities that affect the body and require invention/creation to express or communicate. Sensation thus escapes predetermining structures (social, linguistic, political), and therein, sensation creates space for a person to reconfigure his or her associational life.[10] The immediacy of sensorial experience is crucial in this formulation because it does not allow for any cognitive work of comparison or analogy; no predetermined structure of sense or reason is used to evaluate or determine the use of the sensorial experience. For political theorist Davide Panagia this quality makes sensation a form of aesthetic experience, and he traces the immediacy of sensation back to Kant's analysis of aesthetic judgment and the agreeableness of sensory pleasure. Akin to judgments of beauty, sensory pleasure is not governed by prefigured concepts and affects subjects immediately, arresting attention and disrupting interest.[11] Panagia, while possibly overstating the immediacy of sensation, explains how this disruption of interest is a kind of disarticulation that contributes to a feeling of freedom:

> Rather than the disinterested subject being a version of the impartial observer, what Kant offers his readers is a subject whose interest at the moment of sensory experience is disarticulated, as are his or her conditions of subjectivity.
>
> The feeling of freedom that arises from aesthetic experience occurs because there is no governing principle in the beautiful that commands a submission to its mode of attention.[12]

The result, then, is a radically democratic project, as Panagia describes in terms apropos to *Ratatouille:*

> For Kant, anyone can experience beauty precisely because no one can determine its conditions of existence. This is the egalitarian promise of Kantian aesthetics: both the cook and the critic are afforded the occasion for aesthetic experience and neither the cook nor the critic has the privilege of safeguarding the conditions for that experience. Taste is available, for Kant, regardless of privilege.[13]

Proposing that anyone can cook and that anyone can experience beauty puts the cook and the critic on equal grounds. It is not the case that one provides the rules for the other, or that there are any rules governing aesthetic judgments, and it is the disruptiveness of sensation that disarticulates a subject and makes this evident.

In *Ratatouille* the critic who tastes the first soup that Remy illicitly made at Gusteau's writes in her review that "the soup was a revelation." Her review indicates that tasting the soup changed her life, at least her work life, and she writes that Gusteau's restaurant has regained the attention of French food critics. The sensation serves as an event that ripples outward through the critic and her work, as well as through the cooks, for whom taste is a test of merit. But the most important taste event in *Ratatouille* occurs when the food critic Anton Ego comes to Gusteau's to evaluate the cooking of chef Linguini (the Remy-Linguini apparatus). Boldly, Remy decides to make ratatouille for Ego, even though ratatouille is referred to as a "peasant's dish" by fellow chef Colette. When Anton Ego eats the dish, he has a flashback. The flashback depicts a nostalgic, country scene where the child Anton is comforted by a bowl of his mother's ratatouille. Thus, the "peasant's dish" reminds Anton Ego of his humble beginnings, before he was a famous, wealthy food critic, and it reconnects him to the feelings of comfort generated by his mother's cooking.[14] This Proustian moment motivates Anton Ego to insist on meeting the chef who prepared his meal. After the customers are gone, Linguini and Colette reveal Remy the rat, the

Figures 22 and 23. *Ratatouille* (Bird and Pinkava 2007). The flashback triggered by eating ratatouille provides a visual transformation of Anton Ego that accompanies the character's change in personality and politics. Disney-Pixar, 2007. DVD.

Remy-Linguini apparatus, and how Remy prepared the ratatouille for Ego. In this sequence the character Anton Ego experiences multiple moments of disfiguration and reconfiguration of his sensorial being. The flashback literalizes the transformation of character and setting (Figures 22 and 23). After he is disrupted by the ratatouille's flavor, Ego wants to meet and thank the chef. His character shifts from authoritarian judge to the grateful and inquisitive receiver of a gift. A second moment of disfiguration occurs when Ego meets Remy the rat, which radically alters the critic's theory of fine cooking and, obviously, the

hierarchical stratification he attaches to animals and humans and kitchens.

In short, *Ratatouille* demonstrates how sensation, as a catalyst working in conjunction with a democratic ideology, initiates processes of change; it makes way for the new. After the sensorial experience disrupts a given historico-cultural organization of the senses, a new organization (which can include memories of the past) with revised narratives must be formed. The fictional world of the film allows for similar but radical and fantastic changes to develop with little resistance. As a narrative feature marketed to children and adults, many expected complexities are omitted. For instance, the villain Skinner is depicted working alone in his pursuit of profit through mass-produced, globally distributed frozen foods. The culture supporting Skinner's behavior is left out, although many viewers might recognize it as a cartoon of their own global capitalist culture. The Skinner character is doubly problematic given that he is a villain with potentially racist coding—he is a small, brownish man with a large nose—and this further distracts from the critical work of analyzing the systemic conditions of Skinner's greed. Without the presence of these systemic conditions the democratic ideology of anyone-can-cook never becomes co-opted by capitalist formulations—anyone can become wealthy, develop a successful business, or enjoy being a powerful consumer. As an animated film, *Ratatouille* is limited by its Hollywood, global-capitalist context. Thus, the film faces the challenge of presenting a narrative about newness while being sure to follow certain entertainment rules and cinematic conventions.

The aesthetic aspects of the film's animation, however, explore sensations beyond taste that challenge conventional organizations of bodies and sensation. It is true that the realistic but stylized depictions of food aim to look appealing, fresh, and tasty. These depictions aim to resemble firsthand perceptions of food and photographic images of food, but they also involve exaggerations of shape and size, and highly stylized lighting simulations.[15] Beyond the look of food, the novelty of

Figure 24. *Ratatouille* (Bird and Pinkava 2007). The Remy-Linguini apparatus displays the translation and transmission of touch and movement and serves as a metaphor for mediated creativity. Disney-Pixar, 2007. DVD.

the animation relies on the transmission and translation of touch, coordination, and the sensorial experiences of cooking and eating. Here I am referring to the Remy-Linguini apparatus as a gimmick that entertains audiences but also serves as a possible metaphor for mediated creativity and identity (Figure 24). Remy's aptitude for cooking is transmitted through Linguini. Linguini's body transmits the feel of working in the kitchen to Remy. This activity of translation and transmission can be compared to the processes of digitization and programming that occur through a human-computer interface (HCI). It clearly alludes to the "rigging" process in computer animation, which often draws on the similarities between puppetry and manipulating digital figures.

The Remy-Linguini apparatus can be understood as a meditation on mediated existence—whether creating moving images through computer programs or experiencing the world through recorded images. Both characters' retraining through sensation correlates with understanding technical media as extensions of the human body and its senses. Their retraining resonates with the reorientation of the body during the computer age as the eye becomes a little less dominant with the rise of interactive media and gaming that rely heavily on the hands and coordination between screen-viewing and sensorimotor

knowledge. This does not mean that the animation is no longer cinematic. As film theorists have noted, cinematic expression has functioned through its presentation of shared structures of embodied existence.[16] The common experiences of embodied action and perspective shared by spectators provides sensorimotor and conceptual knowledge that lends itself to comprehending the moving images onscreen. The onscreen presentation of the Remy-Linguini apparatus, as a coordinated set of caricatured bodies, relies on embodied experience familiar to audiences but also challenges bodily norms. As in the case of learning to use new personal technologies, new technical practices and sensations assist in new descriptions and perceptions of the world.[17]

The history of modernization consists of technological developments that alter the human interface with the world, and *Ratatouille* presents a localized narrative of such an epistemological adjustment. Consider the substantial series of scenes devoted to depicting how Remy and Linguini learn the kinesthetics of their apparatus and how to cook through it. With Remy directing from his perch on Linguini's head, Linguini cooks in his apartment while wearing a blindfold. The physical comedy is here in full force, as the pair tumbles into the refrigerator, as food is tossed out the window, and as Remy is doused with wine and tomatoes. It takes some getting used to, but the pair is unbelievably adept at adapting to their reorganization. Linguini remarks that his body responds "involuntarily" to Remy's tugs, and with practice Remy learns how to mobilize that body with precise coordination. As Figure 24 shows, the main characters in *Ratatouille* experience a mirror stage comparable to those in *Toy Story* and *Monsters, Inc.* Here the characters view their new integrated bodies and identity; they are synced.

The film indulges in Remy's point of view from atop Linguini; it is clear that part of the cinematic pleasure of the film involves participating in reimagining the world—and, metaphorically, cinema—through the Remy-Linguini apparatus. As Tom Gunning notes, spectator participation is prompted by cinematic movement, which conveys a sense

of presence and reality apart from indexicality: "We experience motion on the screen in a different way than we look at still images, and this difference explains our participation in the film image, a sense of perceptual richness or *immediate* involvement in the image."[18] This quality becomes exaggerated in many animated sequences, including those depicting the Remy-Linguini apparatus. Linguini's body moves with an alien speed and coordination entirely new to him, and in addition to Remy's new view the rat gains a new kind of agency as well. Although he is not able to touch the food, Remy is free to see, smell, and create through Linguini. The "immediacy" of watching movement experienced by an audience is paired with the immediate sensorial experiences of the characters. This pairing alludes to spectators adjusting to transitions within cinema itself. After all, *Ratatouille* was released in 2007, the year D. N. Rodowick published *The Virtual Life of Film* and argued that through the continuous isomorphic recording offered by motion photography, film presents duration in a mode that digital cinema cannot.[19] While digital photography can certainly perform the duration-sensitive tasks traditionally performed by analog photography, the Remy-Linguini apparatus reminds us that knowing how something was made can alter our experience of it.

To further extend the mediation metaphor, the Remy-Linguini apparatus can be considered a figuration of the tension between immediacy and hypermediacy that persists through media history.[20] Immediacy—that is, instant and transparent access to phenomena—is typically invoked by representational images that are so precise and instantly comprehensible that the medium is overlooked. Immediacy has a slightly different function in Panagia's treatment of sensation as it contributes to total disruption in which former interests cease and new interests begin. In this formulation, sensation functions less as a moment without mediation than as a moment when the mode of mediation changes. This reconfiguration is akin to a moment of dissensus in which there are opportunities to perceive and acknowledge new persons and possibilities. Meanwhile, hypermediacy, that is, engagement with a medium that

announces itself through its multiple signs and functions, initially applies to the complex and dynamic contact between Remy and Linguini. But once they master their apparatus and it becomes second nature, the kitchen, with its multiplicity of sights, sounds, smells, and tastes, becomes the hypermediated environment par excellence.

In *Ratatouille* the hybridized subjectivity generated by the Remy-Linguini apparatus is enabled and organized by sensation. The two characters function through the coordination of movement and touch, which results in a cinematic presentation that attempts to alter the hierarchical order of the optic, the kinetic, and the haptic. Furthermore, within the narrative of the film the Remy-Linguini apparatus is secured by the sensations of the critics and customers who circulate positive reviews and continue to order dishes prepared by chef Linguini. Each taste event contributes to validating the characters' partnership. The hybridized subjectivity of the Remy-Linguini apparatus emerges through the ideology of Gusteau's cookbook, which hinges on the sensations of customers and critics. These sensations, which are democratic and unregulated by determining structures, are translated into material and cultural capital through the restaurant's success. These material conditions created by the Remy-Linguini apparatus work to maintain the apparatus. In this context sensation begins processes of solidification and organization once it disrupts and destabilizes the preceding organization. While the taste of the food prepared by Remy alters the worlds of customers and food critics, it also begins the process of solidifying and perpetuating the conditions that brought it about. For the sake of reproduction, and thereby profit, Linguini keeps his job and partners with Remy. Along these lines a negative sensation, food that tastes bad, would initiate a different organization—one that avoided repetition.

The Remy-Linguini apparatus suggests considering the coordination of bodies and how the movement and touch between bodies contributes to the production and distribution of aesthetic experiences, which in a Parisian restaurant are also commercial experiences. The

innovation of the bodily partnership between Remy and Linguini—the new sensations, feelings, and food it produces—evokes post-Fordist, affective labor conditions in which employees are asked to be innovative and flexible workers. In these conditions workers typically suffer from contingent labor agreements and are encouraged to be individualistic, competitive entrepreneurs but also well-connected and networking agents. The precarity and exhaustive demands of these conditions leads Sianne Ngai to dub "zany" as one of the aesthetic categories typical of late capitalism. Zany performances and depictions abound in late twentieth-century films and television shows; for example, Ngai discusses at length Lucille Ball in *I Love Lucy* and Jim Carey in *The Cable Guy*. Many of these are characterized by an excessive intensity that is amusing from a distance but is not the kind of performance that audiences desire to imitate.[21] The zany performance expresses an excessive demand for activity (animation?). Perhaps the most cynical reading of the Remy-Linguini apparatus is that it is the zany result of exploitative demands coated in Pixar's charming style and inevitable happy ending. While this is certainly a fair reading, it does not negate the more generative reading available through attending to the disruptive feelings and sensations depicted throughout the film. Considering the Remy-Linguini apparatus in the context of Paris and a realistic restaurant raises the stakes for what Remy and Linguini become. Their becoming challenges the order and organizations of that reality. The Remy-Linguini apparatus challenges the distribution of the sensible in the world of the film and presents to viewers not only an example of dissensus but also a cinematic sensorial experience. Reading the Remy-Linguini apparatus metaphorically illuminates how this unconventional relationship resonates with the human-computer and human-cinema relationships that typify modern life. These new partnerships are not simply economic engines; they are political ones that influence worldviews and habits of thought.

The film posits taste as an idealized, impartial judgment of merit that forms the basis of the values at Gusteau's restaurant and in the

French culinary community in the film. This ironically counters taste's long association with elitist, classist, and aristocratic social customs. The film's treatment of taste, like treatments by Panagia and Rancière, foregrounds its aesthetic core, which is sensorial and irrational and available to anyone, and this is how a rat ends up cooking in a restaurant. Once the democratic theme is presupposed (believed in), as it is by the cooks in Gusteau's restaurant, then the restaurant as a political system is ripe for the entrance of the new. The film is an example of a universal or ideal content becoming concrete. It gains an ironic tension in that the ideal content (anyone can cook, taste defines cooking, and taste as a sensation is democratic and fair) is more realistic or believable than the concrete content (Remy the rat is a great chef).

The film plays with the democratic quality of sensation by depicting two communities that value Remy's talents differently. Remy's rat family, or clan, could not care less about his cooking ability. His heightened sense of smell and taste is only valuable to them as a means of detecting poison. Remy's cooking does not provide any of them with the pleasurable sensations that would prompt a reorganizing of their community, even though Remy repeatedly tries to teach his brother, Emile, how to appreciate different flavors and combinations of flavors. But the human community to which Remy is covertly exposed does appreciate his cooking. In accordance with a degree of realism the rats' bodies work differently from the humans and therefore have different sensations, which results in a different social organization. Remy's senses, and the sensations that his cooking evokes, correspond with the human community more than with the rat community. Thus, before the hybrid subjectivity of the Remy-Linguini apparatus and its reorganization of sensation in the film, the character Remy is already hybridized by his anthropomorphism. His hybridity is not purely intrinsic but is cultivated by Gusteau's cookbook. In anyone-can-cook ideology, sensation serves as an impartial judge that can accommodate hybrid subjects such as Remy and the Remy-Linguini apparatus. In Rancièrian terms the hybrids in the film persist through the category of the demos. Remy

and then the Remy-Linguini apparatus are heterological elements that reshape society through the categories provided by a democracy organized around aesthetic experience. Sensation is at the center of the universal content of the ideology; therefore, it is at the center of the social organization that holds it. Furthermore, the metaphorical reading of the Remy-Linguini apparatus helps us recognize how our creative, sensorial relationships with media participate in constituting the political landscape of everyday life. In the world of the film, if a new partnership between a human and a nonhuman presents pleasurable sensations that benefit a business and community, then it is likely to thrive.

THE DISCOVERY AND DEFENSE OF THE NEW; OR, "THE NEW NEEDS FRIENDS"

Gilles Deleuze's *Logic of Sense* begins by describing the paradoxical quality of becoming through the example of Lewis Carroll's *Alice in Wonderland*. In the story Alice repeatedly grows or shrinks or travels from place to place. She is either changing from what she was, or she is changing into what she will become. This becoming unhinges or destabilizes her identity; she literally loses her proper name.[22] The world of *Ratatouille* is not that of Alice, but there are characters that change radically. Remy moves from being part of a clan of rats living in the attic of a small house in rural France to forming a pact with a human, to cooking in a five-star restaurant and living in Paris. Likewise, Linguini and Anton Ego change in social position, occupation, and their relation to animals. We have discussed sensation and its disruptiveness, but the aspects of becoming and animality provide the film with the central tension between the animal world and the human world. As I suggested in the foregoing discussion, the immediacy of sensation has its democratic interpretations, but it does not account for the instability already present within bodily and social organizations. Beyond the sudden affective intensities of sensation, processes of becoming involve slow, complex forms of change.

First, here is a more precise definition of *becoming* that Deleuze and Felix Guattari develop in *A Thousand Plateaus:* "Starting from the forms one has, the subject one is, the organs one has, or the functions one fulfills, becoming is to extract particles between which one establishes the relations of movement and rest, speed and slowness that are *closest* to what one is becoming, and through which one becomes.[23] In *Alice in Wonderland* Alice's body, and the many organs, tissues, and particles that constitute it, continually changes; the parts are not able to maintain stable coordinates and relations with the world that they are moving through, expanding and shrinking in. When "becoming" is advanced as a concept in *A Thousand Plateaus*, it fills the book's largest chapter "1730: Becoming-Intense, Becoming-Animal, Becoming-Imperceptible." The passage quoted above highlights the processes of extraction and the relations of movement essential to becoming. Becoming dissolves the solidity of identity through a subject's acquisition of components, traits, or functions from some other entity. Granted, this acquisition is not an exchange of parts or resemblance or imitation or metaphor; it is not representational. Since all bodies consist of a multiplicity of parts, Deleuze and Guattari consider a body an assemblage, and they understand an assemblage by what it does, its affects, not what it represents. Furthermore, "becomings are minoritarian," meaning that they involve a move away from power and privilege: "in this sense women, children, but also animals, plants, and molecules, are minoritarian." Thus, becomings pass through each other; one must first become-woman, then become-child, become-animal, and so on "toward becoming-imperceptible."[24]

To clarify these definitions, Deleuze and Guattari provide many examples from music, literature, and film, and apropos *Ratatouille,* one of the most lucid recurring examples deals with rats. The "Becoming" chapter begins with the example of the 1972 film *Willard,* which is about the character Willard's precariously close relationship with a pack of rats, and the chapter returns multiple times to rat examples to illuminate the concept of becoming-animal. Leonard Lawlor has followed this recurring rat motif through Deleuze and Guattari's oeuvre in an

effort to develop an argument against naive positions of human dominance. In "Following the Rats: Becoming-Animal in Deleuze and Guattari" Lawlor describes how becoming-minor happens through aging. That is, as we age, small changes (in our bodies, our social lives, our environment, etc.) open up cracks for the new to enter. Becoming is not the life-changing moment where one crosses a threshold or hits rock-bottom. Instead, becoming is a gradual process that moves toward an unknown. Lawlor recognizes that successful becoming results in producing written work—for example, writing, a map, or a drawing.[25] To arrive at this conclusion, Lawlor works through another key example from Deleuze and Guattari: "The Lord Chandos Letter," by Hugo Von Hofmannsthal.

A seventeenth-century nobleman, Lord Chandos, writes a letter shortly after he has poisoned and witnessed the death of a whole pack of rats. When he writes the letter, he claims to no longer be himself; he is older, and something from the rat experience has gotten inside of him. This causes him to write differently. Deleuze and Guattari call this "writing like a rat": "Hofmannsthal, or rather Lord Chandos, becomes fascinated with a 'people' of dying rats, and it is in him, through him, in the interstices of his disrupted self that the 'soul of the animal bares its teeth at monstrous [*sic*] fate': not pity, but *unnatural participation*. Then a strange imperative wells up in him: either stop writing, or write like a rat.... If the writer is a sorcerer, it is because writing is a becoming, writing is traversed by strange becomings that are not becomings-writer, but becomings-rat."[26] The Lord Chandos character finds himself in a predicament where his only means of proceeding with his letter is to "write like a rat." This parallels the sort of experiences that Remy, Linguini, and Anton Ego endure in *Ratatouille*. Immediately following intense, sensorial encounters with another species, these characters can only proceed by becoming-animal—for Linguini and Anton Ego, becoming-rat. On this point one must consider that for Remy, becoming-human is extremely unpopular and disapproved of by his family and clan.

Lawlor writes, "The formula for this becoming therefore is: the rats become a thought in man, 'a feverish thought,' while the man becomes a writer who writes like a rat." Lawlor claims that this different kind of writing is the product of becoming, and it can lead to a collective that thinks differently and therefore has different relations to animals and the world: "Chandos becomes rat *so that*, writing like a rat will call forth a people"; and this writing would be "a writing that struggles to escape from the dominant forms of expression." Lawlor makes explicit his critique of the human dominance of animals, but he also suggests a claim similar to Panagia's thesis about common sense: "Following the animals means writing like the animals. As we have suggested, this kind of writing—to write like a rat—would challenge and question common sense."[27]

The narrative of *Ratatouille* follows this logic. For one thing, Remy and Linguini become increasingly vulnerable as they age: Remy loses his clan and must begin a new life; Linguini loses his mother and must get a job—he begins as a garbage boy. Their mutual vulnerability creates cracks through which they can enter each other's lives and form their apparatus. The new being that they create sets to making food for other people, but Linguini is now cooking like a rat and Remy is cooking like a human. Remy's senses are added to Linguini, and Linguini's body is added to Remy: both characters become something else. Linguini's physical comedy, where he is hunched over, moving, darting around the kitchen to smell and grab things is precisely when he is scavenging like a rat. It is a becoming-minor for Linguini because he gives up the dominance of his eyes, his nose, and his bodily autonomy. And as I have mentioned, a parallel situation is written into Remy's character since he must resist and reject the ways of his family and clan to become part of a human apparatus—Remy as a subject hybridized by his sensorial capabilities was already becoming-human. The food produced by this apparatus is delicious and "new." It is a "revelation" for patrons and critics, and the restaurant's following and status grow. And the movement culminates in the becoming-animal of Anton Ego.

On hearing the news that Gusteau's restaurant is popular again, Ego retrieves and reads his old review that condemned Gusteau's to the "tourist trade." The news creates a micrological crack in Ego and opens him up to the new. After dining at Gusteau's and learning about Remy, something of the animal and Remy-Linguini apparatus makes its way into Ego because not only does he write a review in defense of Gusteau's and "the new," but he then invests in a restaurant for Remy the rat to cook in. Ego loses his job for endorsing a restaurant closed by the health inspector, but his becoming-animal produces the written review, and his new restaurant provides jobs for both Remy and Linguini to continue to develop. Ego writes in his review that it is the critic's job to discover and defend the new; this is one of the few risks that the critic takes, but, Ego argues, "the new needs friends" or it will disappear. This conclusion echoes Lawlor's: that becoming generates artifacts that call forth other people.

Ratatouille, then, presents becoming as a process motivated by aging and sensation; it presents becoming-animal as a form of vulnerability; and it presents the food produced by Remy and Linguini's becoming as work that calls forth other people. This includes the becoming-animal of Anton Ego, who likewise, produces work in the form of his written review. It may be funny in this cinematic case, but becoming-animal is a form of self-humbling that opens up new choices and actions, which is akin to Rancière's dissensus since it changes the coordinates of politics in the context of the film. The film features both dissensual events and characters demonstrating becoming-minor. The addition that *Ratatouille* makes, in this regard, is that the writing or map generated through becoming-animal, instead of a letter like Hofmannsthal's, is food. The food becomes a sensorial artifact that embodies the trace of its hybrid, heterological production. Cooking, then, like all art, demonstrates the extended objectification or formalization of sense experience. The alternative sense experiences of Remy and Linguini lead to the outcome of delicious food, and this food leads in turn to a generative body of verbal and written criticism. Sensations become aesthetic when they

generate particular forms available for judgment, that is, when they become available for public consideration.

But the film does not rely on a mere circular logic of sensorial events that initiate social changes, which generate more sensorial events. For sensation to radicalize the characters, they must already be vulnerable to it by becoming-minor. As in a political or religious conversion, one's doubt in a given system becomes belief in another. While sensation itself is democratically available and disruptive, how a subject responds or processes her own reconfiguration depends on a longer history of vulnerabilities and material conditions.

Hence, the villain Skinner, who partakes of Remy's ratatouille dish at the same time as Ego, is profoundly affected by its flavor, but his reaction oscillates between an envious loathing and a disabling delight. Skinner, like Ego, wants to meet the chef, not to thank him but to destroy him. The disruptive flavor of the ratatouille exacerbates Skinner's villainous character. Over the course of the film the character Skinner becomes more villainous as he becomes more vulnerable to losing his restaurant to Linguini (the secret offspring of Gusteau). The inheritance plot that surrounds Linguini assists in the film's realism. It generates a vulnerable situation for Skinner, and it gives Linguini a more secure place at Gusteau's. The implication here is that while the motto "anyone can cook" is generally believed in by the cooks, it is not law and not powerful enough to warrant Linguini's place at the head of the restaurant, even if, thanks to Remy, he is the best cook. This realistic gesture is critical because otherwise the new, as in Remy the chef, would not need to be defended against an oppressively regimented world. The upshot, then, is that for an anyone-can-cook community to function in a world that resembles our own, sensation, vulnerability, and change need to be secured by the very rules of that world. The film itself can be understood as a thought experiment that creates a controlled world for a sensation-based, democratic community to thrive. The film champions characters that are vulnerable to sensation, radical change, and becoming-minor through the category of the demos.

CHANGE IS NATURE

For more than seventy years Disney has been selling princesses and princes to democratic nations. Disney's early animated feature films (1930s–50s) are mainly about lead characters discovering their authentic, noble selves, and this thematic was revitalized in the animated films of the 1990s. M. Keith Booker argues that we can read these films as placing the authentic self on the side of nature and biology instead of culture, which makes it a kind of "essential" self. Instead of endorsing an ideology about self-made, social mobility, Disney films have tended to advance messages about inherent nobility and virtue overcoming socially oppressive situations. The princesses and princes may start out as impoverished, persecuted, and oppressed, but their heritage and indomitable essence, and that of supporting characters, will eventually make things right, producing the utopian, fairy-tale ending.[28]

Pixar's productions have inherited much from this Disney tradition. Many of the studio's animators, artists, and directors worked for Disney before it acquired Pixar in 2006 for a net price of $6.3 billion, and many were trained at the California Institute of the Arts founded by Disney.[29] They have been influenced by Disney's illusion-of-life aesthetic, and they share an optimism and belief in technology. Pixar's narratives respond to its digital medium and the technical contexts surrounding it, but these responses differ from classical Disney's idealistic naturalism. Unlike Disney, Pixar's early films are void of musical numbers, magic, and the medieval worlds that provided a nostalgic salve to modern life. Instead, many of Pixar's features present nostalgia for modernity in the context of postmodernity. This is certainly the case in the *Toy Story* films, *Monsters, Inc.*, and *The Incredibles*. And it can be read into *Ratatouille*, as my metaphorical reading suggests, by comparing the Remy-Linguini apparatus to computer animation and human technologized life more generally.

Relevant to this topic is a key conversation between Remy and his father. After Remy experiences success through his partnership with

Linguini, he is reunited with his family and clan, and, while outside in the rainy street, he stands with his father before a glass storefront displaying dead rats (an exterminator's shop). Remy's father, Django, reminds Remy that humans are a powerful enemy. He tries to persuade Remy to leave the human community and assume his rightful place within the rat community. But Remy objects:

> REMY. No. Dad, I don't believe it. You're telling me that the future is... can only be... more of this.
>
> DJANGO. This is the way things are. You can't change nature.
>
> REMY. Change is nature, Dad—the part that we can influence, and it starts when we decide.

Through this naturalization of change Remy justifies not only his becoming-human but also his essentially anthropomorphic self. Remy experiences, within himself and in the world, existence as multiple and fluid: he identifies with both rats and humans, and he has changed along with his shifting environment. The "change is nature" theme maintains an essentialism and pursuit of authentic self typical of Disney but presents a revised ontological formulation. Instead of Remy's search for his authentic self uncovering an inherent nobility that returns stability and security to the world, Remy discovers that subjects and worlds continually emerge. This leads to the utopian ending of *Ratatouille* with the formation of a harmony between human and rat communities. In Anton Ego's restaurant, Remy cooks in the kitchen with Colette and Linguini, the humans dine on the main floor, and the rats dine in human fashion in the rafters hidden from human view. This dual-species order presented at the film's end is strikingly different from Disney endings, which usually involve a return to utopian stasis and hierarchy as in *The Lion King*. If *Ratatouille* had been made in classical Disney style, the character Linguini would be the lead with Remy as sidekick. The Linguini character, after all, is part of an inheritance plot.

Remy's motto "change is nature" naturalizes cultural change. Instead of expressing cultural evolution as apart from biological evolution, this

motto replaces the modern split between culture and nature with a single narrative that recognizes human activity as part of nature. It does not endorse a social constructionist view since Remy qualifies the motto by indicating that he is referring to "the part [of nature] that we can influence." The rats, as anthropomorphic, autonomous individuals, take part in constructing nature but Remy's word choice indicates the recognition of a natural world extending beyond their influence as well. In other words they are a part of nature: they take part in shaping it, but they do not constitute its totality, nor do they consider it as only having meaning through their subjective viewpoint. Bridging the culture-nature divide contributes to preparing us for the posthuman outcomes of our own cultural evolution (i.e., our self-destruction or displacement by the technology we create) and recognizes the agency of nonhumans in a way that Disney's magical worlds never could.

The main claim here is that while classical Disney animation refers back to gothic and romantic imagery and to fairy tales when presenting its innovative, illusion-of-life animation, Pixar animation refers to modern consumer goods, media, and industry when presenting its hyperrealism animation. As I have discussed with respect to Leon Gurevitch's work, Pixar films can be understood as offering a form of consumerist, media culture training. This capacity is effectively enhanced by the lack of essentialism in animated film to the extent that it opens space for alternative forms of essence, like the product essentialism of the *Toy Story* films. In contrast, classical Disney's naturalism holds on to a modern biological essentialism, whereas Pixar's naturalism incorporates nonhumans (animals and artifacts) that more thoroughly disrupt modern social hierarchies. The same openness that lends itself to the product essentialism of *Toy Story* is that which lends itself to the democratic allegory presented in *Ratatouille*. The latter offers a more promising form of sociocultural change by showing how sensation, becoming-vulnerable, and creative apparatuses contribute to new modes of existence within a democracy.

Ratatouille employs the premise of sensation as central to democratic activity in order to bring a nonhuman-human apparatus into the

diegesis (kitchen) of the film. The Remy-Linguini apparatus is a het-erological element within the "anyone-can-cook" democracy and per-sists through the category of the demos. Democracy, in the world of the film and in Rancière's formulation summarized above, is inherently variable in its generation and integration of the heterological, which necessitates repeatedly reorganizing the political system. The implica-tion is that this notion of democracy is well suited to accommodate the increasingly serious demands of posthuman scenarios and to recognize the agency of nonhuman actors. But the film's characterization of becoming as a vulnerable process, susceptible to history and material conditions, complements this theory of democracy with a representa-tion of some of the work needed to maintain it. As described above, the Remy-Linguini apparatus requires support from other characters, and it needs the support of inheritance law. This is not too different from Pixar's history with its own list of benefactors: Alexander Schure, George Lucas, and Steve Jobs. Without these investors and the capital-ist state supporting them, the technical innovations and the brain trust of the group would not have developed into Pixar Studios.[30]

Although not resolving the tension between the film's realistic and fantastic depictions, the film's final theme, "change is nature," provides a rationale justifying mediated expertise and merit against the con-servative political claims of Remy's father, Django, who argues that there is a natural order to be followed. By dethroning natural order and reason, sensation, becoming-vulnerable, consensus ("the new needs friends"), and creative apparatuses become even more powerful in the politics of reorganizing democratic society. Unfettered by external authorities (Nature, Reason, God, etc.), the allegorical democracy pre-sented in the film is subject to an internal authority, sensation, and with sensation as judge, the "anyone can" category is extended beyond national borders and then beyond species borders. Unfortunately, this democratic formulation appears homologous to a basic capitalist and consumerist formulation in which social order has no appeal to exter-

nal authority beyond individual sensations, feelings, and the creativity of human action cultivated in and for the marketplace. As seems to be the case with aesthetic experience generally in the context of late capitalism, it is at once a generative source for political thinking and the site of social control and regimentation.

Conclusion

This book treats aesthetics as a contested domain. The Pixar films it analyzes tell stories in which fictional, computer-animated characters interact with fabricated worlds and therein address aesthetic experience. These stories evoke familiar aesthetic concepts and the contradictory, transformational logics that tend to characterize them. Although these aesthetic concepts and experiences are generative and creative and lead to new community formations within the films, they also express the precarious demands of creativity labor, personalized digital commodities, and vast technological infrastructures. The uncertainty portrayed by the characters is likely to resonate with viewers to the extent that both wonder about the rules and limits of the animated worlds. It seems significant, then, that many of Pixar's early films feature a fantasy-realism balance that evokes modern society—whether the nostalgia of the *Toy Story* films, the networks and industrial structures of *Monsters, Inc.*, the 1960s liberal Americana of *The Incredibles*, or the culinary scene of Paris in *Ratatouille*. These animated films continue to address aesthetic experience through characters exploring worlds, but they also present distorted versions of our own world that are ripe for being explored anew. This form of storytelling promotes the contemplation of new encounters and particular appearances and, by extension, encourages

questioning how spectatorship and judgment relate to our own being in the world.

An animated film, whether photographic or computer-generated, presents views of *a* world and of *the* world. This includes traces of human labor, decision making, and imagination. Human decisions may be delegated to software, but this does not erase the trace of human labor and the material world. It only obscures it. Different forms of animation have different technical mediators that shape and style the view of the world offered. This raises the question of what to attend to when watching animated films. Do we search for the human traces or appreciate the distance and obscurity generated by the layers of mediation? This is not an either/or question necessarily, but there are conditions that influence and restrict forms of attention. If animated cartoons are merely appreciated for being otherworldly, then audiences risk overlooking animation labor and historical conditions. This traditional reception warrants close reading of cartoons, one frame at a time (which is easier with digital tools), to reveal the conditions and world of production.[1] This exercise offers substantial political insight into labor, craft, and the animator imagination, but what then is revealed, if anything, by attending to the obscurity and otherworldliness of animated cartoons?

These questions assume that making distinctions and connections between *the* world and *a* world is largely the responsibility of the spectator, and spectators themselves are mediated by technology, culture, history, and environment. Given how often the same media and materials are used for historical or scientific purposes and for artistic purposes, there are numerous occasions for spectators to decide whether or not to read against the grain of an interpretive tradition. In these situations it can be easy to forget that part of the knowledge produced through analytical readings includes an awareness of the space for switching modes of reading, interpretation, and judgment.

Instead of valuing animated films for presenting a view of *a* world or a view of *the* world, the position of this book is that many of these films, whether photographic or computer-generated, address the process

through which perception and sense experience lead to a meaningful sense of *world*. Following Bazin and Cavell, who appreciate ambiguity and uncertainty presented through film, the approach to animated films deployed in this project has brought to the foreground how animated films, Pixar's in particular, explicitly address ambiguous and uncertain views.[2] This can be observed through characters learning or discovering the physical and social rules and limitations of their worlds. A character's exploration of an artificial world may then serve as a projection of an audience's desire to experience the world differently or to experience a different world. This corresponds with audience expectations for new organizations of sense experience and the suspension of their own judgment when watching animated films. The obscurity of and distance from recognizable traces of everyday work and materials are fundamental to this address of aesthetic experience. As described in the first chapter, the absence of human actors and the presence of extensively mediated human performances contribute to a relief of conceptual burdens and offer a thorough interrogation of nature. This aesthetic storytelling tradition affirms dialectical theories of animation that emphasize the capacity for animated film to deconstruct, subvert, and denaturalize, while also naturalizing and reproducing norms, values, and notions of social and natural order.

In the Pixar films I have discussed, the discord and uncertainty internal to aesthetic concepts contribute to this animation dialectic. In these films there persists the idea of sensitive characters making sense of worlds, and this resonates with a range of challenges to human perception and understanding. The *Toy Story* films, for instance, offer uncanny depictions that address uncertainty about contradictory commodity logics. These logics thrive in highly automated contexts that render technology intensely personal and relational while being mass produced. *Monsters, Inc.*, likewise, offers an opportunity to contemplate how the ego-affirming, technological sublime associated with industrial structures, complex systems, and detailed digital moving images differs from postmodern formulations of the sublime. This is represented by animated characters that

express how the uncontainable and unknowable qualities of sensorial, interpersonal experience can both undermine the stability of structured environments and serve the liquid infrastructure of late global capitalism. *The Incredibles* contemplates how building mundane and fantastic depictions of life through computer animation resonates with contemporary conditions in which social order is maintained through routine and exceptional experience and through advanced and personalized technologies. In this context the mythic order of superheroes appears as a clearer social hierarchy that delivers consumers and citizens from the deceptive machinations of a technology- and market-driven, competitive, liberal society. Finally, *Ratatouille* offers an exploration of the relationships between taste and democracy and between sensation and mediated creativity. While suggesting cynical readings about the precarity of post-Fordist, innovative workers, the film also presents optimistic depictions of disruptive sensations and processes of becoming that expand society. In each of these analyses perception, feeling, and knowing are treated as activities integral to aesthetic experience. And conceptualization of these activities— uncanny, sublime, fantastic, taste—reveals the extent to which they are fraught and vulnerable activities fundamental to social organization and being in the world.

What this analysis adds to accounts of neoliberal and digital culture is the idea that Pixar films are not simply addressing our technological and market-based condition; they are addressing our aesthetic condition as well. This condition includes the constant stimulation of feelings and affects by market forces, the centrality of individual creativity in the realm of labor, and the challenges the human faculty of judgment faces in the fast-paced, abstract world of late capitalism. The aesthetic concepts raised by the films highlight the personal and social discord common to aesthetic experience. They at once affirm a subject-world formulation but problematize any notion that knowing the world is separate from being affected by the world. This sets up a direct connection between how characters feel the world and how they feel about the world. Experiences that hyperbolically influence perception—moving

like a rat, running on water, encountering a toxic child, or discovering living toys—have an equally large political effect in the fictional lives of the characters. Watching animated films, then, offers an opportunity to think about these dynamics from a considerable distance. Instead of being subject to a barrage of stimulating forces, spectators can step back and think about the intimate, contradictory relationships between persons and commodities, between ideological objects and intimate contact, between mundane and fantastic practices, and between taste, sensation, and democracy.

This aesthetic condition implies that the era of modernization that Pixar films address entails serious challenges to the human faculty of judgment. As we saw in the first chapter, aesthetic concepts follow from the activity of judging, which formalizes and communicates experience. In recent history the proliferation of screens and advances in computer graphics have generated a surplus of appearances. Digital media landscapes stretch consumer attention, commodifying it and converting it to labor. These processes occur through a speedy and massive technological infrastructure that is not always visible or representable. This infrastructure contributes to the extensive and intensive growth of the marketplace and its abstraction of value. In her study of aesthetic categories in this late capitalist context, Sianne Ngai concludes that "the rise of the zany, the interesting, and the cute suggests a certain dialing down of the affective force of judgment (if not its total disappearance) in aesthetic experience and discourse in general." More specifically, the realm of autonomous art displays "a weakening of the verdictive dimension of postmodern aesthetic experience" in that artworks increasingly judge themselves and include the tropes of evaluation in their performance and display.[3] On the one hand the modern tradition of judging art with respect to its autonomy seems to be waning. On the other hand, popular culture is increasingly interested in judgment as illustrated by reality television featuring all manner of competitions from singing and cooking to fashion design and tattoo art. Ngai suggests that these shows are part of a broader cultural

phenomenon that aestheticizes work in general. The dramatization of judgment correlates with post-Fordist labor that is increasingly performative and reliant on personal creativity.[4] The inclusion of panels of judges and audience votes reaffirms the interactive sociality of judgment and offers audiences the opportunity to position themselves with or against a formalized judge, expert, or other authority figure.[5]

Pixar's animated films address this condition in a very different fashion. These films offer an opportunity to consider the difficulties and functions of judgment but with significantly lower stakes and stranger outcomes. Comparable to culinary reality television shows, the characters Remy and Linguini face the judgment of professional food critics, which alludes to the judgment that creativity workers face generally. But the fictional world of *Ratatouille*, with its anthropomorphism and fantastic elements, facilitates thinking about taste, sensation, and becoming at a greater remove from the concepts and customs that give "reality" to reality television—namely, the recorded unscripted performances of working people. We might even say that the animated film is a less social form. Granted, this distance may help audiences isolate and think about the relationship between aesthetic judgment and being in the world without feeling that they are part of the show. The address of aesthetic experience includes a withdrawn spectatorship that enables judging the faculty of judgment itself.

The notion of withdrawn spectatorship is too old and problematic to unpack at the end of a book, but the obscurity and otherworldliness of animated films does prompt reconsidering it along with the concept of judgment. Focusing on judgment rather than interpretation or evaluation shifts analysis onto a more fundamental, epistemological terrain that is actually quite appropriate for animated films that explore being in the world. The central idea here is that being-in-the-world necessitates judgment because worlds are made of particularities, or, as Hannah Arendt writes in *The Life of the Mind*, "Plurality is the law of the earth."[6] This plurality or world of particularities includes the distinct standpoints of individuals and the basic diversity of appearances that constitute everyday

experience. Implied in this formulation is the idea that any object (not just other humans) can become a subject with a particular standpoint. The fact of this plurality affirms human interest in depictions of other worlds and characters exploring them. The degrees of difference and unknowability present in the world are hyperbolically re-presented in many animated films. In short, the very real presence of different entities compels imagining even more radically different entities.

Moreover, it is worth noting that for Arendt this relationship between plurality and judgment emerges through aesthetic experience. Arendt famously borrowed from Kant's formulation of aesthetic judgment to propose that aesthetic experience is essential to thinking and living in a pluralistic environment. She thought judging to be a fundamental aesthetic and political activity that reckoned with new, particular experience by considering the presence of others who likewise experience the world from particular standpoints.[7] What is interesting about Arendt's work is that she considers judging as a political and reflective activity that entails both sociality and withdrawn spectatorship.[8] A spectator retreats from active engagement in the world in an effort to view activity from a distance in order to be less involved and better able to view and then judge the activity in its entirety. The action of retreat establishes a particular viewpoint, and judgment from a viewpoint presupposes contention with the views of others. Withdrawn spectatorship is not a sustained avoidance of the world if it serves intersubjective activity. In a succinct parenthetical statement Arendt expresses this point in terms of taste: "You must be alone in order to think; you need company to enjoy a meal."[9] This formulation illuminates the critical function of animated films and other media that distance themselves from reality but, nevertheless, focus on aesthetic experience and, in turn, living with others. Contemplating the aesthetic condition of being in the world through watching a film anticipates critical, public discussion about our shared aesthetic condition.

While spectatorship of Pixar's animated films enables us to step back and see the contested realm of aesthetics, it is critical to remember that

spectatorship is not a solitary activity. Spectatorship promotes a space for shifting modes of reading and interpretation that are just as imaginative and alternative as the media analyzed. Spectatorship is an occasion for judgment, which is an opportunity to acknowledge and challenge other standpoints. And, as the foregoing chapters discussing aesthetic concepts and animated films suggest, judgment remains a problematic issue within techno-neoliberal culture. Pixar's animated films address how sense experience and perception are fundamental to understanding the world within which a person exists, thinks, and acts. These experiences are exaggerated through cartoon characters discovering the rules and limitations of their worlds in both physical and social terms. These stories are presented to audiences for contemplation, as well as consumption. Animated films address aesthetic experience by dramatizing sensorial character interactions with worlds; only the characters themselves are not sensorial beings. Character animation puts on display action and judgment in a way that live-action performances cannot. By making a character act as if she had senses, we see how our senses work or, more precisely, how we imagine and think about our senses working. And they work in and with worlds. Thus, the integration of everyday sensorial judgment and being-in-the-world is put on display for spectatorial judgment. The philosophical discourse of critical aesthetics—whether working through concepts of uncanny, sublime, fantastic, or taste—relies on spectatorial judgment and the idea that private judgments are social and political. This treatment of aesthetics as a contested domain helps define the important but ambiguous term *criticism*. Here, criticism follows from spectatorship and entails making judgments public and available for the judgment of others.

NOTES

INTRODUCTION

1. See Price, *The Pixar Touch*; Capodagli and Jackson, *Innovate the Pixar Way*; and *The Pixar Story* (Iwerks 2007).

2. Brian Gabriel provides a summary of the wage-fixing scandal in "What Is the Animation Wage-Fixing Lawsuit? An Explainer for the Community." See also Mark Ames's reporting on the story, "REVEALED: Emails, Court Docs Show How Sony Stood up to Steve Jobs' and Pixar's Wage-Fixing Cartel."

3. Although the computer animation of Pixar and other studios such as DreamWorks tends to use software governed by algorithms to produce three dimensional space and camera effects commensurate with real-world film recording, it is also true that "the teeming masses of animated objects betray a certain industrial and mass-produced nature" (Gurevitch, "Computer Generated," 134).

4. Gurevitch, "From Edison to Pixar," 9.

5. Flaig, "Slapstick after Fordism," 72.

6. Lane, "The Fun Factory: Life at Pixar."

7. Halberstam, *The Queer Art of Failure*, esp. 29.

8. See Negroni, "The Pixar Theory"; and Munkittrick, "The Hidden Message in Pixar's Films."

9. Douglas, "The Pixar Theory of Labor."

10. Catmull describes the development of the braintrust in *Creativity, Inc.* The meetings themselves resemble academic defenses, public hearings, peer reviews, and creative workshops. See esp. 87–105.

11. The reach and influence of this standardization is unclear, but it is significant that the studio has operated consistently in the context of global CGI production, which ranges from applications for mobile devices to contract-based studios to rival conglomerates. For a description of global animation production see Yoon, "Globalization of the Animation Industry."

12. One of Lasseter's most famous sayings is that "the art challenges the technology, and the technology inspires the art." See Lasseter, interview by Charlie Rose.

13. Telotte, *Animating Space*, 217.

14. For an analysis of the nostalgia and white-male perspective prevalent in Pixar's productions, see Montgomery, "Woody's Roundup and Wall-E's Wunderkammer."

15. For a comparison of classical Disney animation to Pixar's see Booker, *Hidden Messages*. For an extended discussion of Pixar's traditional characterizations of masculinity see Wooden and Gillam, *Pixar's Boy Stories*.

16. Christensen's corporate authorship thesis insists that a studio's films are always part of corporate strategy and that analyzing films can illuminate that strategy and the broader industrial and cultural contexts that influence it. In his chapter on Pixar, Christensen analyzes the *Citizens United* case and develops the syllogistic conclusion that if a corporation is a person and an author, then it is also responsible for wrongdoing. The formulation of a corporate conscience exemplified by the "culture" of Pixar guiding Disney provides Christensen with a demonstration of corporate moral and ethical interiority. Granted, Christensen concludes his chapter by noting that this formulation does not interrogate the difference between a conscience that knows right from wrong in terms of market success and a conscience that knows right from wrong in moral terms (Christensen, *America's Corporate Art*, 314–40).

17. When Disney acquired Pixar in 2006, the deal included keeping Pixar animation separate and distinct from Disney animation, the idea being that they would produce distinct products in accordance with their distinct brands and creative cultures (Price, *The Pixar Touch*, 253).

18. At the broadest level Christensen's chapter is about thinking through the implications of the *Citizens United* case. This case equates money and speech through its protection of the corporate right to speech, but the case also makes it unclear about what constitutes corporate culpability and liability. The corporation is free to speak, but who is responsible for those speech acts, and what does responsibility mean for a corporation that does not have guilty feelings or knowledge centralized in a single consciousness?

The cultural figures of Jiminy Cricket and the industry example of the Disney-Pixar merger help Christensen think through this structurally. Thus, his target is not just a studio or industry but the nexus of industry, culture, and law.

19. Catmull, *Creativity, Inc.*, 210–14.

20. In addition to basic drawing courses, employees are encouraged to expose themselves to new ideas and fields of study through Pixar University and to remember what it is like to be a beginner. Catmull relates this explicitly to childhood: "Most of what children encounter, after all, are things they've never seen before. The child has no choice but to embrace the new" (221).

21. Noë, *Varieties of Presence*, 59 (emphasis in original).

22. Catmull's constructivist approach to management and CGI may have helped him get along with Steve Jobs, who aggressively challenged the realities other people constructed. See the afterword to *Creativity, Inc.*, "The Steve We Knew."

23. Noë, *Varieties of Presence*, 126–27.

24. Zipes, *Fairy Tales and the Art of Subversion*, ix–x.

25. Zipes, *The Enchanted Screen*, 4.

CHAPTER ONE

1. Bukatman, *The Poetics of Slumberland*, 2.

2. Gunning, "Animating the Instant," 40. Gunning argues that the instant exists at the core of both animated and photographic technologies (49–51), and his conclusion supports my own: that distinctions between animated and live-action film are more aesthetic and generic than simply technological. Animated and live-action film, if treated separately, share a photographic nature, but that nature can be employed and approached differently.

3. Crafton, *Shadow of a Mouse*, 2.

4. For example, when discussing Donald Graham's role in developing embodied character animation at Disney, Crafton describes how advances in lifelike, believable performance produced complicated readings: "The more the animators succeeded in vitalism, the less control they had over how the characters would be understood and used by the films' audiences. Indeed, we may read characterization against the grain" (Crafton, *Shadow of a Mouse*, 48).

5. Buchan defines "animated worlds" as "realms of cinematic experience that are accessible to the spectator only through the techniques available in animation filmmaking" (*Animated "Worlds,"* vii).

6. Lasseter has given many interviews in which he discusses his approach to making animated films, but one of the more comprehensive interviews is that conducted by Charlie Rose on December 1, 2011. See Lasseter, interview by Charlie Rose.

7. Gadassik, "Ghosts in the Machine," 233–34.

8. Rodowick, *Virtual Life*, 184.

9. Schivelbusch, *The Railway Journey*, 193.

10. Doane, *The Emergence of Cinematic Time*, 11.

11. A compelling engagement with the complexity of multicultural democratic society and the faculty of judgment occurs in Zerilli, *A Democratic Theory of Judgment*.

12. For accounts of social and psychological challenges presented by recent technological developments see Turkle, *Alone Together*, and Turkle, *Reclaiming Conversation*. The *Harvard Journal of Law and Technology* and the *MIT Technology Review* regularly report on areas in which law lags behind technological practice and innovation.

13. Perhaps the best-known is Stanley Cavell's claim that cinema provides insight into the modern condition of skepticism. See Cavell, *The World Viewed*, 188–89.

14. See Shaviro, *Without Criteria*, 13. Shaviro writes, "The critical aestheticism that I discover in the conjunction of Kant, Whitehead, and Deleuze helps to illuminate contemporary art and media practices (especially developments in digital film and video), contemporary scientific and technological practices (especially the recent advances in neuroscience and in biogenetic technology), and controversies in cultural theory and Marxist theory (such as questions about commodity fetishism, about immanence and transcendence, about the role of autopoietic or self-organizing systems, and about the ways that 'innovation' and 'creativity' seem to have become so central to the dynamics of postmodern, or post-Fordist, capitalism)" (ibid., xv).

15. *Critique of Judgment* distinguishes between beautiful objects, agreeable sensations, and the morally good. The latter is distinct in that it requires interest and a governing concept beforehand. Kant claims that agreeable sensations have a sensual interest while only judgments of beauty are disinterested. It is worth noting, as Patchen Markell does, that beauty refers to presentations that bring the understanding and imagination into a state that Kant variously calls "animation," "free play," and "harmony." This state is pleasing because it marks a fit between our cognitive powers and the presentation of the object (see Markell, "Arendt, Aesthetics," 69–70).

16. See Kant, *Critique of Judgment*, 53–54.

17. Ngai writes:

> We project the feeling that the object inspires to create a *distance* between ourselves and that feeling. But why are we compelled to separate ourselves from the feeling that the object elicits? Precisely *because* our feeling has made the object into an object of concern. In other words, the desire for detachment is a direct consequence of the kind of interest our feeling about the object has fostered, and it is precisely this combination of steps—an affective engagement *that itself prompts distancing*—that constitutes the object as an *aesthetic* object: to introduce such a distance into our affective relationships to candy and perfume would be to make them aesthetic objects as well. The creation of distance in turn produces fresh affect and ensures that aesthetic engagement will be maintained—in a feedback loop made possible by *a momentary disconnection in the circuit.* (*Ugly Feelings*, 85; emphases in original)

18. Ngai, *Our Aesthetic Categories*, 40.

19. In Alva Noë's words, "Our lives are structured by organization. Art is a practice for bringing our organization into view; in doing this, art reorganizes us" (*Strange Tools*, 29).

20. This method of examining the obvious form and content of entertainment art is well established and is perhaps best exemplified by Siegfried Kracauer's analysis in "The Mass Ornament." This methodology has been deployed more recently by Constance Balides in "Jurassic Post-Fordism."

21. Arendt, "The Crisis in Culture," 207.

22. Markell addresses this explicitly in his analysis of Arendt's "The Crisis in Culture": "Whenever we insulate an artifact from the immediate demands of use in order to encounter it differently, to linger—as Kant says—over the shape that it cannot help but display, to let the question of what the object is good for to open out into the larger question of 'how [the world] is to look, what kind of things are to appear in it' ('Crisis,' 223), we're establishing the conditions for an aesthetic experience or—better yet—for an experience that is at once aesthetic and political" (Markell, "Arendt, Aesthetics," 87).

23. Paul Wells discusses *The Flintstones* and other animated television shows that continue this tradition of exploiting an incongruity between the animated world and the external world of everyday life in his chapter "Synaesthetics, Subversion, Television," in *Animation and America*.

24. Donald Crafton refers to the "tendency of the filmmaker to interject himself into his film" as "self-figuration" (*Before Mickey*, 11).

25. As Tom Sito notes, there are only six minutes of CGI in *Jurassic Park*, which is 126 minutes long (Sito, *Moving Innovation*, 257).

26. Sobchack, "Final Fantasies," 174 (emphasis in original).

27. Quoted in ibid., 172; for the entire comment see Miguel Angel Diaz Gonzales, "Still Too Far from Real Virtual Actors," August 24, 2001, www.imdb.com/title/tt0173840/reviews?start=140.

28. Sobchack, "Final Fantasies," 172–73.

29. The hybrid film *Who Framed Roger Rabbit* (Zemekis 1988) makes this point by highlighting the different rules that "toons" follow that do not apply to humans. *Roger Rabbit* and other hybrid productions tend to foreground that animated film constitutes a world distinct from the human world even within a single diegesis. As Scott Bukatman observes, the hybrid genre restricts excessive cartoon physics when animated characters interact with human characters. Even in superhero films that utilize computer animation for effects, the animation remains "tethered" to the human (Bukatman, "Some Observations,"301–16).

30. Sobchack, "Final Fantasies," 180.

31. Buchan, "Introduction," 4–7.

32. Gunning, "Moving Away," 47.

33. Instead of describing Bazin's ideas about cinema's realism as excluding outright highly stylized cinematic expression, many of the contributors to Dudley Andrew's *Opening Bazin* collection describe Bazin's approach to realism as one concerned with aesthetic choices and style over technical aspects such as photo-indexicality. See, e.g., Jean-François Chevrier, "The Reality of Hallucination in André Bazin" (51); Colin MacCabe, "Bazin as Modernist" (71); Diane Arnaud, "From Bazin to Deleuze: A Matter of Depth" (88); Philip Rosen, "Belief in Bazin" (109); and Daniel Morgan, "The Afterlife of Superimposition" (131).

34. In Daniel Morgan's revisionary reading, Bazin's concept of realism appears to err on the side of openness, not restriction. Morgan explains that it is misleading to highlight Bazin's comments about cinema's photographic basis when the majority of Bazin's analyses of realism have little to do with photo-indexicality but have everything to do with directors' individual responses to social, psychological, and physical reality, and how they understand cinema to relate to, address, and express those realities. See Morgan, "The Afterlife of Superimposition," 131.

35. Bazin writes that depth of field "obliges the spectator to use his freedom of attention and at the same time makes him feel the ambivalence of reality" (quoted in Arnaud, "From Bazin to Deleuze," 90).

36. Eisenstein, *Eisenstein on Disney,* 58.

37. For Thomas Lamarre the work of compositing is crucial to theorizing animation since movement is discernible only through the relative movement and stillness of other objects, and compositing involves arranging movement between layers and components. Rather than contrast animated film with live action, Lamarre evaluates moving images in respect to oppositional poles: *cinematism*, or movement into and through depth, and *animetism*, or movement between layers or planes. Both cinematism and animetism can be created from the same moving image technologies, but they offer different modes of perception and epistemology; cinematism is more closely associated with instrumentalism and violence, animetism with an anti-instrumentalist, contemplative mode. Cinematism "give[s] the viewer a sense of standing over and above the world and thus of controlling it," and it "collapse[s] the distance between viewer and target, in the manner of the ballistic logic of [an] instant strike" (Lamarre, *The Anime Machine*, 5). Animetism, however, separates the image into multiple planes and emphasizes looking at speed laterally, with a sense of openness: "when movement is rendered with sliding planes, the world is not static, inert, lying in wait passively for us to use it" (ibid., 62).

38. Leslie, "Petrified Unrest," 78.

39. Ibid., 92. This conclusion echoes Leslie's claims in *Hollywood Flatlands*, which examines the historical affiliation between modernism and animation and explains how both were overcome by the commercialization of media and art following the Second World War. Critical of Disney's "idealist naturalism" in a fashion similar to Lamarre's critique of the illusion-of-life, Leslie writes, "From *Snow White and the Seven Dwarfs* onwards the laws of perspective and gravity are reinstituted, flatness is repelled and the films no longer explode the world with the surrealistic and analytical cinematic dynamite of the optical unconscious that had been developed in 1920s' cartooning" (*Hollywood Flatlands*, 149).

40. Leslie, "Animation and History," 29.

41. Ibid., 35.

42. Wells, *Animation and America*, 17.

43. Ibid., 24.

44. Cavell, *The World Viewed*, 168.

45. Ibid., 169–70 (emphasis in original).

46. See Cavell, *Must We Mean*, 96. Cavell argues that ordinary language philosophers, such as himself, differ from logical positivists in that they deal with the elements of life that cannot be addressed through straightforward logical proofs and agreed-upon criteria for judgment. Cavell writes that

"philosophy, like art, is, and should be, powerless to *prove* its relevance; and that says something about the kind of relevance it wishes to have. All the philosopher, this kind of philosopher, can do is to express, as fully as he can, his world, and attract our undivided attention to our own" (*Must We Mean*, 96; emphasis in original). The philosopher, like artists and art critics, moves from subjective experience out into the world, which then prompts others to reflect on their own subjective experience.

47. Cavell, *The World Viewed*, 165.

48. Rodowick, *Virtual Life*, 69.

49. Cavell, *The World Viewed*, 26 (emphasis in original).

50. Ibid., 102.

51. Panagia, "Blankets," 260 (emphasis in original).

52. Mulhall, *The Cavell Reader*, 92 (emphasis in original). Cavell's reflections on the ontology of film do not refer to its essence or teleology but rather to a mode of being that correlates with the modern fall into skepticism. This fall refers broadly to the plight of the modern subject after the Reformation and the spread of Enlightenment philosophy, which diminished theologically oriented notions of self, society, and political direction and elevated the role of intellectualized knowledge and modes of scientific and empirical inquiry that reinforce the limitations of the human senses. After World War II, nationalist and ethnic ideologies became less likely to fill in the many philosophical gaps opened up by modernity. Equipped with science, the autonomous modern subject is faced with the responsibility of discovering, knowing, and acting within a world not necessarily designed for meaning, immediacy, and agreeableness. Such isolation renders a person susceptible to her own fantasies, and perception becomes a fraught endeavor. It is in this general context that film and photography offer means for modern subjects to reconnect with the world. The analog process of photography that captures an isomorphic impression of past space forces viewers to reckon with the reality of the past in the present and prompts them "to reflect on [their] own ontological situatedness in space-time" (Rodowick, *Virtual Life*, 65). See also Cavell, "The Avoidance of Love."

53. The camera provides some reassurance and comfort to modern persons who are fatigued by the responsibility of perceiving accurately. Rodowick explains: "The condition of viewing in photography and film expresses the situation of the modern subject. But they also express a displacement of the subject, or even a kind of de-subjectivization or the dissolution of this subject in the anticipation of something else. This happens, first, by relieving us of the

burden of perception by automating it (*'a succession of automatic world pictures'*). Photography and film 'overcome' subjectivity not only in removing the human agent from the task of reproduction, but also in relieving it from the task or responsibility for perceiving in giving it a series of automated views" (*Virtual Life*, 65; emphasis in original).

54. Cavell, *The World Viewed*, 102 (emphasis in original).

55. See Pierson, "On Styles of Theorizing," 21. Pierson explains how the industrial standardization of animated cartoons probably contributed to Cavell's comments. Animation techniques that do less to obfuscate how to judge the recording of reality may not even qualify as animation for Cavell. Unfortunately, this was not Sesonske's contention. A suitable example would be *Neighbors* (1952), in which Norman MacLaren animates human actors in a frame-by-frame method that he refers to as pixilation.

56. For instance, Buchan writes that "the animated figure is not 'dissociated from creative imagination'; it embodies just this, in that the figure's existence and character are defined entirely by the conceptual, stylistic, and technical processes of its design, construction, and animation" ("Animation, in Theory," 119).

57. The capacity of animation materials to resist the designs and intentions of animators and the readings of audiences is a crucial factor in theories of animated film. As in Sianne Ngai's discussion of "animatedness," surplus movement or resistance generated by animation materials (foam in the case of the television show *The PJs*) can disrupt stereotypical depictions and interpretations of character and action (*Ugly Feelings*, 125).

58. Bazin, *What Is Cinema?* 1:102.

59. Perhaps the recent hybrid feature by Ari Folman, *The Congress* (2013), is an indication that the interpretative traditions could soon change. The film depicts a future in which people can elect to live in a fully animated world through the use of manufactured drugs. The lead character's final escape to the nonanimated world functions as the film's expression of disruption.

60. Horkheimer and Adorno write, "Donald Duck in the cartoons and the unfortunate in real life get their thrashing so that the audience can learn to take their own punishment" (*Dialectic of Enlightenment*, 138). This interpretation is typically contrasted with Walter Benjamin's more optimistic, utopian reading of Mickey Mouse. Both are overstatements, but, in both, the inability to immediately discern the laws of an animated world does not amount to political neutrality. See Hansen, "Of Mice and Ducks."

61. See Sharm, "Drawn-Out Battles," 78–82. Television mitigated the circulation of these wartime depictions to an extent as studios became sensitive to creating content that could accommodate long-term series of reruns (Sharm, "Drawn-Out Battles," 82–83), and the major studios themselves have worked to suppress many of these depictions from their animation canons (Sammond, "A Space Apart," 280).

62. Sammond writes, "Minstrelsy replicated a white, primarily northern fantasy of African American life and culture, particularly of plantation life, as populated by lazy black folk wallowing in a sensual torpor, almost devoid of higher mental and moral functions. The minstrel's body—fluid, voracious, and libidinal—represented a freedom from the constraints of Protestant middle-class morality. At the same time, that body suggested the threat of a fall from grace, of labor's ongoing enthrallment to capital" (*Birth of an Industry*, 27).

63. Ibid., 184.

64. Ibid., 1–3.

65. Sammond summarizes Iton's "black fantastic": "This realm, this force, this matrix of meaning is present as much in the trivial productions of television programs (trivial but for their millions of viewers), indie movies, and prizefights as it is in larger moments such as in the highly charged debates over the election (and reelection) of Barack Obama or in the aftermath of George Zimmerman's acquittal in the killing of Trayvon Martin. For it is through the seemingly trivial that fantasies of blackness and whiteness circulate freely and with relatively little critical comment, stabilizing if not producing meaning" (ibid., 17–18). See also Iton, *In Search of the Black Fantastic*.

66. Wells, *Animation and America*, 103–23.

67. See Freeman, "'Monsters, Inc.'"; and Zornado, "Children's Film as Social Practice."

68. Ngai, *Ugly Feelings*, 120–25.

69. As Michele Elam describes it:

McGruder's characters are nearly all head and face, and through them he invokes and revokes traditional stereotyping: he features, for instance, disproportionately large eyes but *no* lips, the corresponding requisite in black minstrelsy. His main black characters are children, calling up the equation of black people as infantile, but McGruder's young people have anime's extremely high brows, which in this context clearly suggest intellect and intense social conscience rather than childish ignorance and civic incapacity. Furthermore, there is almost no attention to the body *below* the head, decoupling the association of black people with the flesh and body rather than the spirit and mind. In this way we have black people on view but not on display. (*Souls of Mixed Folk*, 75)

CHAPTER TWO

1. See Vidler, *The Architectural Uncanny*, 163.
2. Ibid., 161.
3. Montgomery, "Woody's Roundup," 12.
4. Wooden and Gillam, *Pixar's Boy Stories*, xxv–xxvi.
5. As Ngai explains, experiencing objects as cute entails high levels of familiarity and intimacy as the cute thing, through its vulnerable, round, squishy, amorphous appearance, prompts the subject to respond with cute noises and a desire to protect and serve the cute object. The *Toy Story* films, although about toys, are not Pixar's cutest productions in terms of formal aesthetics. Soft, squishy structures are challenging for computer animation, and in Pixar's oeuvre *Finding Nemo* and the *Monsters* films are likely to be judged cuter than the *Toy Story* films, especially *Toy Story* and *Toy Story 2*. See Ngai, *Our Aesthetic Categories*, chap. 1.
6. Isaacson, *Steve Jobs*, 285–86.
7. Lasseter and Daly, *"Toy Story,"* 16.
8. Bennett, *Vibrant Matter*, 99.
9. Heidegger, *Poetry, Language, Thought*, 172.
10. See Munkittrick, "Hidden Message." Sergei Eisenstein argues in his writings about early Disney animation that both the protean, plasmatic quality of animation and its propensity for humanized, animal characters relates to primitive human existence. In short, anthropomorphic animals refer back to the totemistic union between humans and animals, and the closed line and mutable bodies of animation allude to a "primal protoplasm" essential to biological existence. Eisenstein speculated that such protean representations were highly appealing to audiences in the early twentieth century who were living through the static monotony of industrial capitalism. With this in mind Eisenstein praised the work of early Disney animation for its protean and dialectical quality, comparing animation to the entrancing, destructive, and regenerative properties of fire. See Eisenstein, *Eisenstein on Disney* (21–53).
11. See Marx, "Chapter One: Commodities," esp. Section 4: "The Fetishism of Commodities and the Secret Thereof," www.marxists.org/archive/marx/works/1867-c1/cho1.htm#S4.
12. See Adorno and Horkheimer, *Dialectic of Enlightenment*.
13. Arendt, "The Crisis in Culture," 197–99.
14. Adorno, *The Culture Industry*, 42.
15. Ibid., 30.

16. Bauman, *Liquid Modernity*, 126.

17. E-waste is frequently exported to Asia, where there are fewer regulations about its handling (Parks, "Falling Apart," 38–40).

18. Jodi Dean employs psychoanalytic categories to make this point in *Blog Theory:* "in communicative capitalism, the gaze to which one makes oneself visible is a point hidden in an opaque and heterogeneous network. It is not the gaze of the symbolic Other of our ego ideal but the more disturbing, traumatic gaze of a gap or excess, *objet petit a*" (56). The subject cannot control, anticipate, or understand this gaze as it would previous authoritative institutions, be they religious, governmental, or commercial. The *objet petit a* gaze pierces the subject's symbolic network and hinders the psychical faculties that the subject uses to make sense of the world. Dean probably overstates the trauma in general as social media and online life become more socialized as consumers learn and then make demands.

19. Toys have consistently served children as transitional objects, that is, objects that facilitate a child's separation from her mother and realization that there is an external world with which to interact. Hence, many of our stories about toys involve metamorphoses (*Pinocchio*, for example).

20. Kuznets, *When Toys Come Alive*, 2.

21. Ibid., 19, 80.

22. Granted, toy torture and toy play are not always distinguishable. Andy's new toy, Buzz Lightyear, refers to Sid as "that happy child" during Sid's first scene when the toys espy him from Andy's window. Indeed, Sid appears quite happy in the scene as he ignites a small explosive fastened to an action figure.

23. Wooden and Gillam, *Pixar's Boy Stories*, 11.

24. Despite the fact that there is no conclusive evidence that the peripheral figure is Sid's father, the room is coded working class and masculine through typical markers—a large foot in a plain white sock, a mounted hunting trophy, brown-beige wallpaper featuring duck images, a wrench fixed to the television dial, and crunched cans of soda next to the recliner that resemble beer cans. Of course, none of these objects are essentially masculine but have only become so through repetition and cultural instantiation. The point is that, like Sid's room, they are juxtaposed with the polished, shiny, newly furnished, feminine space of Andy's home.

25. See Gurevitch, "From Edison to Pixar," 11. See also Lacan, "The Mirror Stage," 75–81.

26. For an analysis of how issues of media spectacle and attention economy pervade most of Pixar's feature films see Gurevitch, "From Edison to Pixar."

27. Buchan, "A Cinema of Apprehension," 167.

28. Andy's mother appears complicit in this reading since her character is primarily depicted as a source for Andy's new toys via birthday parties and holidays. And the juxtaposition of a fatherless boyhood and a boyhood with a disinterested father presents a false choice between a boy prone to violence and a boy prone to commodity fetishism. There are alternatives, but the film's limited depiction of parents and gender contributes to the limited comparison of the two boy characters.

29. Hayles, *My Mother*, 2.

30. Freud contends that "the uncanny element we know from experience arises either when repressed childhood complexes are revived by some impression, or when primitive beliefs that have been *surmounted* appear to be once again confirmed" (*The Uncanny*, 155; emphasis in original). This position treats primitive beliefs and repressed feelings similarly, thereby equating a kind of Western modernization with adulthood. This imperialist, Eurocentric view discredits Freud's theory, but the logic of his explanation remains compelling. Freud explains that those who have remnants of belief in a more primitive way of thinking experience the uncanny, but for those who have "wholly and definitively rejected these animistic convictions, this species of the uncanny no longer exists" (154). The uncanny, in this definition, is about regimes of belief and how uncanny experience plays on one's doubt about reality. It raises the specter of doubt in life's explanations and science's rationalization. It can be an indication that the world is not what a person thought it was, or more precisely, it indicates that this world bears unseen possibilities that the person secretly knew all along. Freud's point is that the experience is not one of pure intellectual uncertainty or inexplicability. It is an inexplicability that harkens to an earlier time. In this way the uncanny is subversive, and the secret life of toys and dolls has been a recurring example of the uncanny in fictional media for generations.

31. Ibid., 156.

32. Computer animation has a history of being received as uncanny when human characters become extremely lifelike but fail to pass completely as human. This "uncanny valley" phenomenon has been described as a prediction error experienced by a spectator. That is, the person watching the animation makes subtle, involuntary predictions about the perceived movement—for example, does it belong to a machine or a biological organism? As the images and figures move, those unconscious predictions can be wrong, leaving an uncanny feeling with the spectator (Saygin et al., "The Thing That Should Not

Be," 413–20). This can happen in many ways, as when a figure looks strikingly real and biological in one sequence but then mechanical and artificial in another or when a mechanical looking figure suddenly begins to move and gesture in a manner associated with biological creatures. Both roboticists and computer animators study the human Action Perception System to learn about the unconscious cues that inform a person about what is alive and what is not.

33. Freud, *The Uncanny*, 158.

34. Flaig, "Life Driven by Death," 4. For Flaig animated films are able to capture the comic uncanny because they can express amorphous energy similar to the death drive, or the uncontainable life force of the libido, which escapes the constraints of the ego. Flaig explains: "Like the ghost-obsessed cinema of attractions, these films privilege gag, surprise and shock over narrative continuity, character depth or spatial consistency," and a spectator's reaction to such scenes in traditional hand-drawn animation is based in sensation more than cognition (12).

35. Pixar chronicler David Price describes Lasseter's approach: "At the dawn of the medium of computer animation, early projects shown by other artists at SIGGRAPH and animation festivals tended to exploit the power of computer graphics to create novel, often abstract, imagery. Lasseter had gone in the opposite direction. In his short films and in *Toy Story*, he had relied on quotidian objects: a desk lamp, a ball, a snow globe, toys. He believed that audiences would accept a new medium *if* it was rooted in the familiar" (Price, *The Pixar Touch*, 263; emphasis in original).

36. Frequently, digital media have been designed to signal how a new medium improves on the old. As Jay Bolter and Richard Grusin explain, this tends to involve two logics: (1) immediacy—more immediate access to the objects represented; and (2) hypermediacy or enhanced experience through greater mediation—as in the interactive platforms of the web (see Bolter and Grusin, *Remediation*, 33–34).

37. Hayles, *How We Became Posthuman*, 17.

38. See also Schivelbusch, *The Railway Journey*.

39. Isaacson, *Steve Jobs*, 129, 137. Isaacson notes that Jobs "went so far as to design special tools so that the Macintosh case could not be opened with a regular screwdriver" (138).

40. Wooden and Gillam note how strange it is that Woody closely identifies with his character from the television show. If Woody supposedly has a unique identity, memory, and consciousness, then he should know that he is modeled after the character, which is ontologically distinct from being the

TV show character (Wooden and Gillam, *Pixar's Boy Stories,* 114). But Woody's easy identification reinforces product essentialism; it is his design and purpose that matter, and fulfilling the continuation of the television show character is a reasonable interpretation of product purpose—some toys are made to be collectibles.

41. Price, *The Pixar Touch,* 59.

42. Ackerman, *Seeing Things,* 119.

43. Ibid., 115.

44. Lamarre, "New Media Worlds," 138–40; see also my discussion of Sobchack's essay in chapter 1 of this book.

45. The best example of Pixar's simulating distinct camera effects remains the first act of *WALL-E,* which simulates the camera perspective and imperfections that viewers would customarily find in 1970s science fiction films (Price, *The Pixar Touch,* 264). For additional examples of Pixar sequences that play with an inability to discern media or reality, see Telotte, *Animating Space,* 210–11.

46. Ackerman, "The Spirit of Toys," 911. Ackerman notes that the ethics of cloning were being debated in the 1990s when the first two films were being made (903).

47. Ackerman, *Seeing Things,* 100–101.

48. The decay of this aura is a result of modern life—urbanization, industry, mass society, mechanically reproducible art, etc. Baudelaire, in particular, explores how being jostled by the crowd produces a "mirrorlike blankness" in subjects, and this opaqueness between people diminishes the reciprocation of the gaze. But, as Benjamin observes in Baudelaire's work, this can be a pleasurable, liberating experience. The gaze of the other can be burdensome as well as pleasurable: "But looking at someone carries the implicit expectation that our look will be returned by the object of our gaze. Where this expectation is met . . ., there is an experience of the aura to the fullest extent. . . . Experience of the aura thus rests on the transposition of a response common in human relationships to the relationship between the inanimate or natural object and man. . . . To perceive the aura of an object we look at means to invest it with the ability to look at us in return" (Benjamin, "On Some Motifs in Baudelaire," 188–90).

49. Hansen, *Cinema and Experience,* 104–7.

50. Gurevitch, "Computer Generated," 138.

51. Ibid., 134.

52. Ibid., 145.

53. Gurevitch claims that this "aesthetic continuity" reinforces the spectator's point of view as a consumer. Although this may often be the case, the consumer-spectator is not the only subject-identity encouraged by these films, and their continuity with design industries is not total. When commenting on Buzz Light-year's reaction shots, animator Glen McQueen notes that the detailed, emotionally rich style used to animate Buzz differs from the less detailed style used in short advertisements: "It's not like the kind of advertising stuff a lot of us are used to, where you have fifteen seconds to capture an entire character and everything's got to be very broad. John [Lasseter] kept encouraging us to keep things very small and very quiet" (Lasseter and Daly, *"Toy Story,"* 107). This counters Gurevitch's argument by reminding us that in terms of practice even what may seem like a two-hour advertisement tends to differ from advertising customs because it is two hours long. McQueen's comment shows that character depiction in a big-screen feature, which includes subtle facial expressions, presents industry-specific challenges and possibilities that break up "aesthetic continuity."

54. Lash and Lury, *Global Culture Industry,* 87.

55. Lash and Lury construct their argument by following the life cycles of cultural objects and brands (20). They explain the life force of these objects as distinct from artworks and commodities and as resembling self-organizing organisms. Brands such as Nike or Swatch consist of a vast array of parts—logos, slogans, material products, human icons, and so forth—and these components at times coalesce to form larger bodies, but they are always capable of breaking off and generating another life-course or of being incorporated by another system. *Toy Story* serves their theory quite well because as a popular feature film it consists of many parts that circulate broadly and interact with other media and that contribute to various products. Central to this argument is the capacity for characters to become products in their own right, separate from the narratives and cinematic screens from which they emerged. See Lash and Lury, *Global Culture Industry,* esp. chap. 5, "The Thingification of Media."

56. Lash and Lury, *Global Culture Industry,* 199.

57. Ngai, *Our Aesthetic Categories,* 66, 98.

58. Ibid., 91–92.

CHAPTER THREE

1. Bukatman, *The Poetics of Slumberland,* 137.

2. On this point Bukatman quotes a well-known passage from Lev Manovich's *The Language of New Media:* "Once the cinema was stabilized as a technol-

ogy, it cut all references to its origins in artifice. Everything that characterized moving pictures before the twentieth century—the manual construction of images, loop actions, the discrete nature of space and movement—was delegated to cinema's bastard relative, its supplement and shadow—animation. Twentieth-century animation became a depository for nineteenth-century moving-image techniques left behind by the cinema" (Manovich, *The Language of New Media*, 298).

3. Bukatman, *The Poetics of Slumberland*, 137–40.

4. Costelloe, *The Sublime*, 5–7.

5. Holmqvist and Pluciennik, "A Short Guide," 724.

6. Frank, "'Delightful Horror,'" 8–10.

7. Ibid., 25.

8. Ngai considers the cute, the interesting, and the zany in *Our Aesthetic Categories*.

9. Bukatman, *Matters of Gravity*, 81.

10. Ibid., 90–91.

11. Fear has been a consistent component in processes of globalization, and it is important to note that the film's November release followed closely on the terrorist attacks of 9/11, which led to a global "war on terror" and a revitalization of fear for many people. Given that its production preceded these events, I am less inclined to read *Monsters, Inc.* as offering a corresponding comment, allegorical or otherwise, about the "war on terror" and the "culture of fear" associated with it. However, the broad conditions referenced in the film have continued through the end of the twentieth century and into the twenty-first and were certainly involved in the tragedy of 9/11 and its aftermath.

12. See Tranter and Sharpe, "Escaping Monstropolis"; Tranter and Sharpe, "Disney-Pixar to the Rescue"; and Freeman, "'Monsters, Inc.'"

13. "Monsters, Inc.: Production Notes."

14. Poster, "Global Media and Culture," 24.

15. As J. Zornado explains, "Monster hegemony over children has simply discovered a more efficient, a more sustainable manner of exploitation, but the basic power relation remains intact" ("Children's Film," 9).

16. Ibid., 6.

17. Holmqvist and Pluciennik, "A Short Guide," 722.

18. Nye, *American Technological Sublime*, 100–107.

19. Kant, *Critique of Judgment*, 119.

20. Buck-Morss, "Aesthetics and Anaesthetics," 8–9.

21. Leslie, "Animation and History," 29; see also chapter 1 herein.

22. Gurevitch, "Computer Generated," 134.

23. Ibid., 137.

24. Ibid., 135.

25. For example, Jim Blinn and Alvy Ray Smith produced 3-D computer-animated videos for the Voyager 1 and 2 NASA missions in the late 1970s and early 1980s. The cameras onboard the ships produced photographic images, but these took a long time to send to Earth and were difficult to process. Computer animation proved itself to be more efficient and dramatic. See Sito, *Moving Innovation*, 48–50.

26. See Mihailova, "The Mastery Machine," 141

27. Friedberg, *The Virtual Window*, 84.

28. Ibid., 230.

29. A Heideggerian reading of *Monsters, Inc.* could interpret the children as natural material understood as "standing reserve," a resource material for the monsters' use and benefit. Enframing in this case amounts to a perspective that determines the character of children for the monsters. See Heidegger, "The Question Concerning Technology," 300–301.

30. The terms *technical mediator* and *delegation* are used by Bruno Latour to describe the agency of nonhuman actants working within agential networks (see Latour, *Pandora's Hope*, 178–89).

31. Bauman, *Liquid Modernity*, 117–21.

32. Keller, "Beauty, Genius, Epigenesis," 47.

33. Lyotard, *Assassination of Experience*, 189 (emphasis in original). Monory's *Sky no. 39* is an example that Lyotard refers to in his essay "Sublime Aesthetic of the Contract Killer" (*Assassination of Experience*, 156–95). It is a painting of a star-filled sky that relies on a map of the sky produced by a computer in 1976 (161). In this case the sublime has already been framed by the instruments of capitalism and technoscience; it is immanent, not transcendental. But because painting is not exclusively part of this technologically reproducible world, it can disturb it and draw attention to the social order that has become natural. Lyotard's emphasis on the medium indicates the considerable weight he gives to the kind of industrial, aesthetic continuity observed by Gurevitch. The task, then, is to find and circulate media with affiliations to alternative systems, as in the example of Monory, whose work comments on technocapitalism while maintaining an affiliation with an older aesthetic system.

34. Lyotard, *Assassination of Experience*, 191 (emphasis in original).

35. Woodward, "Nihilism and the Sublime in Lyotard," 62 (emphasis in original). The major difference between Lyotard's *differend* and Rancière's *dis-*

sensus is that Lyotard's concept relies primarily on incommensurability between discourses, whereas Rancière's dissensus relies on partitions of the sensible; this is a difference of emphasis between intelligibility and sensibility. Lyotard's sublime troubles discursive intelligibility and therein preserves the potency of sensation from being delimited by discourse. Rancière's theory figures how sensations are already partitioned and configured. See Déotte and Lapidus, "The Differences."

36. Lyotard, "Anima Minima," 242–43 (emphasis in original).

37. Lyotard, *The Inhuman*, 98.

38. See ibid., 4–6.

39. Ibid., 103.

40. Bakhtin, for example, locates "unfinalizability" at the core of human aesthetic instincts. In short, we create and imagine characters as unified wholes in order for them to serve as personalities that could potentially see us as complete in return. This aesthetic theory understands a subject's sense of self as developed through seeing others and by being seen by others in return. From this premise there is a need to surround oneself with a diversity of others in order to have a fuller sense of self because this reciprocation must come from an Other who is different, who possesses "outsideness." *Outsideness* for Bakhtin refers to every entity's unique situatedness; thus, sociocultural differences enhance outsideness (see Emerson, *The First Hundred Years*, 221–24).

41. Tranter and Sharpe, "Escaping Monstropolis," 299; and Freeman, "'Monsters, Inc.,'" 90.

42. See Edelman, *No Future*.

43. Many theorists understand childhood as always queer and families and other institutions as participating in normative training. Queer culture, in these terms, has been described as failing to grow up or about "growing sideways" instead. See, e.g., Bond-Stockton, *The Queer Child*.

44. See Argent, "Monsters, Inc.," 23.

45. Žižek, *The Sublime Object*, 232.

46. Ibid., 105–6.

47. Ibid., 106–7.

48. One of Žižek's favorite film examples is M. Night Shyamalan's *The Village* (2004), which tells the story of a community whose elders fabricate a series of outside threats, literally monsters who live in the surrounding forest, to maintain the community's isolated, close-knit, primitive existence (see Žižek, *Violence*, 26–27).

49. See Žižek, *First as Tragedy*, 3.

CHAPTER FOUR

1. "The Incredibles—Production Notes."

2. Bird and Walker, "Audio Commentary."

3. According to Agamben, a state of exception creates a space in which norms need to be applied, and therein new norms can be established. But the exceptional space also does the work of "welding norm and reality" through a process of referentiality:

> The state of exception is the opening of a space in which application and norm reveal their separation and a pure force-of-law realizes (that is, applies by ceasing to apply) a norm whose application has been suspended. In this way, the impossible task of welding norm and reality together, and thereby constituting the normal sphere, is carried out in the form of the exception, that is to say, by presupposing their nexus. This means that in order to apply a norm it is ultimately necessary to suspend its application, to produce an exception. In every case, the state of exception marks a threshold at which logic and praxis blur with each other and a pure violence without *logos* claims to realize an enunciation without any real reference. (Agamben, *State of Exception*, 40; emphasis in original)

4. In other words the changeability of norms and laws defuses/diffuses their immediate instrumentality and necessity and enables reconsidering them without using means-to-ends reasoning. For a comparison of Agamben's "pure violence" / "pure medium" and Benjamin's "pure violence" / "pure language" in relation to Kantian aesthetics see Morgan, "Undoing Legal Violence."

5. Sianne Ngai, following Cavell and Austin, notes that aesthetic judgments have a constative structure while describing personal experience. Instead of saying "I judge this flower to be beautiful," we tend to say that "the flower is beautiful" (Ngai, *Our Aesthetic Categories*, 40). The dialectic between the fantastic and the mundane approaches Ngai's formulation of the interesting as an aesthetic category. Central to this formulation is the idea that interesting things exist within a series or sequence and mark novelty or difference. The interesting stands out for unknown reasons at first, but it then prompts discussion and investigation (ibid., 120).

6. Consider Jack Zipes's explanation of the liberating potential of the fantastic in fairy tales:

> On a psychological level, through the use of unfamiliar (*unheimlich*) symbols, the fairy tale liberates readers of different age groups to return to repressed ego disturbances; that is, to return to familiar (*heimlich*) primal moments in their lives, but the fairy tale cannot be liberating ultimately unless it projects on a conscious, literary, and philosophical level the objectification of home as real democracy under non-

alienating conditions. This means not that the liberating fairy tale must have a moral, doctrinaire resolution but that to be liberating it must reflect *a process of struggle* against all types of suppression and authoritarianism and posit various possibilities for the concrete realization of utopia. Otherwise, the words *liberating* and *emancipatory* have no aesthetical categorical substance. (Zipes, *Fairy Tales*, 176; emphasis in original)

7. For a discussion of the realism-fantasy balance in the Fleischers' Superman cartoons see Telotte, *Animating Space*, 102–12.

8. The propensity for animated film to present biopolitical expressions influences the work of Thomas Lamarre, who contrasts the planar composition of animation (e.g., Miyazaki's work) to character animation through the terms *animetism* and *cinematism*. In short, "when movement is rendered with sliding planes, the world is not static, inert, lying in wait passively for us to use it, in the form of standing reserve, to evoke Heidegger's term. The world is not 'enframed' or made into a picture. On the contrary, Miyazaki assures that when we move, the world moves, and vice versa. Opening a relation through animation technology to the dynamism of the world promises a way for us to gain a free relation to our modern technological condition, to save ourselves from it" (Lamarre, *The Anime Machine*, 62–63). A preference for animetism leads Lamarre to champion compositing and to criticize illusion-of-life and character animation for inserting an ideology of realism into biopolitics. In short, it contributes to a politico-aesthetic regime in which certain movements denote life, while other movements, even though they are equally technological, do not (Lamarre, "Coming to Life," 139–41).

9. Bird and Walker, "Audio Commentary."

10. The production notes elaborate on the technology:

This changed the entire animating process. Animators are not so much technicians as they are artists-actors or puppeteers of a sort who creatively choreograph the characters' movements and expressions through specially programmed computer controls. Now, the animators had greater, and deeper, control of the characters than ever before. Explains [Rick] Sayre: "It's very typical in visual effects for an animator to animate a rigid skeleton, and that's all they see. But with the complex characters in this film, that wasn't going to be acceptable. What I think is groundbreaking is that we ended up building a system where the animators are essentially moving the underlying skeleton, and the muscles are being activated, and the fat layer is causing the skin to slide over the muscles, and then the skin is rendered. The animators can see all that happening while they're working. When they move Bob, they're posing his full muscle-skin-skeleton rig, and it's happening essentially in real-time, giving them far more information and flexibility." ("The Incredibles—Production Notes")

11. See Žižek, *Violence*, 9–11.

12. Elsaesser, "Tales of Sound and Fury," 58–59.

13. Rancière, *Chronicles*, vii–x.

14. Ferguson, *All in the Family*, 5, 27 (emphasis in original).

15. Ibid., 26–27.

16. See Telotte, Animating Space, 216.

17. According to *IMDb*, "the name of the island that Mr. Incredible is summoned to, Nomanisan Island, is a reference to the well-known book title: 'No Man is an Island,' written by Thomas Merton, in turn a reference to John Donne's Meditation XVII, 'The Bell': 'No man is an island, entire of itself…'" (www.imdb.com/title/tt0317705/trivia).

18. From *IMDb*: "Most of the story takes place in a city called Metroville. It's a combination of Metropolis and Smallville, which are, respectively, the cities where Superman lives and where he was raised. In the beginning of the film (supposedly before they were relocated), Bob, Helen and Lucius Best (Frozone) are living in Municiberg, another play on Metropolis, both roughly meaning 'hometown'" (www.imdb.com/title/tt0317705/trivia).

19. The film opens with a series of black-and-white television interviews of the Supers before they are forced to retire. In this newsreel the heroes are in their prime; they are ambitious, confident, and fully committed to their vocation. The interviews follow the convention of using a newsreel to introduce a diegetic world and to generate nostalgia for a fictional, alternate past. When Elastigirl concludes her interview by refusing to leave the "saving of the world to the men," she repeats the phrase "I don't think so" with diminishing fervor. As her eyes drift away from the camera, the impression is that she does not believe what she is saying.

20. Gardner, "Democracy's Debt," 96.

21. In the context of modern democracy Francis Fukuyama subdivided Plato's thymos, or spiritedness, into a desire to be recognized as equal, isothymia, and a desire to be recognized as superior, megalothymia (see Fukuyama, *The End of History*, 326–27).

22. Gardner, "Democracy's Debt," 96.

23. Bird and Walker, "Audio Commentary."

24. Considering that the animators on the DVD commentary remark that Edna emulates Bird's own approach to filmmaking, Edna can serve as a hallmark of a competitive, liberal ethos that resonates across Bird's films, such as *The Iron Giant* (1999), which features a villainous 1950s American government acting against the heroics of a small-town boy who befriends a giant robot

from outer space. Similarly, *The Incredibles* is set in an alternative mid-1960s vision of the future that influences the film's mise-en-scène and musical score. Bird's handling of nostalgic themes and Americana aligns with that of the other core directors and writers at Pixar.

25. Nietzsche's Zarathustra tells of the last men who have discovered happiness and refuse to live difficult or dangerous lives. They no longer struggle for recognition or power but are content with comfort, health, and the satisfaction of petty desires. Nietzsche argues that the pursuit of contentment is a rationalization of the Christian pursuit of redemption, which replaces the tragic, Dionysian comfort with metaphysical comfort, or an ethic of asceticism that domesticates passional life and infects it with meaninglessness. Zarathustra intends to disrupt the rational culture or Socratic culture of the last man; he wants to interrupt modernity and its culture of nihilism (*Zarathustra*, 1.prologue.5). See also Gooding-Williams, *Zarathustra's Dionysian Modernism*, 45–46.

26. Bullock, "Origins of the Danger Market," 70.

27. Ibid., 78.

28. Bukatman, *Matters of Gravity*, 199.

29. Ibid., 198–99.

30. Ibid., 188–89.

31. Gardner, "Democracy's Debt," 95.

32. Žižek, *Violence*, 90 (emphasis in original). Envy is a critical element in Žižek's discussion of violence because it has been critically attributed to the revolutionary left—that is, that their animosity toward the ruling class is primarily motivated by envy. It also can evolve into a sacrificial form of evil— that is, when the envious person is willing to suffer if it causes the Other to suffer as well. This enables Žižek to disparage the logic of sacrifice that conservative critics, such as Stephen Gardner, endorse. But alas, Syndrome does not go to this extreme and remains a more generic egotist.

33. Ngai, *Ugly Feelings*, 21.

34. In the superhero comic's alternative–Cold War setting the character Ozymandias creates a fictional, alien threat to resolve the conflict between the United States and the Soviet Union. He effectively engineers a giant monster that explodes in New York City, killing half of the city's population. To protect his plan, Ozymandias initiates an effort to hunt down retired superheroes, but his devastating plan is ultimately meant to reorganize society through the creation of a new myth—an alien threat. Although very different in scope and tone, *The Incredibles* shares several plot devices and raises similar political questions to *Watchmen*—namely, how would individuals with superpowers

reshape modern democratic society, and then, what would their personal experiences be like? In *Watchmen* superheroes either retire or become government agents once a police strike disrupts their domestic social function.

35. See Paik, *From Utopia to Apocalypse*, 23–25.

36. Hayles, *How We Think*, 10.

37. Sobchack, "Sci-Why?" 295–97.

38. For a discussion of overorthodoxy, or a revolutionary's propensity to practice social and political ideas more devoutly than members of the orthodox class, see Žižek, *The Plague of Fantasies*, 99.

39. Ngai, *Our Aesthetic Categories*, 218.

40. Mary Ann Doane claims that the "woman's film" struggles to abandon the conventionalized male gaze of cinema. This produces masochistic narratives with unstable women characters who represent the male fear of losing epistemological dominance. The women seem to lose their own bodies and pleasures, while embodying the male fear of lost dominance. The woman spectator then oscillates between identifying with this male position and with the persecuted female. See Doan, "The 'Woman's Film.'"

41. Butler, *Bodies That Matter*, xi–xxx.

42. Warren-Crow, *Girlhood and the Plastic Image*, 8.

43. *Natality* is Hannah Arendt's term, borrowed from Augustine, for the unpredictability of action and politics that enters the world with every birth (see Arendt, *The Human Condition*, 178–79).

CHAPTER FIVE

1. *Representation* here alludes to the social and political order built on "habits of indexicality" or the standardization of correspondences between our perceptions and assigned meanings (Panagia and Richard, "Introduction").

2. "The new" is an expression used by the food critic character Anton Ego.

3. See chapter 3.

4. Rancière, *The Politics of Aesthetics*, 85.

5. Rancière, "The Aesthetic Dimension," 9.

6. Here *ethical* refers to the Platonic, ethical regime that is primarily concerned with how ways of making and doing affect the ethos of individuals and communities (Rancière, *The Politics of Aesthetics*, 20–21).

7. Rancière, "The Aesthetic Dimension," 10.

8. Rancière, *The Politics of Aesthetics*, 83–84.

9. Telotte, *Animating Space*, 134–35.

10. Panagia, *Political Life*, 2–3.

11. Panagia's equivalence of sensation and aesthetic experience strays from Kant's original formulation. In a passage where Kant distinguishes agreeable sensation and the judgment of beauty from moral and utilitarian judgments of the good, it appears that beauty and sensation share a kind of immediacy but not the durational immediacy that Panagia purports: "in the case of the good there is always the question whether it is good merely indirectly or good directly (i.e., useful, or intrinsically good), whereas in the case of the agreeable this question cannot even arise, since this word always signifies something that we like directly. (What we call beautiful is also liked directly.)" (Kant, *Critique of Judgment*, 48–50). The translator, Werner S. Pluhar, notes that *mediately* and *immediately* are more literal to the German *mittelbar* and *unmittelbar* than *indirectly* and *directly*, but Pluhar chose the latter intentionally to avoid the temporal sense of *immediately*. Panagia is insisting, then, that Kant's notion of the direct/unmediated nature of the agreeable and beautiful has durational implications in addition to a nonconceptual structure. He describes this "durational intensity" as referring to the subject's state of attention when engaged with a beautiful object, which can then be applied to a pleasant sensation as well given that both are "immediate" or "direct." Whereas Kant deliberately elevates beauty above sensory pleasure, Panagia latches on to the fact that Kant equates their immediacy. Kant's elevation of beauty has to do with his effort to treat it as symbolically related to the good. Panagia is not interested in this romantic project but is interested in a democratic project comparable to Hannah Arendt's usage of Kant's aesthetic judgment.

12. Panagia, *Political Life*, 26.

13. Ibid., 31. Panagia's passage borrows from Kant, who was writing in response to Hume, "although, as *Hume* says, critics can reason more plausibly than cooks, they still share the same fate. They cannot expect the determining basis of their judgment [to come] from the force of the bases of proof, but only from the subject's reflection on his own state (of pleasure or displeasure), all precepts and rules being rejected" (Kant, *Critique of Judgment*, 149; emphasis in original).

14. It must be noted that the film *Ratatouille* also lends itself to a psychoanalytic interpretation. Naming the critic character Ego and having him represent order and judgment is only a slightly less explicit allusion to psychoanalysis than the chef Gusteau character, who doubles as Remy's superego. Although such a reading is beyond the scope of this chapter, it may be useful to recognize that Freudian psychoanalysis has been credited with contributing to the narrativization of early cinema and to the structuralist, representationalist treatment of aesthetic objects generally, which is precisely the regime of the

sensible that Panagia argues against. *Ratatouille* could potentially support an antipsychoanalytic argument through the dethroning of Anton Ego and the diminution of Remy's conscience, the chef Gusteau, but it would not be as simple as that since the film relies heavily on these two characters as interpreters, judges, and beacons of psychosocial order.

15. For a discussion of the techniques and approaches used to produce food imagery and sequences in *Ratatouille* see Shah, "Anyone Can Cook."

16. See Elsaesser and Hagener, *Film Theory*, 117.

17. Bruno Latour discusses this point in *Reassembling the Social*, and he emphasizes how advances in information technology have enhanced our ability to describe and transcribe layers of action. He adds a footnote about computer graphics that resonates with *Ratatouille:* "A splendid allegory of this layered makeup is offered by computer-generated imagery. *Siggraph* meetings in Los Angeles, for example, have entire sessions devoted to it. There is a morning dedicated to the shine of nylon, one afternoon to the refraction of light onto red hair, one evening to the 'realistic rendering' of blows, and so on. As usual 'virtual' reality is a materialization of what is needed for 'natural' reality" (Latour, *Reassembling the Social*, 208n277).

18. Gunning, "Moving Away," 42 (my emphasis).

19. Rodowick, *Virtual Life*, 104.

20. See Bolter and Grusin, *Remediation*.

21. Ngai, *Our Aesthetic Categories*, 8–9.

22. Deleuze, *The Logic of Sense*, 1–3.

23. Deleuze and Guattari, *A Thousand Plateaus*, 272 (emphasis in original).

24. Ibid., 291.

25. Lawlor, "Following the Rats," 170–78.

26. Deleuze and Guattari, *A Thousand Plateaus*, 240 (emphasis in original).

27. Lawlor, "Following the Rats," 180–83.

28. For the history of this essentialist theme in Disney's animated films see Booker, *Hidden Messages*, esp. chaps. 1 and 2.

29. Price, *The Pixar Touch*, 254.

30. Ibid.

CONCLUSION

1. See Frank, "Traces of the World."

2. Cavell, *The World Viewed*, 26, 168; Bazin, *Orson Welles*, 58. See also Arnaud, "From Bazin to Deleuze," 90.

3. Ngai, *Our Aesthetic Categories,* 236.

4. Ibid., 237.

5. Reality TV actually presents diverse forms of judgment-based programming, including courtroom programs featuring judge characters and programs examining extreme behavior that feature psychological and sociological experts—for example, A&E's *Hoarders.* Despite these different forms, it seems common for the authoritative voices in these shows to blame the less fortunate for their misfortunes. See Ouellette, "'Take Responsibility for Yourself'"; and Petro, "Austerity Media."

6. Arendt, *The Life of the Mind,* 19.

7. In her *Lectures on Kant's Political Philosophy* Arendt explains how the synonymous relation between taste and judgment is justified through the fact of human sociability and argues that Kant is correct to link seemingly private judgments to living in community: "Kant stresses that at least one of our *mental faculties,* the faculty of judgment, presupposes the presence of others" (73–74; emphasis in original).

8. A common critical interpretation of Arendt's incomplete theory of judgment (she had planned to write a third volume for *The Life of the Mind* on judging) is that she overemphasizes Kant's formulation of judgment, with its reflective and determinative modes, and neglects the many modes of judgment involved in practical and goal-oriented activities. This critical reading is largely based on Arendt's shift from writing about the *vita activa* in her earlier work to the *vita contemplativa* in her later work. See Beiner, "Hannah Arendt on Judging," 131–38.

9. Arendt, *Lectures,* 67.

BIBLIOGRAPHY

Ackerman, Alan L. "The Spirit of Toys: Resurrection and Redemption in *Toy Story* and *Toy Story 2*." *University of Toronto Quarterly* 74, no. 4 (2005): 895–912. doi:10.1353/utq.2005.0266.

———. *Seeing Things: From Shakespeare to Pixar*. Toronto: University of Toronto Press, 2011.

Adorno, Theodor W. *The Culture Industry: Selected Essays on Mass Culture*. New York: Routledge, 2005.

Adorno, Theodor W., and Max Horkheimer. *Dialectic of Enlightenment*. Translated by John Cumming. London: Verso, 1997.

Agamben, Giorgio. *State of Exception*. Translated by Kevin Attell. Chicago: University of Chicago Press, 2005.

Ames, Mark. "REVEALED: Emails, Court Docs Show How Sony Stood up to Steve Jobs' and Pixar's Wage-Fixing Cartel." *Pando Daily*, July 10, 2014. http://pando.com/2014/07/10/revealed-court-docs-show-how-sony-stood-up-to-steve-jobs-and-pixars-wage-fixing-cartel/.

Andrew, Dudley, ed. *Opening Bazin: Postwar Film Theory and Its Afterlife*. With Herve Joubert-Laurencin. New York: Oxford University Press, 2011.

Aneesh, A., Prof Lane Hall, and Patrice Petro, eds. *Beyond Globalization: Making New Worlds in Media, Art, and Social Practices*. New Brunswick, NJ: Rutgers University Press, 2011.

Arendt, Hannah. *Between Past and Future: Eight Exercises in Political Thought*. New York: Penguin, 2006.

————. "The Crisis in Culture." In Arendt, *Between Past and Future*, 194–222.

————. *The Human Condition*. 2nd ed. Chicago: University of Chicago Press, 1998.

————. *Lectures on Kant's Political Philosophy*. Edited by Ronald Beiner. Chicago: University of Chicago Press, 1989.

————. *The Life of the Mind*. Edited by Mary McCarthy. New York: Mariner, 1981.

————. *The Origins of Totalitarianism*. New York: Harcourt, Brace, Jovanovich, 1973.

Argent, Daniel. "Monsters, Inc.: Andrew Stanton on Writing for Pixar." *Creative Screenwriting* 8, no. 6 (2001): 22–23.

Arnaud, Diane. "From Bazin to Deleuze: A Matter of Depth." In Andrew, *Opening Bazin*, 85–94.

Balides, Constance. "Jurassic Post-Fordism: Tall Tales of Economics in the Theme Park." *Screen* 41, no. 2 (2000): 139–60.

Bauman, Zygmunt. *Liquid Modernity*. Malden, MA: Blackwell, 2000.

Bazin, André. *Orson Welles*. Paris: Chavane, 1950.

————. *What Is Cinema?* Vol. 1. Essays selected and translated by Hugh Gray. Berkeley: University of California Press, 2004.

Beckman, Karen, ed. *Animating Film Theory*. Durham, NC: Duke University Press, 2014.

Beiner, Ronald. "Hannah Arendt on Judging." In Arendt, *Lectures on Kant's Political Philosophy*, 89–156.

Benjamin, Walter. *Illuminations*. Translated by Harry Zohn. New York: Schocken, 2007.

————. "On Some Motifs in Baudelaire." In Benjamin, *Illuminations*, 155–200.

Bennett, Jane. *Vibrant Matter: A Political Ecology of Things*. Durham, NC: Duke University Press, 2009.

Bird, Brad, and John Walker. "Audio Commentary." *The Incredibles*. DVD. Directed by Brad Bird. Burbank, CA: Disney/Pixar, 2005.

Bolter, J. David, and Richard Grusin. *Remediation: Understanding New Media*. Cambridge, MA: MIT Press, 2000.

Booker, M. Keith. *Disney, Pixar, and the Hidden Messages of Children's Films*. Santa Barbara, CA: ABC-CLIO, 2010.

Buchan, Suzanne. "A Cinema of Apprehension: A Third Entelechy of the Vitalist Machine." In Buchan, *Pervasive Animation*, 143–71.

————, ed. *Animated "Worlds."* Eastleigh, UK: John Libbey, 2006.

————. "Animation, in Theory." In Beckman, *Animating Film Theory*, 111–30.

————. "Introduction: Pervasive Animation." In Buchan, *Pervasive Animation*, 1–21.

————, ed. *Pervasive Animation*. New York: Routledge, 2013.

Buck-Morss, Susan. "Aesthetics and Anaesthetics: Walter Benjamin's Artwork Essay Reconsidered." *October* 62 (Autumn 1992): 3–41. doi:10.2307/778700.

Bukatman, Scott. *Matters of Gravity: Special Effects and Supermen in the 20th Century*. Durham, NC: Duke University Press, 2003.

————. *The Poetics of Slumberland: Animated Spirits and the Animating Spirit*. Berkeley: University of California Press, 2012.

————. "Some Observations Pertaining to Cartoon Physics; or, The Cartoon Cat in the Machine." In Beckman, *Animating Film Theory*, 301–16.

Bullock, Marcus. "The Origins of the Danger Market." In *Rethinking Global Security: Media, Popular Culture, and the "War on Terror,"* edited by Andrew Martin and Patrice Petro, 67–84. New Brunswick, NJ: Rutgers University Press, 2006.

Burke, Edmund. *Philosophical Enquiry into the Origin of Our Ideas of the Sublime and Beautiful*. Project Gutenberg, 2005. www.gutenberg.org/files/15043/15043-h /15043-h.htm.

Butler, Judith. *Bodies That Matter: On the Discursive Limits of "Sex."* New York: Routledge, 2011.

Capodagli, Bill, and Lynn Jackson. *Innovate the Pixar Way: Business Lessons from the World's Most Creative Corporate Playground*. New York: McGraw-Hill, 2009.

Catmull, Ed. *Creativity, Inc.: Overcoming the Unseen Forces That Stand in the Way of True Inspiration*. With Amy Wallace. New York: Random House, 2014.

Cavell, Stanley. "The Avoidance of Love (External-World Skepticism)." In Mulhall, *The Cavell Reader*, 89–93.

————. *Must We Mean What We Say? A Book of Essays*. Cambridge: Cambridge University Press, 2002.

————. *The World Viewed: Reflections on the Ontology of Film*. Cambridge, MA: Harvard University Press, 1979.

Chen, Mel. *Animacies: Biopolitics, Racial Mattering, and Queer Affect*. Durham, NC: Duke University Press, 2012.

Chevrier, Jean-François. "The Reality of Hallucination in André Bazin." In Andrew, *Opening Bazin*, 42–56.

Cholodenko, Alan, ed. *The Illusion of Life: Essays on Animation*. Sydney: Power Institute of Fine Arts, 1993.

Christensen, Jerome. *America's Corporate Art: The Studio Authorship of Hollywood Motion Pictures* (1929–2001). Stanford, CA: Stanford University Press, 2011.

Costelloe, Timothy M., ed. *The Sublime: From Antiquity to the Present.* Cambridge: Cambridge University Press, 2012.

Crafton, Donald. *Before Mickey: The Animated Film, 1898–1928.* Chicago: University of Chicago Press, 1993.

———. *Shadow of a Mouse: Performance, Belief, and World-Making in Animation.* Berkeley: University of California Press, 2013.

Crary, Jonathan. *24/7: Late Capitalism and the Ends of Sleep.* New York: Verso, 2014.

Dean, Jodi. *Blog Theory: Feedback and Capture in the Circuits of Drive.* Malden, MA: Polity, 2010.

Deleuze, Gilles. *The Logic of Sense.* New York: Columbia University Press, 1990.

Deleuze, Gilles, and Felix Guattari. *A Thousand Plateaus: Capitalism and Schizophrenia.* Minneapolis: University of Minnesota Press, 1987.

Déotte, Jean-Louis, and Roxanne Lapidus. "The Differences between Rancière's 'Mésentente' (Political Disagreement) and Lyotard's 'Différend.'" *SubStance* 33, no. 1 (2004): 77–90. doi:10.2307/3685463.

Doane, Mary Ann. *The Emergence of Cinematic Time: Modernity, Contingency, the Archive.* Cambridge, MA: Harvard University Press, 2002.

———. "The 'Woman's Film': Possession and Address." In *Home Is Where the Heart Is: Studies in Melodrama and the Woman's Film,* edited by Christine Gledhill, 283–98. London: British Film Institute, 1987.

Douglas, James. "The Pixar Theory of Labor." *The Awl.* www.theawl.com/2015/07/the-pixar-theory-of-labor.

Edelman, Lee. *No Future: Queer Theory and the Death Drive.* Durham, NC: Duke University Press, 2004.

Eisenstein, S. M. *Eisenstein on Disney.* Calcutta, India: Seagull, 1986.

Elam, Michele. *The Souls of Mixed Folk: Race, Politics, and Aesthetics in the New Millennium.* Stanford, CA: Stanford University Press, 2011.

Elsaesser, Thomas. "Tales of Sound and Fury." In *Home Is Where the Heart Is,* edited by Christine Gledhill, 43–69. London: British Film Institute, 1987.

Elsaesser, Thomas, and Malte Hagener. *Film Theory: An Introduction through the Senses.* New York: Routledge, 2015.

Emerson, Caryl. *The First Hundred Years of Mikhail Bakhtin.* Princeton, NJ: Princeton University Press, 2000.

Ferguson, Kennan. *All in the Family: On Community and Incommensurability.* Durham, NC: Duke University Press, 2012.

Finch, Christopher. *The CG Story: Computer Generated Animation and Special Effects.* New York: Monacelli Press, 2013.

Flaig, Paul. "Life Driven by Death: Animation Aesthetics and the Comic Uncanny." *Screen* 54, no. 1 (2013): 1–19. doi:10.1093/screen/hjs065.

———. "Slapstick after Fordism: *WALL-E*, Automatism and Pixar's Fun Factory." *Animation: An Interdisciplinary Journal* 11, no. 1 (2016): 59–74.

Frank, Hannah. "Traces of the World: Cel Animation and Photography." *Animation: An Interdisciplinary Journal* 11, no. 1 (2016): 23–39.

Frank, Jason. "'Delightful Horror': Edmund Burke and the Aesthetics of Democratic Revolution." In Kompridis, *The Aesthetic Turn,* 3–28.

Freeman, Elizabeth. "'Monsters, Inc.': Notes on the Neoliberal Arts Education." *New Literary History* 36, no. 1 (2005): 83–95.

Freud, Sigmund. *The Uncanny.* Translated by David McLintock. New York: Penguin UK, 2003.

Friedberg, Anne. *The Virtual Window: From Alberti to Microsoft.* Cambridge, MA: MIT Press, 2009.

Fukuyama, Francis. *The End of History and the Last Man.* New York: Simon and Schuster, 2006.

Gabriel, Brian. "What Is the Animation Wage-Fixing Lawsuit? An Explainer for the Community." *Cartoon Brew,* Jan. 19, 2016. www.cartoonbrew.com /artist-rights/animation-wage-fixing-lawsuit-explainer-community-131812 .html.

Gadassik, Alla. "Ghosts in the Machine: The Body in Digital Animation." In *Popular Ghosts: The Haunted Spaces of Everyday Culture,* edited by María del Pilar Blanco and Esther Peeren, 225–38. New York: Continuum, 2010.

Gardner, Stephen L. "Democracy's Debt: Capitalism and Cultural Revolution." In *Debt: Ethics, the Environment, and the Economy,* edited by Peter Y. Paik and Merry Wiesner-Hanks, 94–115. Bloomington: Indiana University Press, 2013.

Gooding-Williams, Robert. *Zarathustra's Dionysian Modernism.* Stanford, CA: Stanford University Press, 2001.

Grossman, Lev. "2045: The Year Man Becomes Immortal." *Time,* Feb. 10, 2011. http://content.time.com/time/magazine/article/0,9171,2048299,00.html.

Gunning, Tom. "Animating the Instant: The Secret Symmetry between Animation and Photography." In Beckman, *Animating Film Theory,* 37–53.

———. "Moving Away from the Index: Cinema and the Impression of Reality." *Differences* 18, no. 1 (2007): 29–52. doi:10.1215/10407391–2006–022.

Gurevitch, Leon. "Computer Generated Animation as Product Design Engineered Culture, or Buzz Lightyear to the Sales Floor, to the Checkout and Beyond!" *Animation* 7, no. 2 (2012): 131–49. doi:10.1177/1746847712438133.

———. "From Edison to Pixar: The Spectacular Screen and the Attention Economy from Celluloid to CG." *Continuum* 29, no. 3 (2015): 445–65. doi:10.10 80/10304312.2014.986062.

Halberstam, Judith. *The Queer Art of Failure*. Durham, NC: Duke University Press, 2011.

Hansen, Miriam Bratu. *Cinema and Experience: Siegfried Kracauer, Walter Benjamin, and Theodor W. Adorno*. Berkeley: University of California Press, 2012.

———. "Of Mice and Ducks: Benjamin and Adorno on Disney." *South Atlantic Quarterly* 92, no. 1 (1993): 27–61.

Hayles, N. Katherine. *How We Became Posthuman: Virtual Bodies in Cybernetics, Literature, and Informatics*. Chicago: University of Chicago Press, 2008.

———. *How We Think: Digital Media and Contemporary Technogenesis*. Chicago: University Of Chicago Press, 2012.

———. *My Mother Was a Computer: Digital Subjects and Literary Texts*. Chicago: University of Chicago Press, 2005.

Heidegger, Martin. *Basic Writings*. 2nd ed. Rev. and exp. New York: Harper Collins, 1993.

———. *Poetry, Language, Thought*. New York: Harper Collins, 2001.

———. "The Question Concerning Technology." In *Basic Writings: From "Being and Time" (1927) to "The Task of Thinking" (1964)*. Edited by David Farrell Krell, 281–317. New York: Harper and Row, 1977.

Herhuth, Eric. "Cooking like a Rat: Sensation and Politics in Disney-Pixar's *Ratatouille*." *Quarterly Review of Film and Video* 31, no. 5 (2014): 469–85.

———. "Life, Love, and Programming: The Culture and Politics of *WALL-E* and Pixar Computer Animation." *Cinema Journal* 53, no. 4 (2014): 53–75.

———. "The Politics of Animation and the Animation of Politics." *Animation: An Interdisciplinary Journal* 11, no. 1 (2016): 4–22.

Holmqvist, Kenneth, and Jaroslaw Pluciennik. "A Short Guide to the Theory of the Sublime." *Style* 36, no. 4 (2002): 718.

Isaacson, Walter. *Steve Jobs*. New York: Simon and Schuster, 2013.

Iton, Richard. *In Search of the Black Fantastic: Politics and Popular Culture in the Post–Civil Rights Era*. New York: Oxford University Press, 2008.

Johnston, Ollie, and Frank Thomas. *The Illusion of Life: Disney Animation*. New York: Disney Editions, 1995.

Kant, Immanuel. *Critique of Judgment*. Translated by Werner S. Pluhar. Indianapolis, IN: Hackett, 1987.

Keller, Sean. "Beauty, Genius, Epigenesis: The Kantian Origins of Contemporary Architecture." *Journal of Architectural Education* 65, no. 2 (2012): 42–51. doi:10.1111/j.1531–314X.2011.01194.x.

Kemper, Tom. *Toy Story: A Critical Reading*. London: British Film Institute, 2015.

Koch, Gertrud. "Film as Experiment in Animation: Are Films Experiments on Human Beings?" Translated by Daniel Hendrickson. In Beckman, *Animating Film Theory*, 131–44.

Kompridis, Nikolas, ed. *The Aesthetic Turn in Political Thought*. New York: Bloomsbury, 2014.

Kracauer, Siegfried. "The Mass Ornament." In *The Mass Ornament: Weimar Essays*, translated and edited by Thomas Y. Levin, 75–88. Cambridge, MA: Harvard University Press, 1995.

Kuznets, Lois R. *When Toys Come Alive: Narratives of Animation, Metamorphosis, and Development*. New Haven, CT: Yale University Press, 1994.

Lacan, Jacques. "The Mirror Stage as Formative of the Function of the I as Revealed in Psychoanalytic Experience." In *Écrits*, 75–81. Translated by Bruce Fink. New York: Norton, 2006.

Lamarre, Thomas. *The Anime Machine: A Media Theory of Animation*. Minneapolis: University of Minnesota Press, 2009.

———. "Coming to Life: Cartoon Animals and Natural Philosophy." In Buchan, *Pervasive Animation*, 117–42.

———. "New Media Worlds." In Buchan, *Animated "Worlds,"* 131–50.

Lane, Anthony. "The Fun Factory: Life at Pixar." *New Yorker*, May 16, 2011. www.newyorker.com/magazine/2011/05/16/the-fun-factory.

Lash, Scott, and Celia Lury. *Global Culture Industry: The Mediation of Things*. Cambridge: Polity, 2007.

Lasseter, John. Interview by Charlie Rose. Dec. 1, 2011. www.charlierose.com /videos/18515.

Lasseter, John, and Steve Daly. *"Toy Story": The Art and Making of the Animated Film*. New York: Disney Editions, 1995.

Latour, Bruno. *Pandora's Hope: Essays on the Reality of Science Studies*. Cambridge, MA: Harvard University Press, 1999.

———. *Reassembling the Social: An Introduction to Actor-Network Theory*. New York: Oxford University Press, 2005.

Lawlor, Leonard. "Following the Rats: Becoming-Animal in Deleuze and Guattari." *SubStance* 37, no. 3 (2008): 169–87. doi:10.1353/sub.0.0016.

Leslie, Esther. "Animation and History." In Beckman, *Animating Film Theory*, 25–36.

———. "Animation's Petrified Unrest." In Buchan, *Pervasive Animation*, 73–93.

———. *Hollywood Flatlands: Animation, Critical Theory and the Avant-Garde*. London: Verso, 2004.

Lyotard, Jean-François. "Anima Minima." In *Postmodern Fables*. Translated by Georges Van Den Abbeele, 235–49. Minneapolis: University of Minnesota Press, 1997.

———. *The Assassination of Experience by Painting, Monoroy / L'assassinat de l'expérience par la peinture, Monoroy*. Translated by Rachel Bowlby, Jeanne Bouniort, and Peter W. Milne. Leuven, Belgium: Leuven University Press, 2013.

———. *The Inhuman: Reflections on Time*. Stanford, CA: Stanford University Press, 1991.

———. *Postmodern Fables*. Translated by Georges Van Den Abbeele. Minneapolis: University of Minnesota Press, 1997.

MacCabe, Colin. "Bazin as Modernist." In Andrew, *Opening Bazin*, 66–76.

Manovich, Lev. *The Language of New Media*. Cambridge, MA: MIT Press, 2002.

Markell, Patchen. "Arendt, Aesthetics, and 'The Crisis in Culture.'" In Kompridis, *The Aesthetic Turn*, 61–88.

Marx, Karl. "Capital Volume One." *Marxists.org*, 2005. www.marxists.org /archive/marx/works/1867-c1/cho1.htm.

Mays, Sas. "Literary Digital Humanities and the Politics of the Infinite." *New Formations*, no. 78 (June 22, 2012): 117.

McMahon, Jennifer A. "The Sense of Community in Cavell's Conception of Aesthetic and Moral Judgment." *Conversations: The Journal of Cavellian Studies*, no. 2 (2014): https://uottawa.scholarsportal.info/ojs/index.php /conversations/article/view/1104.

Mihailova, Mihaela. "The Mastery Machine: Digital Animation and Fantasies of Control." *Animation: An Interdisciplinary Journal* 8, no. 2 (2013): 131–48.

"Monsters, Inc.: Production Notes." http://cinema.com/articles/724/monsters-inc-production-notes.phtml.

Montgomery, Colleen. "Woody's Roundup and Wall-E's Wunderkammer: Technophilia and Nostalgia in Pixar Animation." *Animation Studies Online Journal* 6 (Sept.2,2011):http://journal.animationstudies.org/colleen-montgomery-woodys-roundup-and-walles-wunderkammer/.

Moore, Alan. *Watchmen*. New York: DC Comics, 1995.

Morgan, Benjamin. "Undoing Legal Violence: Walter Benjamin's and Giorgio Agamben's Aesthetics of Pure Means." *Journal of Law and Society* 34, no. 1 (2007): 46–64.

Morgan, Daniel. "The Afterlife of Superimposition." In Andrew, *Opening Bazin*, 127–41.

———. "Rethinking Bazin: Ontology and Realist Aesthetics." *Critical Inquiry* 32, no. 3 (2006): 443–81. doi:10.1086/505375.

Mulhall, Stephen. *The Cavell Reader.* Cambridge, MA: Blackwell, 1996.

Munkittrick, Kyle. "The Hidden Message in Pixar's Films." Science Not Fiction. *Discover Magazine*, May 14, 2011. http://blogs.discovermagazine.com /sciencenotfiction/2011/05/14/the-hidden-message-in-pixars-films/.

Negroni, Jon. "The Pixar Theory." Blog. *Jonnegroni.com,* July 11, 2013. http:// jonnegroni.com/2013/07/11/the-pixar-theory/.

Ngai, Sianne. *Our Aesthetic Categories: Zany, Cute, Interesting.* Cambridge, MA: Harvard University Press, 2015.

———. *Ugly Feelings.* Cambridge, MA: Harvard University Press, 2007.

Nietzsche, Friedrich Wilhelm. "Thus Spake Zarathustra." Translated by Thomas Common. *Project Gutenberg,* 2008. www.gutenberg.org/files/1998/1998-h /1998-h.htm.

Noë, Alva. *Strange Tools: Art and Human Nature.* New York: Hill and Wang, 2015.

———. *Varieties of Presence.* Cambridge, MA: Harvard University Press, 2012.

Nye, David E. *American Technological Sublime.* Cambridge, MA: MIT Press, 1996.

Ouellette, Laurie. "'Take Responsibility for Yourself': *Judge Judy* and the Neoliberal Citizen." In *Reality TV: Remaking Television Culture,* edited by Susan Murray and Laurie Ouellette, 231–48, New York: New York University Press, 2004.

Paik, Peter Y. *From Utopia to Apocalypse: Science Fiction and the Politics of Catastrophe.* Minneapolis: University of Minnesota Press, 2010.

Panagia, Davide. "Aesthetics and Politics." In *The Encyclopedia of Political Thought.* John Wiley and Sons, 2014. http://onlinelibrary.wiley.com/doi /10.1002/9781118474396.wbept0009/abstract.

———. "Blankets, Screens, and Projections: Or, the Claim of Film." In Kompridis, *The Aesthetic Turn,* 229–62.

———. *The Political Life of Sensation.* Durham, NC: Duke University Press, 2010.

Panagia, Davide, and Adrienne Richard. "Introduction: A Return to the Senses." *Theory and Event* 13, no. 4 (2010). https://muse.jhu.edu/journals /theory_and_event/v013/13.4.panagia.html.

Parks, Lisa. "Falling Apart: Electronics Salvaging and the Global Media Economy." In *Residual Media,* edited by Charles R. Acland, 32–47. Minneapolis: University of Minnesota Press, 2007.

Petro, Patrice. "Austerity Media." In *After Capitalism: Horizons of Finance, Culture, and Citizenship,* edited by Kennan Ferguson and Patrice Petro, 89–105. New Brunswick, NJ: Rutgers University Press, 2016.

Pierson, Ryan. "On Styles of Theorizing Animation Styles: Stanley Cavell at the Cartoon's Demise." *Velvet Light Trap,* no. 69 (Spring 2012): 17–26.

Poster, Mark. "Global Media and Culture." In *Beyond Globalization: Making New Worlds in Media, Art, and Social Practices,* edited by A. Aneesh, Lane Hall, and Patrice Petro, 15–29. New Brunswick, NJ: Rutgers University Press, 2012.

Price, David A. *The Pixar Touch: The Making of a Company.* New York: Vintage, 2009.

Rancière, Jacques. "The Aesthetic Dimension: Aesthetics, Politics, Knowledge." *Critical Inquiry* 36, no. 1 (2009): 1–19. doi:10.1086/606120.

———. *Chronicles of Consensual Times.* New York: Continuum, 2010.

———. *The Politics of Aesthetics.* New York: Continuum, 2009.

Roberts, William Rhys. *Longinus on the Sublime: The Greek Text Edited after the Paris Manuscript, with Introduction, Translation, Facsimiles and Appendices.* Cambridge: Cambridge University Press, 1899.

Rodowick, D. N. *Elegy for Theory.* Cambridge, MA: Harvard University Press, 2014.

———. *Philosophy's Artful Conversation.* Cambridge, MA: Harvard University Press, 2015.

———. *The Virtual Life of Film.* Cambridge, MA: Harvard University Press, 2009.

Rosen, Philip. "Belief in Bazin." In Andrew, *Opening Bazin,* 107–18.

Sammond, Nicholas. *Birth of an Industry: Blackface Minstrelsy and the Rise of American Animation.* Durham, NC: Duke University Press, 2015.

———. "A Space Apart: Animation and the Spatial Politics of Conversion." *Film History* 23 (2011): 268–84.

Saygin, Ayse Pinar, Thierry Chaminade, Hiroshi Ishiguro, Jon Driver, and Chris Frith. "The Thing That Should Not Be: Predictive Coding and the Uncanny Valley in Perceiving Human and Humanoid Robot Actions." *Social Cognitive and Affective Neuroscience* 7, no. 4 (2012): 413–22. doi:10.1093/scan/nsr025.

Schivelbusch, Wolfgang. *The Railway Journey: The Industrialization of Time and Space in the Nineteenth Century.* Berkeley: University of California Press, 2014.

Shah, Apurva. "Anyone Can Cook—Inside *Ratatouille*'s Kitchen." In *SIG-GRAPH 2007 Course 30*, August 5, 2007. http://graphics.pixar.com/library /AnyoneCanCook/paper.pdf.

Sharm, Rekha. "Drawn-Out Battles: Exploring War-Related Messages in Animated Cartoons." In *War and the Media: Essays on News Reporting, Propaganda and Popular Culture*, edited by Paul M. Haridakis, Barbara S. Hugenberg, and Stanley T. Wearden, 75–89. Jefferson, NC: McFarland, 2009.

Shaviro, Steven. *Without Criteria: Kant, Whitehead, Deleuze, and Aesthetics*. Cambridge, MA: MIT Press, 2009.

Sito, Tom. *Moving Innovation: A History of Computer Animation*. Cambridge, MA: MIT Press, 2013.

Sobchack, Vivian. "Final Fantasies: Computer Graphic Animation and the [Dis]Illusion of Life." In Buchan, *Animated "Worlds,"* 171–82.

———. "Sci-Why? On the Decline of a Film Genre in an Age of Technological Wizardry." *Science Fiction Studies* 41, no. 2 (2014): 284–300.

Stockton, Kathryn Bond. *The Queer Child, or Growing Sideways in the Twentieth Century*. Durham, NC: Duke University Press, 2009.

Telotte, J. P. *Animating Space: From Mickey to Wall-E*. Lexington: University Press of Kentucky, 2010.

"The Incredibles—Production Notes." *Pixar Talk*. www.pixartalk.com/feature-films/the-incredibles/the-incredibles-production-notes/.

Thompson, Kristin. "Implications of the Cel Animation Technique." In *The Cinematic Apparatus*, edited by Stephen Heath and Teresa de Lauretis, 106–9. London: Macmillan, 1980.

Tranter, Paul J., and Scott Sharpe. "Disney-Pixar to the Rescue: Harnessing Positive Affect for Enhancing Children's Active Mobility." *Journal of Transport Geography* 20, no. 1 (2012): 34–40. doi:10.1016/j.jtrangeo.2011.04.006.

———. "Escaping Monstropolis: Child-Friendly Cities, Peak Oil and Monsters, Inc." *Children's Geographies* 6, no. 3 (2008): 295–308. doi:10.1080 /14733280802184021.

Turkle, Sherry. *Alone Together: Why We Expect More from Technology and Less from Each Other*. New York: Basic Books, 2012.

———. *Reclaiming Conversation: The Power of Talk in a Digital Age*. New York: Penguin, 2015.

Vidler, Anthony. *The Architectural Uncanny: Essays in the Modern Unhomely*. Cambridge, MA: MIT Press, 1994.

Vighi, Fabio, and Heiko Feldner. "From Subject to Politics: The Žižekian Field Today." *Subjectivity* 3, no. 1 (2010): 31–52. doi:10.1057/sub.2009.32.

Wadhwa, Vivek. "Laws and Ethics Can't Keep Pace with Technology." *MIT Technology Review*, April 15, 2014. www.technologyreview.com/view/526401/laws-and-ethics-cant-keep-pace-with-technology/

Warren-Crow, Heather. *Girlhood and the Plastic Image*. Lebanon, NH: Dartmouth College Press, 2014.

Weidenfeld, Matthew C. "Visions of Judgment: Arendt, Kant, and the Misreading of Judgment." *Political Research Quarterly* 66, no. 2 (2012): 254–66.

Wells, Paul. *Animation and America*. Edinburgh: Edinburgh University Press, 2002.

———. *Understanding Animation*. New York: Routledge, 2013.

Wooden, Shannon R., and Ken Gillam. *Pixar's Boy Stories: Masculinity in a Postmodern Age*. Lanham, MD: Rowman and Littlefield, 2014.

Woodward, Ashley. "Nihilism and the Sublime in Lyotard." *Angelaki* 16, no. 2 (2011): 51–71. doi:10.1080/0969725X.2011.591585.

Yoon, Hyejin. "Globalization of the Animation Industry: Multi-scalar Linkages of Six Animation Production Centers." *International Journal of Cultural Policy*, Sept. 11, 2015, 1–18.

Zerilli, Linda M. G. *A Democratic Theory of Judgment*. Chicago: University of Chicago Press, 2016.

———. "'We Feel Our Freedom': Imagination and Judgment in the Thought of Hannah Arendt." In Kompridis, *The Aesthetic Turn*, 29–60.

Zipes, Jack. *The Enchanted Screen: The Unknown History of Fairy-Tale Films*. New York: Routledge, 2010.

———. *Fairy Tales and the Art of Subversion*. New York: Routledge, 2007.

Žižek, Slavoj. *First as Tragedy, Then as Farce*. New York: Verso, 2009.

———. *The Plague of Fantasies*. New York: Verso, 2009.

———. *The Sublime Object of Ideology*. 2nd ed. London: Verso, 2009.

———. *Violence: Six Sideways Reflections*. New York: Picador, 2008.

Zornado, J. "Children's Film as Social Practice." *CLCWeb: Comparative Literature and Culture* 10, no. 2 (2008): 1–10. doi:10.7771/1481-4374.1354.

INDEX

CPSIA information can be obtained
at www.ICGtesting.com
Printed in the USA
LVOW07*1605270717
542864LV00001B/7/P